W9-CPF-599

GERMAN EXPRESSIONISM

DIE BRÜCKE AND DER BLAUE REITER

GERMAN EXPRESSIONISM
DIE BRÜCKE AND
DER BLAUE REITER

By Barry Herbert

HIPPOCRENE
BOOKS, INC.

ACKNOWLEDGEMENTS

In writing this survey of the rapid rise, development and equally sudden fall of Germany's two most important, well-organized and proudly distinctive Expressionist artists' groups, I owe an enormous debt of gratitude to the many scholars, especially in America, who in recent years have conscientiously shed sober light on a period in modern art history once considered notorious for its complexity and apparent contradictions. Specialists in the subject will recognize to whom credit is due, and for the interested general reader who may want to know more as a result of this introduction, the bibliography at the end of each section lists all my sources and a selected guide to further reading.

I have also greatly benefited from the help and interest of colleagues, friends and relatives. My warmest thanks go to Alisdair Hinshelwood of the Leicestershire Museum and Art Gallery, Jeffrey Solomon of Fischer Fine Art Ltd., London and Rosemary Treble, formerly of the Witt Library, all of whom put themselves out on my behalf over a long period of time with the utmost kindness and generosity. I am especially grateful to my sister Brenda Deer formerly of the Leicestershire County Libraries for her unfailing assistance in obtaining books and periodicals and for her help in typing the final manuscript. For her patient typing of the earlier drafts of the book, as well as for her work on the final manuscript, a special word of thanks to Elaine Frost. Martin Heard of Jupiter Books has given me sterling support at all times, and I thank him most sincerely.

Throughout the preparation of this book I have been conscious of the great benefit I have enjoyed as a writer in dealing with artists who shared such a remarkable gift for recording and expressing their experiences so vividly and excitingly. This is especially true of Kandinsky, Marc and Klee, and it is good to know that a substantial part of their literary output is available to the English reading public, with more translations on the way.

Needless to say that none of the people mentioned above is in any way responsible for whatever shortcomings the book may have.

First published in UK 1983 by
JUPITER BOOKS (LONDON) LIMITED
167 Hermitage Road, London N4.
ISBN-0-88254-746-1
Printed in Singapore

CONTENTS

DIE BRÜCKE

DER BLAUE REITER

The colour plates are between pages 96–97

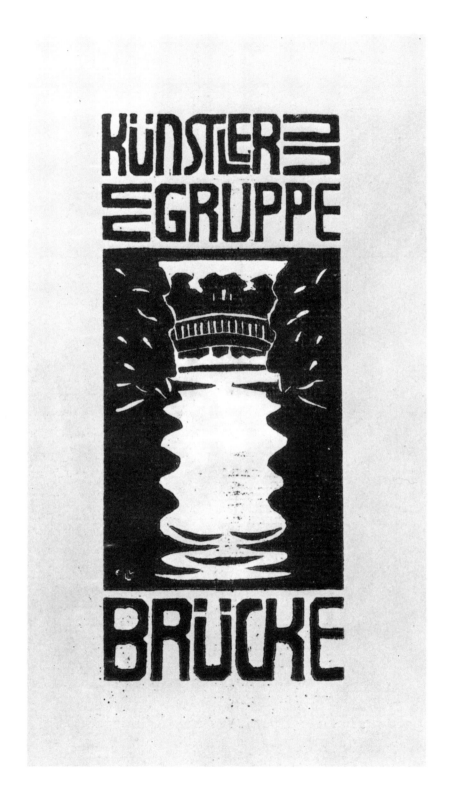

1 Ernst Ludwig KIRCHNER 1880–1938
The Brücke Manifesto, title page. NEW YORK, Museum of Modern Art
(gift of J. B. Neumann). 1906. Woodcut 12.6 × 5 cm. (Dube H694).

DIE BRÜCKE

I INTRODUCTION

What is great in man is that he is a bridge and not a goal.
Friedrich Nietzsche, *Also sprach Zarathustra*, 1883–92

On an unrecorded day in the summer of 1905 four students of architecture in the old and beautiful city of Dresden formed their own artists' group. They decided to call it *Die Brücke* (The Bridge), a name originally suggested by Schmidt-Rottluff, the youngest member, because of their mutual enthusiasm for the writings of Nietzsche, originator of the doctrine of man's perfectibility through forcible self-assertion. Their official title was doubly apposite, for they saw themselves fulfilling a crucial role in providing other young artists in revolt against academic tradition and social convention with a way over to a radical modern style of painting which would express a positive and instinctive response to art and life. In their first communal studio the *Brücke* artists lived out their protest against a passionless, middle-class dominated society. They made all their own furniture; they decorated the walls and ceilings with their own pictures and fabric designs—emulating the *Jugendstil* artist-craftsmen who sought to break down the traditional barriers between the fine and the applied arts in order to establish a socially viable, aesthetically harmonious environment.

As well as advocating the artist's sovereignty over his materials as a means of improving the general quality of life, the *Brücke* artists went one stage further and sought to achieve the anonymity and community spirit of the medieval workshop guilds. At the outset of their careers, they seldom either signed or dated their canvases, sometimes painting them on both sides in defiance of established studio practice. Group solidarity and individual selflessness were strengthened by the faithful translation of an oil painting by one artist into a woodcut executed by one of his colleagues. 'The way this aspect of our daily surroundings developed, from the first decorated ceiling in the first Dresden studio to the total harmony of the rooms in our separate Berlin studios was an uninterrupted logical progression, which went hand in hand with our artistic development', Ernst Ludwig Kirchner wrote in 1923.

Kirchner was the group's unacknowledged leader and its main driving force, the only one of the four founder members to have received anything like a formal art training. The other three *Brücke* artists: Fritz Bleyl, Erich Heckel and Karl Schmidt-Rottluff were all virtually self-taught, looking to one another for support and stimulation in their struggle to achieve a new way of painting, one simultaneously charged with personal meaning whilst still directly concerned with transmitting the rhythm of contemporary life.

When Fritz Schumacher, their long-suffering drawing teacher at the Technische

Hochschule, reproached Heckel for not bringing his work to the required level of finish, the young man stoutly defended his right to improvise, arguing that it was much better for him to sacrifice naturalistic detail than to stifle the honest expression of his feelings. The result of this emotionalism in their early paintings was frequently demonstrated by a wild spontaneity in relation to both their subject and their materials. Strong, brilliant colours were applied straight from the tube in short, undulating brush strokes that activated an exaggerated sense of violent movement across the canvas which, to quote Paul Fechter, one of the group's more generously disposed critics, 'made one feel real terror when looking at the things'.

Over the next five years this intuitive response to painting was gradually subjected to a more thoughtful and better informed approach brought about by the new discoveries which were giving direction to modern art. A richly varied succession of travelling art exhibitions devoted to the leaders of the new European avant-garde found their way to Dresden between 1905 and 1910. In this way the young German artists were introduced to the work of van Gogh, Gauguin, Munch, Vuillard and the *Fauves*, to name but the most significant of their formative contemporary influences. By 1911 when the group moved to Berlin, it had played a vital role in pioneering an aggressively simplified, arbitrarily coloured, two dimensional style manifesting a heightened relationship between the artist and his response to the external world. Lesser artists began to imitate their manner, a sure sign that the success which continued to elude them in Dresden had now arrived. National recognition soon followed. The stylistic uniformity which had made it difficult for some critics to distinguish one artist's work from another in Dresden, and which had driven the strongly individualistic Emil Nolde to resign from the group in desperation after only a few months, had already given way to personal tendencies.

In Berlin each artist cultivated his own unique style, and after an abortive attempt to salvage the group's corporate image by publishing a chronicle tracing its evolution, the *Brücke* was dissolved by mutual consent of the remaining members in 1913.

In the emotional power of its raw expression of feeling *Brücke* art presented the spectator with an elemental vision of reality. Their distorted forms and intensely brutal colours gave cathartic release not just to the individual psyche, but to the basic fears and desires of a nation burdened by a sense of impending disaster during the years leading up to the First World War.

The following short survey traces the history of the *Brücke* artists' group from its foundation in Dresden during the summer months of 1905 to its disbandment in Berlin eight years later.

II 1905

It was just a lucky chance that brought together a group of individuals whose person-
alities and talents led them naturally to the vocation of artists. Their way of life, though
strange to the ordinary man was not meant to shock; it was a pure and simple compul-
sion to integrate art and life.

Ernst Ludwig Kirchner, *Diary*, 1923

Kirchner was eighteen when he knew that he had to be an artist. In 1898 a school trip from
the Realgymnasium in Chemnitz, present day Karl-Marx-Stadt, to the Germanisches
Museum at Nuremberg filled him with a life-long appreciation of the glories of medieval
German art. Inside the old Carthusian monastery, which housed the city's museum and art
gallery, he saw works by Michael Wolgemut (Plate 2), Albrecht Dürer, Hans Holbein and
their contemporaries. In the city's old quarter with its narrow, crooked streets and gabled
house fronts Kirchner found an architecturally integrated townscape far removed from the
modern industrial despoliation of Chemnitz or the 'Saxon Manchester', as it was called by
contemporary English industrialists. Three resplendent Gothic Churches, the Church of
Sankt Lorenz, the Church of Sankt Sebald and the Church of Our Lady, embellished the
scene with their elaborately carved facades, blazing stained-glass windows and bronze and
wood sculptures by Veit Stoss and Pieter Vischer, a glorious testimony to the medieval
artists' workshop tradition. Kirchner's sensitive, impressionable mind was fired with the
desire to create, and the thought of one day becoming an artist himself obsessed him. He
never doubted his abilities and it remained an ambition to which he clung all the more
tenaciously when his father, a chemical engineer, arranged for him to study architecture at
the Technische Hochschule in Dresden, fifty miles away. Since he could not persuade his
parents to let him paint immediately, Kirchner reconciled himself to their overruling
decision, which at least freed him from their narrow, bourgeois background. He arrived in
Dresden in 1901 and, while never shirking his official studies, devoted all his spare time to
sketching and painting.

A year after his arrival Kirchner made friends with Fritz Bleyl, a fellow student who
shared his passionate interest in art and joined him in his private painting sessions. In his
memoirs Bleyl, who was six months younger than Kirchner, remembered how the latter's
lodgings always looked more like a bohemian's studio in their extravagant disorderliness
than the rooms of a diligent student of architecture.

Whilst Bleyl looked to Kirchner for guidance, Kirchner did not fail to recognize his
own need to profit from another's greater experience, as his talent for drawing and painting
owed more to his natural enthusiasm than to his technical gifts. Confronted with the
problem of getting on to canvas the images teeming in his mind, Kirchner decided to
interrupt his architectural studies and to seek professional training in the studio of an
advanced and reputable teacher. Accordingly, in the winter of 1903 he travelled south to
Munich, Germany's acknowledged 'city of art'.

On his arrival in Munich Kirchner registered at the experimental art school run by two
of the city's most prominent *Jugendstil* artists, Wilhelm von Debschitz and Hermann
Obrist, in Hohenzollernstrasse in Schwabing, the city's bohemian district. Kirchner quickly

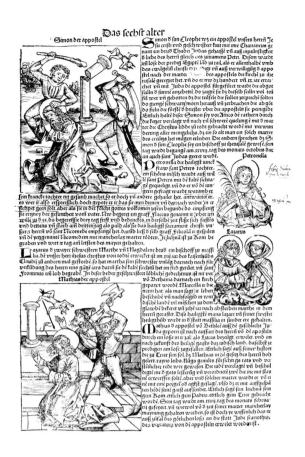

2 Michael WOLGEMUT 1434–1519 and Wilhelm PLEYDENWURFF d. 1494
Illustrations to the **Book of Chronicles** by Hartmann Schedel, Nuremberg, 1493.
BREMEN, Kunsthalle. Woodcut.

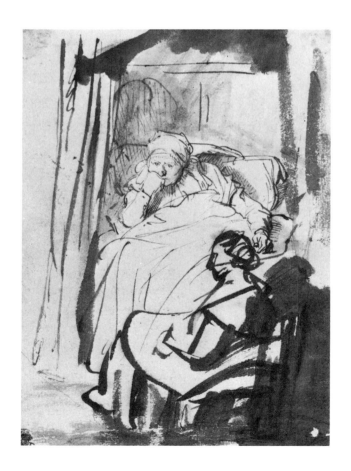

3 REMBRANDT van Rijn 1606–1669
Saskia lying in Bed and a Nurse
MUNICH, Staatliche Graphische Sammlung. 1635–38.
Pen and ink 22.8 × 16.5 cm. (Benesch 405).
Rembrandt's dramatically intense and vital drawing of his wife Saskia remained a vivid inspiration to Kirchner long after he first saw it in the Alte Pinakothek during his years of apprenticeship in Munich in 1903–04. In 1937, a year before his suicide, Kirchner wrote in recollection of that time: 'With what speed Rembrandt had sketched the figure of the woman sitting beside the bed . . . I had to try and draw like that; then maybe I could discover how to give pictorial expression to contemporary life'.

learned how to simplify and stylize form, flatten perspective and bind the compositional design together by means of the sinuously curving *Jugendstil* whip-lash line. Despite the excellent teaching methods employed by both Obrist and Debschitz, their formal approach depended too exclusively on the 'abstract' qualities of *Jugendstil* design and was too far removed from everyday reality to engage Kirchner's whole-hearted sympathy and attention. In order to better realize in his own work that spontaneous vitality which he believed was the most forceful expression of life itself, Kirchner familiarized himself with the drawings by Rembrandt (Plate 3) in the print room of the Alte Pinakothek. These bold sketches were conceived with a breadth of vision and economy of technique that encompassed at once both the individual and the collective consciousness of their time. Kirchner never tired of exploring Rembrandt's bravura use of line, and his visits to the gallery also afforded him the opportunity of studying works by Dürer and Cranach. These old masters were memorable for their unrestrained vitality and passionate commitment to life, qualities too often missing, in Kirchner's opinion, from the displays of contemporary art organized by the Munich Secession. Kirchner especially loathed the Germanized impressionism of Liebermann, Corinth and Slevogt—'anaemic, lifeless studio daubs', he called them many years later.

In April 1904 Kirchner's interest in radical modern art trends was excited by a small but stimulating exhibition of Neo-Impressionist paintings organized by Wassily Kandinsky and his friends of the Phalanx Art Society, one of Munich's most forward-looking groups. Among the artists represented in this show, Vallotton, Signac and Toulouse-Lautrec (Plates 4 and 5) particularly impressed the young Kirchner with the boldness of their ravishing colour technique and, in the case of the latter, the inspired brilliance of his frankly dispassionate view of the *demi-monde*, which made no concession to comfortable middle-class opinion. Full of enthusiasm and bursting to communicate his experiences to Bleyl, Kirchner returned to Dresden for the Easter holiday. During his stay Kirchner was introduced to Erich Heckel, the brother of an old school friend, also recently arrived from Chemnitz to take the architecture course.

Heckel, who was three years younger than Kirchner, also wanted to be an artist. To find himself suddenly thrown into contact with this remarkably extrovert young man whose idealistic, outspoken attitude towards art and life accorded so well with his own instincts seemed an amazing piece of good luck, and Heckel found that he slipped quite naturally into the free-and-easy habits of Kirchner's informal painting sessions and energetically conducted discussions. Heckel's innate ability for painting and drawing had been cultivated twice a week at the art classes of the Chemnitz Kunstverein, which he had attended with his best friend Karl Schmidt. Although wildly undisciplined and gauche in their technique, they were clear in their own minds that it was better to express what they felt honestly and directly rather than to bind their talent to mere correctness of form and finish. They prided themselves on their spontaneity, a quality not always regarded by Fritz Schumacher, their Dresden college drawing teacher, with such tolerance. This total lack of inhibition and a passionate concern for giving free expression to their poetic instincts won Kirchner's whole-hearted approval. Heckel was warmly welcomed into the private painting circle. As he climbed the stairs on his first visit to Kirchner's studio Heckel could be heard declaiming from Nietzsche's *Also sprach Zarathustra*, an extravagant piece of showing-off that did not fail to endear him to his equally voluble, egocentric host.

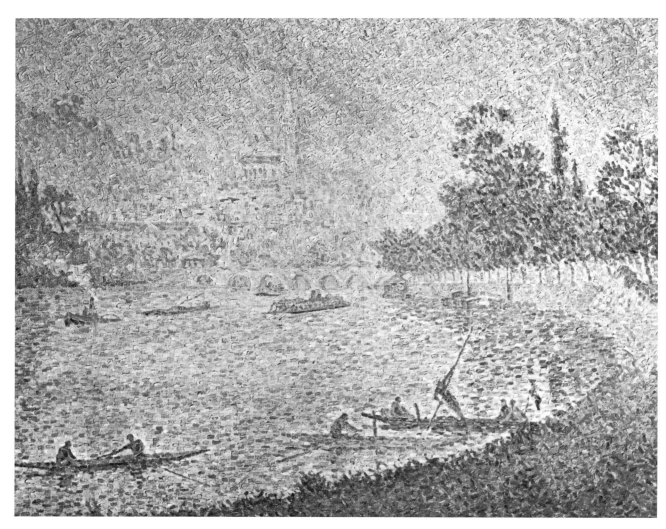

4 Paul SIGNAC 1863–1935
The Seine at Saint-Cloud ESSEN, Museum
Folkwang. 1900. Oil on canvas 65.5 × 82 cm.
Signed and dated: *P. Signac 1900.*

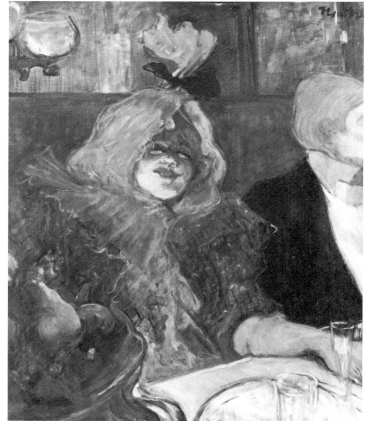

5 Henri de TOULOUSE-LAUTREC 1864–1901
In a Private Room at the Rat Mort LONDON,
The Courtauld Institute. 1899. Oil 55 × 45 cm.
Signed: *H. T-Lautrec.*

A year after Heckel's arrival in Dresden his friend Schmidt also enrolled for the architecture course, and was quickly drawn into the compulsive intimacy of the little band of like-minded friends. No less remarkable than the others in his arrogant, unsentimental disrespect for conventional *mores*, Schmidt's tough, stubborn nature formed a sharp contrast to Heckel's quiet intensity and Kirchner's highly strung energy, adding a sharp, even at times disruptive, element to their feverish activities. His whole-hearted commitment to the common cause was beyond doubt, however, and his early disaffection with his official course of study served as an extra incentive to the desire they all felt to bind themselves to a world of their own making in the service of art. And so, soon after Kirchner and Bleyl's graduation on 1st July, all four friends simultaneously abandoned their architectural careers in order to dedicate themselves wholeheartedly to art. They envisaged a brave, new future for modern art in Germany, a future made possible by their single-minded determination to overthrow sterile, outmoded foreign traditions, and to replace them by a vivid, indigenous pictorial language evoking the essence of German life as the world moved forward into the twentieth century. Their efforts would prepare the way for other progressive artists eager to rescue German art from the thrall of its dishonoured past, and to restore it to something like its former nationalistic glory. Karl Schmidt's suggestion that they call the group *Die Brücke* was unanimously agreed upon.

Before they could seriously engage in frutiful action, however, they had first to find a place where they could all work together, for it was their intention to attempt to follow the example of a medieval workshop, living and working as an anonymous artists' community. The problem was solved by Heckel, whose resourcefulness in matters of a practical nature was an invaluable asset to the group's needs throughout its existence. Renting a disused butcher's shop in the Berlinerstrasse close to the city's marshalling yards in the working-class district of Friedrichstadt, he and his friends converted it into the group's first communal studio. Far removed from the city's fashionable quarter, the area's proletarian atmosphere was ideally suited to their self-conscious throwing-off of middle-class comforts and restraints.

They began by decorating the old shop throughout with their own flamboyant designs, and hand-carved furniture and utensils, scorning any kind of manufactured article which, in their eyes, lacked true craftsmanship and the honest use of natural materials. Their enthusiasm for new expression in all the various artistic media led to wildly animated bouts of work interspersed with no less lively and heated discussions about painting, poetry and philosophy, all of which worked them up to a tremendous pitch of nervous stimulation. Heckel and Schmidt (who had recently embellished his plebeian surname with the name of his birthplace Rottluff) would often read poetry to the assembled group. Byron, Baudelaire, Whitman, Heine and Holz were among their particular favourites.

Periodicals such as the English magazine *Studio* and the homegrown *Jugend* and *Pan* gave them access to current developments in the European arts and crafts movement, known in Germany as *Jugendstil*. The sinuous, assymetrical linearity of Toulouse-Lautrec's lithographs (Plate 6) and the richly pungent black and white contrasts demonstrated by Vallotton's contemporary revival of the medieval woodcut medium (Plate 7) had a considerable influence on the early graphic technique of *Die Brücke*. The young Germans delighted in the gregarious, *fin-de-siècle* raffishness of the work of these Parisian artists. In particular the

6 Henri de TOULOUSE-LAUTREC

May Milton

PARIS, Bibliothèque Nationale. 1895. Colour lithograph
79 × 60 cm. (Delteil 356).

From 1900 examples of Toulouse-Lautrec's graphic work
could be seen in Dresden's Kupferstichkabinett. The
director, Max Lehrs, made it a policy to exhibit and buy
modern foreign graphics for this important public collection.

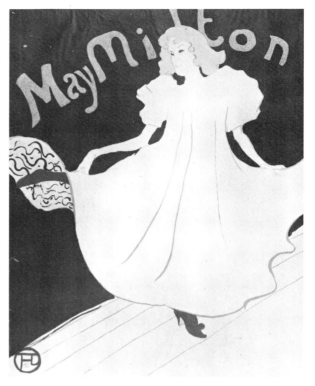

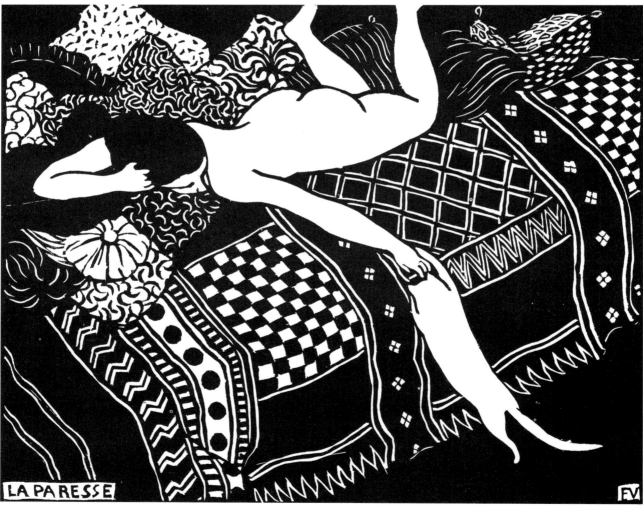

7 Félix VALLOTTON 1865–1925

Laziness BREMEN, Kunsthalle. 1896. Woodcut 17.7 × 22.2 cm (Georg-Vallotton 169).

woodcut's concentrated and elemental power was ideally suited to the fiercely intransigent *Brücke* temperament, providing the group with its first successful and, in many ways, most perfect vehicle of emotive pictorial expression (Plates 8, 9 and 10). As early as the summer of 1905, examples of their graphic art appeared in the Saxon Art Association print exhibitions.

Their early experiments in oil remained basically in the Neo-Impressionist style which Kirchner had brought back with him from Munich, with its broken brushwork and brilliant, but in their case frequently harsh, colour contrasts (Plate 12). Signatures and dates were, more often than not, deliberately excluded from their works at this time according to the practice of the anonymous medieval artists' guilds which they sought to emulate.

However, in November 1905 the Kunstsalon Ernst Arnold in Dresden's Old Market held an exhibition of fifty paintings by van Gogh. The *Brücke* artists found themselves suddenly confronted by the work of an artist who used his picture surface not simply to imitate external reality or to satisfy conventional taste, but to re-create the world according to the dictates of his own intelligence and inner compulsion. Van Gogh's whirling, animated brush strokes and bold emancipated colours, suggestive of strong human emotions, were aggressively applied, twisting forms out of their natural shapes, redefining their proportions and creating rhythms that addressed themselves directly to the spirit as well as to the eye (Plate 13). Over the next two years van Gogh's exalted and strident pictorial model was absorbed and adapted into the young German artists' early communal style, sometimes to such a heightened degree that, according to one of their critics the agitated rhythms, broad brushstrokes and exaggerated colours of their canvases made the fluent, directional brushwork and bright emphatic colours of the Dutchman seem as inoffensive as the work of any harmless Academy professor.

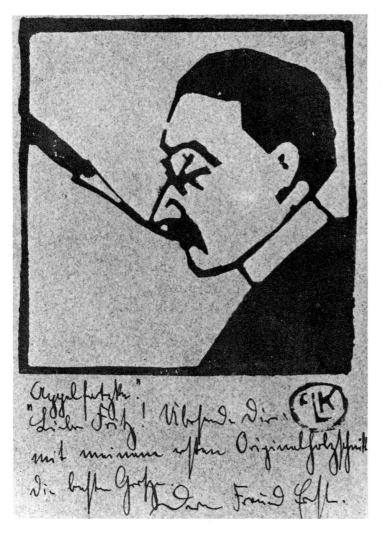

8 Ernst Ludwig KIRCHNER
Appelfatzke
HAMBURG, Altonaer Museum. 1904. Woodcut 9.5 × 8.5 cm
(Dube H 1).

This caricature portrait of a local Munich worthy was the
first in a series of seven satirical heads, produced during
Kirchner's stay in the Bavarian capital, which he derogatorily
entitled *The Idiots*. It is also the artist's earliest known
woodcut and was sent as a postcard greeting to Fritz Bleyl in
Dresden on 18 March 1904, thus inaugurating the *Brücke*
artists' habit of communicating with one another and their
close friends in the form of personally illustrated postcards.
The message reads: 'Dear Fritz, sending you my best wishes
with my first original woodcut. Your friend, Ernst'. The
composition's decorative, two-dimensional linear style with
its strongly contrasted areas of dark and light was typical of
the prevailing *Jugendstil* tradition. However, Kirchner's tense
dynamic line and extreme simplicity of presentation already
anticipated his later expressive urgency.

(Opposite Bottom)

10 Karl SCHMIDT-ROTTLUFF 1884–1976
Boy Sleeping BERLIN, Brücke-Museum. 1905. Woodcut 15 × 20.2 cm. Initialled: *KS* (not in Schapire).
The subject of children was a popular theme in German art at the turn of the century. Schmidt-Rottluff's
early woodcut with its bold contrasting areas of black and white, and gently curving rhythms shows the
young artist's indebtedness to *Jugendstil*.

9 Fritz BLEYL 1880–1966

House with Steps 1905.

Woodcut 22.5 × 17 cm (Bolliger-Kornfeld 3).

Like Kirchner, Bleyl's early output consisted largely of woodcuts, a medium renowned for its expressive potential and which, in their hands, became a major independent means of self-expression. Bleyl eventually found it impossible to keep pace with the searching, restless spirit of the others, but his work at the beginning shared their indebtedness to the general *fin-de-siècle* mood of *Jugendstil*. If anything this woodcut is more conventionally decorative in its varied pattern of black and white shapes than anything currently being produced by his colleagues. Bleyl exhibited examples of his graphic work at the Saxon Art Association in July 1905, and *House with Steps* was one of the three woodcuts distributed in the first *Brücke* portfolio in 1906. He withdrew amicably from the group in 1908 in order to devote himself to a career as an architect.

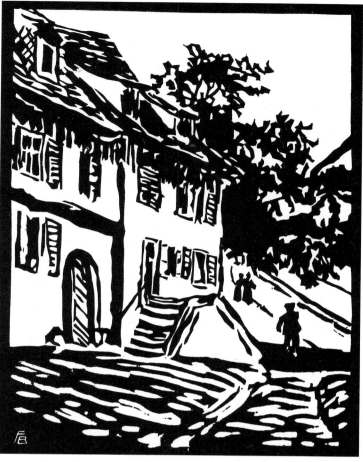

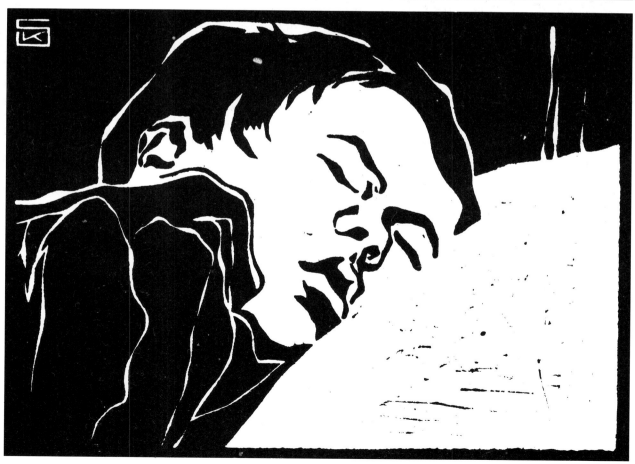

11 Max PECHSTEIN 1881–1955
Still Life with Winter Cherries HANNOVER, Niedersächsische Landesgalerie. 1906. Oil 65.5 × 70 cm.
Initialled and dated: *HMP 06*.

Pechstein was the only member of the *Brücke* to have received a formal period of art training. After leaving
school at fifteen he was apprenticed to a decorative painter in his native Zwickau, where his father worked
in the local textile industry. Four years later, in 1900, he began studying art at Dresden's Kunstgewer-
beschule and won five of the six annual prizes in 1902. Following this success he transferred to Otto
Gussmann's studio at Dresden's Akademie der bildenden Künste where he was a student at the time of his
meeting with Heckel. During this extensive period of training Pechstein acquired great technical facility,
sufficient to win him the Rome prize for painting, but very little original creative flair of his own. His
affinity to van Gogh was probably the closest of all the *Brücke* artists at this time, in both style and
content, as this still life shows.

12 Erich HECKEL 1883–1970

Sunset PRIVATE COLLECTION. 1906. Oil on cardboard 50 × 70 cm. Signed and dated: *E Heckel 06* (Vogt 1906/6).

This landscape is characteristic of the early *Brücke* style. Like Kirchner who was also producing open-air paintings in a neo-impressionist style at the time, Heckel was more interested in the use of colour for its emotional effectiveness than in the cause of scientific accuracy. The brick-like slabs of colour—clashing pinks, blues, reds, greens, yellows and purples—create a strident, disquieting effect. The picture was probably painted during the summer months of 1906.

13 Vincent van GOGH 1853–1890
Portrait of Dr. Gachet PARIS, Louvre. 1890. Oil on canvas 68 × 57 cm. Not signed.

III 1906

> I was not alone. There were other young painters also full of ambitions whose efforts resembled mine.
>
> Emil Nolde, *Jahre der Kämpfe*, 1934

Although Emil Nolde's career as an artist did not begin until 1898, when he was thirty-one, by 1906 his work in oils was much more advanced than the *Brücke*. He had seen his first van Gogh painting in 1898, probably *Portrait of the Artist with a Pipe* of 1889 (Chicago, collection of Leigh B. Block), and had summarily dismissed it at the time as 'somewhat mad'. In 1899 he studied at the Académie Julian in Paris, and in 1905 exhibited at the Berlin Secession. That same year he visited the Folkwang Museum at Hagen which had recently purchased two van Goghs, *Portrait of Armand Roulin* of 1888 and *Harvest* of 1889 (both now in the Folkwang Museum, Essen). In the light of his greater experience Nolde was now able to recognize van Gogh's achievement and to respond to his influence.

It opened his eyes to colour as an unrestrained force of spiritual and emotional expression, and to an awareness and taste for dynamic movement through vigorous diagonal rhythms. As a result his personal style became stronger and bolder, and colour assumed its maximum expressive intensity in his work. From the beginning Nolde had always shown an eagerness to learn, his most important teacher being Adolf Hölzel at Dachau with whom he had studied landscape painting as a vehicle for the expression of form and colour in 1899. Yet Nolde's harsh northern sensibility and natural insularity consistently protected him from becoming a slavish imitator of his chosen masters. In January 1906 a small exhibition of Nolde's landscape and garden pictures was shown at the Kunstsalon Ernst Arnold in Dresden and so impressed the *Brücke* artists by their bold colour harmonies that, although he was completely unknown to them, they decided to write to Nolde inviting him to join their group (Plate 14). Schmidt-Rottluff, with typical lack of equivocation, wrote:

> To come straight to the point, this artists' group known as the Brücke would consider it a great privilege to welcome you as a member. Naturally you probably know as little about the Brücke as we did about you prior to your exhibition at Arnold's. Now one of our aims is to unite all the revolutionary and radical elements—that is what the Brücke stands for. The group also arranges several exhibitions that tour Germany every year. Another aim—only a dream right now as there is no money—is to get our own exhibition space. Now, dear Herr Nolde, you can think what you like, we only wanted to let you know how much we admire your violent colour storms.

This letter, written on 4 February 1906, came as a complete surprise to Nolde. Normally of a solitary and unsociable nature, on this occasion Nolde threw aside all his inbred reserve and suspiciousness of people and accepted the invitation to join the Dresden group.

The contrast between his retiring way of life on the remote North Sea island of Alsen, where he lived with his wife in a fisherman's cottage, and the high-spirited gusto of the Dresden studio must have given Nolde immediate cause for doubt. Accustomed to working alone without reference to any laws other than those determined by his own almost mystical

(Opposite)

14 Emil NOLDE 1867–1956

Spring Indoors SEEBÜLL, Nolde-Stiftung. 1904. Oil 88 × 73 cm. Signed and dated: *Emil Nolde 1904.*
Nolde's iridescent portrait of his wife Ada is a brilliant demonstration of how this powerfully individualistic artist reworked Impressionism in terms of the emotional value given to colour by the discoveries of van Gogh and Gauguin, both of whom he admired greatly. The landscapes and garden scenes which he painted at this time on the island of Alsen are firmly rooted in things seen, but his expressive use of colour overwhelms the other pictorial elements, transforming nature into a thrilling, intoxicated vision of reality. 'From the very beginning I was interested in the characteristics of colour, its gentleness and its strength—especially in cool and warm colours', Nolde wrote in his autobiography. 'I love their purity, and avoided any mixture of cool and warm colours, because the mixture always turns cloudy and kills the light'. In 1905 *Spring Indoors* was purchased by Karl Ernst Osthaus for the Folkwang Museum at Hagen, one of the earliest and finest collections of contemporary painting to be established in Germany when it opened in 1902.

rapport with nature, he abhorred the *Brücke* artists' habit of subjecting each other's work to endless group diagnosis as much as he shrank from their overheated intellectual arguments. A serious and mutually beneficial exchange of ideas, particularly concerning their individual interpretation of the various graphic media did however take place at the beginning of their association. Although Nolde had been trained as a woodcarver and cabinet-maker in Flensberg as a youth, he had never tried his hand at the woodcut process until joining the *Brücke*. His rugged, highly instinctive approach to any technical procedure was stimulated by the dramatic struggle between the naturally resistant material and his creative concepts. The woodcut quickly assumed an importance in Nolde's work equal to the place it already held for the *Brücke* (Plates 1 and 15). In it he combined the demanding manual handling of the block with an emotional excitement that, in its febrile strength, embodied a subjective fusion of the real world with that of the imagination (Plate 16). Nolde in his turn taught Kirchner and the others how to etch. Shrouded in velvet black mystery, Nolde's dramatically atmospheric use of the etching process enriched the *Brücke* artists' range of pictorial expression in the graphic media (Plate 17).

Nolde's pietistic regional upbringing on the lonely northern plains of Schleswig, where generations of his family had eked a living from the soil, gave him little in common with the intellectual aspirations of Kirchner, but he found Schmidt-Rottluff's more withdrawn, down-to-earth manner appealing. Far from wanting to make a proselyte out of the younger artist, Nolde was eager to help him find his own artistic personality, for he observed with some misgivings how heavily the group relied on van Gogh's example in their painting style. On his return to Alsen later that year Nolde invited Schmidt-Rottluff to visit him for a working holiday. Despite an age difference of seventeen years the two men forged a close bond of comradely respect for one another and their work (Plates 18 and I). This seems to have been Schmidt-Rottluff's first real contact with a totally wild, unspoilt landscape, an experience which awakened in him a deeply rooted longing for nature. He and Nolde both sought in nature those elemental effects that spoke directly to their own excitable temperaments and in these harsh and lonely settings they steeped themselves in an atmosphere free from the multifarious distractions that were always prone to disrupt work

15 Ernst Ludwig KIRCHNER
The Brücke Manifesto
NEW YORK, Museum of Modern Art (gift of J. B. Neumann).
1906. Woodcut 15.2 × 7.5 cm. (Dube H696).

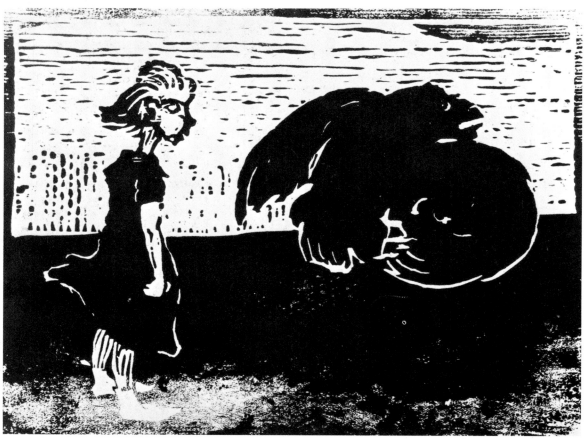

16 Emil NOLDE

The Large Bird SEEBÜLL, Nolde-Stiftung. 1906. Woodcut 16.5 × 22.7 cm. Signed: *Emil Nolde.*
(Schiefler-Mosel H9/III).

Nolde's apprenticeship as a woodcarver in Sauermann's factory at Flensburg (1884–88) served him well
when he came to make his own woodcuts after joining the *Brücke.* Unlike the subjects of his paintings
at this time which are based on observed reality, Nolde's woodcuts frequently give vent to more
imaginative and even, as here, satirical themes, whose exaggerated feeling for the grotesque is reminiscent
of his earlier series of picture postcards in which he represented the Swiss Alps as vulgar old men.

17 Emil NOLDE

Self-portrait LEICESTER, Leicestershire Museums and Art Galleries. 1905. Etching 17.8 × 12.9 cm.
Signed and dated: *Emil Nolde 05*. (Schiefler-Mosel R6/IV).

During his brief membership of the *Brücke*, Nolde taught Kirchner and the others his own special etching technique. He had mastered the art of turning an occasional accidental effect to expressive advantage in the finished work, as well as exploiting the medium's natural properties to promote mysteriously subtle, emotional and psychological feelings through a dramatic chiaroscuro. 'No one before had made the same full use of the properties of acid and metal in this way', he wrote. 'After having drawn on the copper plate, leaving parts of it empty, I placed it in the acid bath, achieving effects full of subtle nuances that surprised even me'.

in the studio. Alsen released Schmidt-Rottluff from his dependency on Dresden. Without deserting the studio altogether he formed the habit of escaping from the city to spend the greater part of each year working in the country by himself.

In February 1906 the Swiss artist Cuno Amiet (1868–1961) was invited to join the *Brücke* on the strength of a magazine article illustrating nine of his paintings which appeared in that month's edition of *Kunst und Künstler*. Like Nolde, Amiet had studied at the Académie Julian in Paris after which, in 1892, he had been drawn into contact with the Pont-Aven artists associated with Gauguin. Later in the same year, on his return to Switzerland, he had met Hodler whose highly mystical style, Symbolist in content, and demonstrating the influence of *Jugendstil* in its treatment of form, had also recommended him to Nolde. Amiet's active involvement with the European vanguard was already an established factor in his life long before he joined the *Brücke*, and although over the next six years he contributed regularly to the group's organized programme of exhibitions, he continued to live in Switzerland, and did not actually meet his Dresden colleagues until 1912, when they were all in Cologne for the great *Sonderbund* exhibition.

Akseli Gallén-Kallela (1865–1931) Finland's leading *Jugendstil* artist, also brought the prestige of an internationally recognized name to the provincially-rooted *Brücke*, and this factor alone no doubt helped to lessen the group's awareness of its own artistic isolation. But Gallén-Kallela's contribution to their activities also remained marginal and no stylistic influences resulting from his recruitment are discernible in the Dresden artists' work.

Just as van Gogh before him had monitored the 'terrible passions of humanity', so Edvard Munch expressed the intellectual restlessness and spiritual crisis of the northern European psyche in his own time: 'in these pictures the painter gives his most prized possession—he gives his soul—his unhappiness and joy—he gives his life's blood', he wrote in his diary in 1890. With penetrating insight and a melancholy understanding of the modern psychological dilemma afforded him by a lifetime's experience of personal suffering, Munch explored a brooding anti-bourgeois world of stark existential complexity. In the great series of paintings for his *Frieze of Life* cycle he symbolized the contemporary obsession with sex and death and man's inconsequence in the face of the terrible forces of nature in images of a searing, tortured intensity. At the end of February 1906, the *Brücke* painters were given their first opportunity of seeing the Norwegian artist's work when an exhibition of Munch's paintings and drawings went on show at the Saxon Art Association. His concern with men and women locked in a lonely, threatening confrontation with self, and set against the mysteriously remote landscape of his native Norway revealed a mind much given to self-doubt, but also highly sensitive to the shifting emotional and psychological patterns of modern life. Munch's frank depiction of man as a primitive sexual animal, burdened with the knowledge of its own mortality, and the gift of rational thought, had a tragically poignant appeal for the *Brücke* artists who had already made their own united stand in protest against the hypocrisy and convention surrounding the individual expression of libido (Plate 19).

Munch's thematic preoccupation with man's inner battle with himself combined with his symbolic use of colours applied in flat surface patterns had a vital, formative influence on the young German group's efforts to come to pictorial terms with their own milieu. His concise graphic style—a synthesis of *Jugendstil* form and symbolist content—also impressed

18 Emil NOLDE

Portrait of Karl Schmidt-Rottluff SEEBÜLL, Nolde-Stiftung. 1906. Oil 52 × 37 cm. Signed and dated: *Nolde 1906.*

Painted during the summer months of 1906 when Schmidt-Rottluff was staying with Nolde at his home on the island of Alsen this portrait is a strong example of Nolde's feeling for vigorous movement and bold, bright colours. Even so, when compared to the contemporary self-portrait by Schmidt-Rottluff (Plate I), Nolde's loose, fluid brushstrokes look positively restrained and restful.

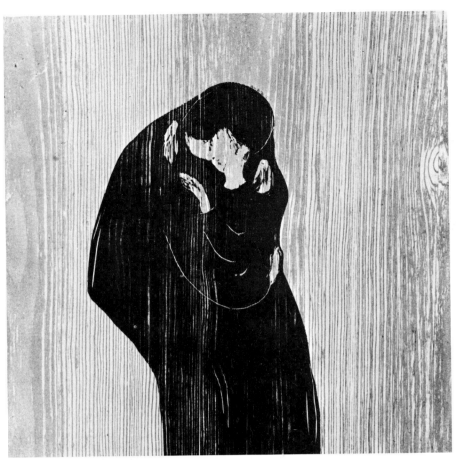

19 Edvard MUNCH 1863–1944
The Kiss
OSLO, Munch-Museet. 1902. Woodcut. 44.7 × 44.7
(Schiefler 102).

them by its ability to invest the real world with the darkness of nightmare, exposing corners
of the mind previously hidden from view (Plate 20). The result of their admiration for
Munch's work soon manifested itself in the *Brücke* artists own paintings and prints, most
notably in the sociological *angst* of Kirchner's early *Street* of 1908 (Plate IV) and the bold
sexual precocity of his *Marcella* of 1909–10 (Plate 43) which is reinforced in Schmidt-
Rottluff's harshly expressive woodcut *Two Lovers* of 1909 (Plate 39).

In November 1908 when a selection of *Brücke* graphics was shown for the first time at
the Berlin Secession, a critic in the December edition of *Kunst und Künstler* remarked on the
thematic similarities between the Germans' work and that of the Norwegian (Plates 21 and
22). But Munch refused to accept any responsibility for the *Brücke* artists' brutalized forms
and exaggerated view of life. On being shown some recent examples of Schmidt-Rottluff's
graphic work by the Hamburg collector Gustav Schiefler in 1907, Munch was quite
appalled. 'May God protect us, evil times are coming', he declared. His polite but firm
rejection of an invitation to take part in an early *Brücke* exhibition was interpreted as a
personal insult by the proudly self-conscious German group. Thereafter, his part in
moulding the early *Brücke* style was rigorously denied by them all.

To help keep himself Heckel worked in the office of the prominent Dresden architect
Wilhelm Kreis. Throughout the spring of 1906 he was involved in Kreis's scheme for the
forthcoming International Arts and Crafts Exhibition, and it was then he met Max

20 Edvard MUNCH 1863–1944
Evening, The Yellow Boat OSLO, Nasjonalgalleriet. 1891–93. Oil on canvas 65 × 96 cm.

Pechstein, a young student at the Dresden Academy who had been commissioned to
decorate the ceiling of the Saxon Pavilion. To Pechstein's indignation his bright red tulip
design had, without his permission, been drastically toned down on his employer's instruc-
tions. Such high-handed interference made Pechstein so angry that he seized on Heckel, who
happened to be standing nearby, to witness the injustice done to his work. Sympathetic to
Pechstein's feelings of frustration and despair, and impressed by his undoubted technical
gifts, Heckel recommended him for group membership. Pechstein already considered
himself a revolutionary, and displayed a willing eagerness to fight with his new friends in
order to win the right to paint as he pleased. He also shared the group's passionate
admiration for van Gogh, and the influence can be clearly seen in the free and excited way
Pechstein used line and colour to express feelings and emotions, and not just as an excuse for
sensational optical effects (Plate 11). Not long after joining the *Brücke* he and Kirchner
bribed an employee of the Kunstsalon Ernst Arnold to smuggle them into the gallery's
storeroom so that they could study some paintings by van Gogh being housed there.

As the months passed, Nolde grew steadily more impatient with his younger
colleagues' excessive dependence on van Gogh's characteristically emotive style. He had only
agreed to join their group in the first place because it had been presented to him as a radical,

21 Ernst Ludwig KIRCHNER
Head of Doris
HAMBURG, Kunsthalle. 1907. Colour lithograph 26 × 21 cm.
Initialled: *ELK*. (Schiefler 1; Dube L3).

Following the exhibition of twenty works by Edvard Munch
at the Saxon Art Association in February 1906, the *Brücke*
artists' style began to show a marked similarity to the
Norwegian painter's manner. As in Munch's female portraits,
the downturned face of Doris in Kirchner's composition is
dominated by the withdrawn, psychological intensity of its
expression. The print's expressive mood is heightened by the
heavy mass of hair falling over the girl's forehead, and the
floral patterned frock with its lace collar and chunky beads,
elements which were quite possibly derived from the decora-
tive *Jugendstil* portraits of Gustav Klimt, the Viennese
Secessionist, examples of whose work were shown in Dresden
in October 1907. Kirchner's compositional design is more
consciously assymetrical than either of his sources however,
and with the characteristic *Brücke* colour combinations of
red and green, works to produce a highly subjective study.

(Opposite Top)

22 Karl SCHMIDT-ROTTLUFF
Harbour at Low Tide LEICESTER, Leicestershire Museums and Art Galleries. 1907. Lithograph
27.5 × 34.8 cm. Signed, dated and titled: *Schmidt-Rottluff 1907: Hafen bei Ebbe*. (Schapire S 16).

In 1906 Schmidt-Rottluff became the first *Brücke* artist to make lithographs. Always a fastidious
technician, he signed only those prints which entirely satisfied his expressive demands on the medium.
Until 1913 it was his practice to inscribe both the date and the title of the print. After 1913, he
abbreviated this to a number comprising the last two numerals of the year and the print number, so that
245 means the fifth print produced in 1924. This early lithograph probably resulted from his visit to
Oldenburg in the summer of 1907. It subsequently belonged to Rosa Schapire who bequeathed it to the
museum at Leicester in 1955.

(Opposite Bottom)

23 Emil NOLDE
Like birds LEICESTER, Leicestershire Museums and Art Galleries. 1907. Lithograph 34.5 × 35.5 cm.
Unsigned. (Schiefler-Mosel L 14).

Nolde's greatest single debt to the much younger *Brücke* artists was probably in terms of his deeper
involvement with the woodcut and the lithograph techniques, which resulted largely from the stimulating
exchanges which took place in the Dresden studio. Like Kirchner and the others at this time, Nolde's
graphic style was strongly influenced by the acute observation and imaginative flair of the Paris
fin-de-siècle artists. Whilst Vallotton's bold and witty revival of the woodcut medium served as a primary
inspiration, Toulouse-Lautrec's sensuous and schematic lithograph drawings provided the German artists
with an equally evocative method of expressing the mood of a scene rather than a factual description of
the event. Toulouse-Lautrec's example (Plate 6) can be felt in the fluently dramatic linear abbreviations of
Nolde's study of his wife Ada and her sister Louise Vilstrup, although the strong sense of agitation is
essentially his own.

24 Emil NOLDE

Trollhois Garden SEEBÜLL, Nolde-Stiftung. 1907. Oil 73.5 × 100 cm. Signed and dated: *Nolde 07*.
After leaving the *Brücke* Nolde returned to Alsen where he resumed work on his beloved landscape and
garden pictures. Unmixed colours are spread directly on to the canvas in a woven, tapestry-like effect.
A much stronger emotional intensity is evident in the artist's deep-rooted empathy with nature and the
composition is more crude than in *Spring Indoors* (1904), painted before he joined the *Brücke*. Like the
contemporary landscape paintings of Schmidt-Rottluff this enhanced expressiveness served a similar
purifying function, affording Nolde a measure of cathartic release from inner pressures.

25 Erich HECKEL

The Windmill at Goppeln PRIVATE COLLECTION. *c.*1907. Oil 64 × 70 cm. Initialled and dated: *EH 07*. (Vogt 1907/6).

The Windmill at Goppeln was one of three paintings by Heckel included in the *Brücke* exhibition of June 1909, the month he returned from Rome. It is possible that this painting was not executed until 1908, as inferred by the critic Paul Fechter in his contemporary review of the show, and that Heckel pre-dated the canvas at some later stage. The expressive intensity of the impasto brushwork, however, is consistent with the rather wild, and overly subjective style which characterized much of the group's work during 1906 and 1907 when their communal working life was at its height.

progressive organization bent on uniting the new German avant-garde, instead of which they seemed content merely to go on exploiting van Gogh's bold impasto and the freedom with which he adapted the motif to suit his mood (Plates I and 25). Even their disturbing combinations of red and green had parallels with van Gogh's late style, whilst the varied and agitated rhythms of their brushwork showed an undeniable reliance on his example. Nolde's formative period of indebtedness to van Gogh was already a thing of the past and he resented being held back by their current obsession which made him deeply suspicious and critical of their apparent inability to move beyond the orbit of the Dutch artist's powerful influence.

In the meantime, Kirchner had written and printed the groups' official manifesto (Plates 1 and 15). With its appeal to a new generation of revolutionary artists the manifesto echoed Schmidt-Rottluff's letter of invitation to Nolde. On a purely practical level it also appealed to anyone interested in the growth of modern art to join with them and help in the struggle to overthrow timeworn traditionalism:

> With a belief in progress and in a new generation of creators and supporters we summon all youth together. As youth we carry the future and want to create for ourselves freedom of life and movement in opposition to the well-established older forces. Everybody belongs to our cause who reproduces directly and passionately whatever urges him to create.

To encourage interest they extended membership of the group to affiliated non-professionals who, for a yearly subscription of twelve (later twenty-five) marks, would each receive an annual portfolio containing original *Brücke* graphics. In 1906 approximately twenty such portfolios were issued containing three woodcuts, one each from Kirchner, Bleyl (Plate 9) and Heckel. Two of the group's first and most dedicated supporters came from Hamburg, the lawyer Gustav Schiefler and the art historian Dr. Rosa Schapire (Plate II), both of whom later became distinguished authorities on and collectors of *Brücke* art.

The next important step in their campaign to take the art world by storm was to organize their first group exhibition. Since none of the established private commercial galleries in Dresden were interested in handling the work of a group of unproven, self-taught extremists, it was left to Heckel (Plate 51), with his customary enterprise, to come up with a solution. His work with Kreis had recently involved him in the design and construction of a modern showroom for the Seifert Lamp Factory in the suburb of Lobtau. Convinced by Heckel's personable sincerity and sympathetic to his eloquent appeal, Seifert finally agreed to give his permission for the *Brücke* to use the new showroom as the group's first exhibition venue. The result was a fiasco. Critics and public alike shunned this display of paintings and drawings by an unknown group of young artists, incongruously staged in an out-of-the-way factory.

Disappointed but far from defeated the *Brücke* artists followed the September exhibition three months later with a show exclusively devoted to their graphic work, to which they also invited Kandinsky to take part. This exhibition, which lasted over the Christmas holidays into January, came and went without attracting any more attention than its predecessor. In these frustrating circumstances it became evident that in order to attract critical attention to their work it was necessary to find a centrally situated location for their next exhibition. It was about this time that Kirchner and his colleagues gave vent to their

26 Edouard VUILLARD 1868–1940
Dinner Time NEW YORK, Museum of Modern Art (gift of Mr. and Mrs. Sam Salz and an anonymous donor). 1889. Oil on canvas 72 × 92.5 cm.
Paintings by Vuillard and other members of the *Nabis* group were included in a large exhibition of Post-Impressionist works held at the Ernst Arnold Salon in Dresden in November 1906.

disgust with public philistinism and complacency in a jointly written and illustrated book acidly entitled *Odi profanum*. This unique early example of expressionist book design was subsequently destroyed in an air-raid which wrecked Heckel's Berlin studio in 1944.

In the midst of their disappointments, an exhibition of Post-Impressionist paintings opened at the Kunstsalon Ernst Arnold in November 1906. Van Gogh was again well represented but there were also important works by Gauguin, Bonnard, Vallotton and Vuillard (Plate 26). Such contacts with the latest developments and trends in the Paris avant-garde movement gave the *Brücke* artists ample opportunity to study and experiment with a variety of mainstream tendencies in French painting. They also offered a provocative challenge to the group's strong sense of national pride, a challenge that it was vehemently determined to accept, meet and return in kind.

IV 1907

Compared to the Brücke artists van Gogh is an innocent Academy professor.
Paul Fechter, *Dresdener neueste Nachrichten*, 10 September 1907

Eager to experience the therapeutic benefits of the open-air life once again, Schmidt-Rottluff left Dresden in the summer of 1907 accompanied this time by Heckel, and travelled to the small town of Dangast in the moorland area of Oldenburg flanking the North Sea. The natural power and intensity of Oldenburg's sea-threatened plains and marshlands thrilled and intoxicated the two friends. After the hermetically sealed world of the studio, they exulted in its infinite space, lowering skies and strong, revitalizing winds. Heckel loved nature deeply but with Schmidt-Rottluff it became an all-consuming passion. His visits to Oldenburg became a yearly event whereby he spent the summer months away from the city, working amongst its sand dunes and fens. This arrangement also tacitly asserted his personal right to the unconditional freedom of movement and independence which each of the *Brücke* artists now demanded, whilst remaining loyal to the group's communal public identity (Plate III).

During the months that had elapsed since the failure of the first two *Brücke* exhibitions, the artists had successfully negotiated for the privately owned Kunstsalon Emil Richter to stage their next exhibition. The contrast between the improvised arrangements necessitated by the suburban Seifert Lamp Factory showroom and the handsomely equipped Kunstsalon Richter, situated on the city's smart Pragerstrasse, could not have been greater. Its central position meant that this time both critics and public would be forced to notice their work, and for the opening on 1st September the group assembled nearly one hundred works, more than half of which were graphics. In the only newspaper review given to the show the critic Paul Fechter, after voicing his dismay and terror at the sight of so wild a display of undisciplined freedom, and at the annihilating brilliancy of the colours, went on to decry the manner in which the *Brücke* artists had reduced van Gogh's original innovations to a demented and unconvincing formula. Fechter exempted Kirchner from his generally unfavourable report and lavishly declared him to be the group's only outstanding talent. Nolde was intensely hurt and angry at being passed over in favour of the younger man; an understandable reaction perhaps, but one has only to compare contemporary examples of each artist's work to see that Kirchner was now without question the bolder and more inventive of the two, not only taking greater risks, but successfully realizing a stronger synthesis of carefully observed fact with an imaginative freedom of self-expression. Soon after the Richter exhibition Nolde resigned from *Die Brücke*. In parting from the group that, only nineteen months before he had hailed as a beacon to light the whole German avant-garde art revolution, Nolde could not refrain from bitterly remarking that they should 'not be calling themselves the Bridge but the van Goghians'.

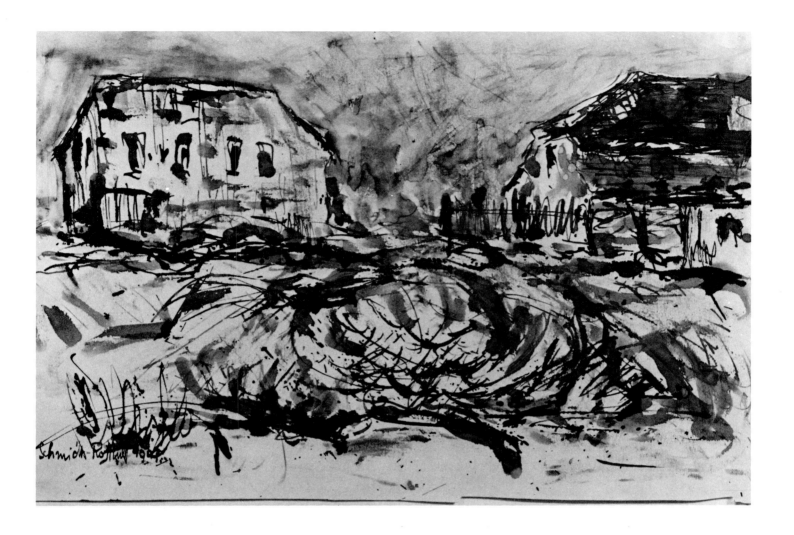

27 Karl SCHMIDT-ROTTLUFF
Houses SEEBÜLL, Nolde-Stiftung. 1907. Pen and ink wash 23.1 × 34.2 cm. Signed and dated: *Schmidt-
Rottluff 1907.*
Like Schmidt-Rottluff's oil technique at this time (see Plate III, *Windy Day*), his aggressively spontaneous
style of drawing suggests a creative temperament bursting to transcend reality in order to liberate its own
original sensibility. The whirling strokes of the pen, and the convulsive blobs of ink spattered across the
paper destroy all sense of balance and constraint in a violent explosion of radically abbreviated, often
meaningless, forms.

V 1908

Composition is the art of arranging in a decorative manner the various elements at the painter's disposal for the expression of his feelings.

Henri Matisse, *Notes d'un peintre*, 1908

Shaken by the double blow of Nolde's departure and the failure of their third successive exhibition, the *Brücke* artists were prompted to question their own individual needs and aspirations. The succeeding twelve month period saw a gradual breakdown in the closely-knit working relationship which had been such a characteristic feature of their life together in the Berlinerstrasse and a conscious effort to launch out on their own independent course. Pechstein's painterly accomplishments as a student of Otto Gussmann at Dresden's Academy had won him a travel scholarship to Italy during 1907 and, on the completion of this trip, he moved on to Paris where he remained until the summer of 1908. Always ambitious, and straining to break free from the provincial obscurity and cultural isolation of the Dresden group, Pechstein wasted no time in establishing contact with the Parisian revolutionary artistic cell. He made two important and invaluable contacts, which introduced him into the lively circle of radical young artists working around Henri Matisse. One of these men, Hans Purrmann, a former student of Franz Stuck at the Munich Academy, was an associate member of the Berlin Secession. At the time of his meeting with Pechstein, Purrmann was trying to persuade the Berlin Secession to sponsor the first one-man exhibition of Matisse's paintings in Germany. Purrmann's influence in the German capital, and his willingness to introduce Pechstein into the world of national art politics, fanned Pechstein's nascent desire for the fame and success that had so far eluded him and his colleagues in Dresden. At the same time he met Kees van Dongen, a Dutch painter also closely associated with Matisse, who had studied with him and exhibited with the *Fauve* group at the *Salon d'Automne* in 1906. Van Dongen's vigorous sensualism and total lack of intellectualism in his approach to painting astonished and delighted the young German (Plate 28). His bold improvisations and insolent dexterity as a draughtsman and colourist made van Dongen a natural choice for *Brücke* candidacy when Pechstein reported back to his colleagues. As a direct consequence of his contacts in Montmartre (van Dongen's studio was situated in the colourful *Bâteau-Lavoir* which also housed Picasso), Pechstein's style became simpler, more nervous and economical of line and more brilliantly coloured (Plate 29). The wilder excesses that gave *Fauvism* its special energy and emotional vehemence appealed both to his taste and to his temperament. Among the many American, Scandinavian and European artists who flocked to Paris in January 1908 for the opening of the Académie Matisse in the rue de Sèvres was Franz Nölken a young painter from Hamburg who, prior to his departure from Germany, had briefly been associated with the *Brücke*. Thus, Kirchner and the others in Dresden were almost certainly being fed with information about the notorious 'wild beasts' of Paris, from both Pechstein and Nölken, for some time before they themselves had the opportunity of seeing examples of this new expressive art form. When Pechstein returned to Germany it was not to live in Dresden. On his arrival he settled in Berlin, the first member of the group to make the move to the capital.

In April 1908 Kirchner exhibited independently from the rest of the group at the Saxon

28 Kees van DONGEN 1877–1968
Gipsy Dancer
PRIVATE COLLECTION. 1907. Oil on canvas
65 × 50.5 cm.

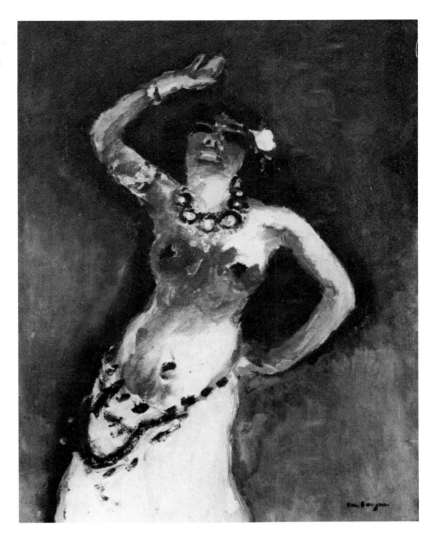

Art Association. At the end of the month the largest exhibition of van Gogh's paintings yet seen in Dresden opened at the Kunstsalon Richter, and this major display of one hundred pictures must still have been fresh in Kirchner's mind when he left the city in June to travel to the lonely Baltic island of Fehmarn (Plate 30). There he resumed painting once again in the open air using thickly loaded brush strokes and a deliberately shocking combination of colours which thrust themselves upon the spectator with an almost threatening intensity. Returning to the city in September he painted scenes expressing the oppressive constraint and tension of urban life (Plate IV), a mechanized world which threatened to turn men and women into robot-like caricatures of themselves.

Before leaving Dresden in May for his second successive summer visit to Dangast with Schmidt-Rottluff, Heckel had handed the keys of the Berlinerstrasse studio over to Kirchner, informing him that on his return in the autumn he planned to find a place of his own. This gradual relaxation of their dependence upon one another coincided with Bleyl's decision to leave the group. For almost three years his modest talent as an artist had been overshadowed almost to the point of complete extinction by his energetic and competitive friends. Bleyl left to pick up the traces of his architectural career.

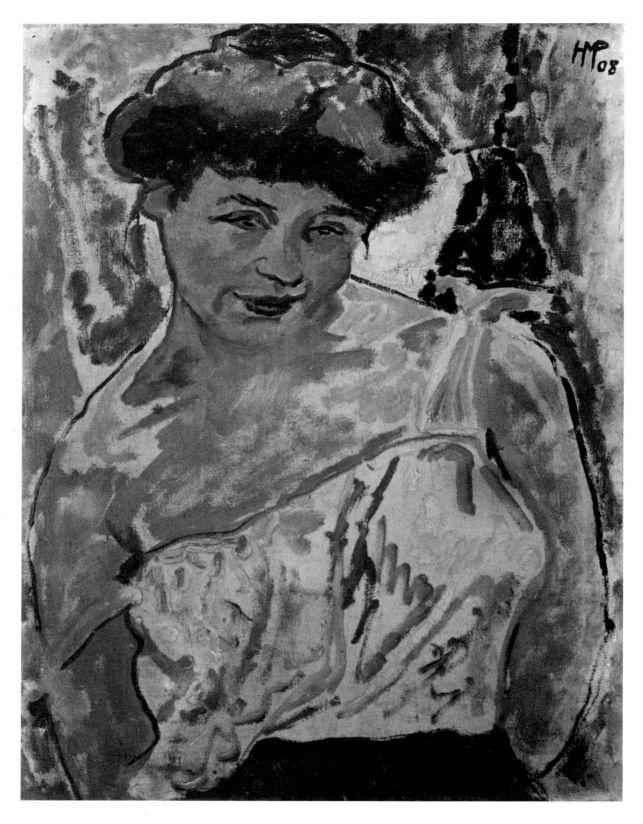

29 Max PECHSTEIN
Young Girl BERLIN, Nationalgalerie. 1908. Oil 65.5 × 50.5 cm. Initialled and dated: *HMP 08*.

30 Ernst Ludwig KIRCHNER

Harbour Scene

HAMBURG, Kunsthalle. 1908. Woodcut 50 × 40.5 cm.
Unsigned. (Schiefler 137; Dube H 135).

In November 1908 Pechstein arranged for the *Brücke* artists to
take part in the Berlin Secession's annual print exhibition,
the first time the group's work had been shown in the capital.
During the previous summer months, Kirchner had made his
first journey to the island of Fehmarn, which has been seen as
marking the end of his early *Brücke* period. By this time his
work was strongly influenced by Munch's style and subject
matter, a fact seized upon by the critic of *Kunst und
Künstler* when he reviewed the Secession exhibition in order
to place the Dresden artists' startlingly primitive graphic
art into some kind of historical context.

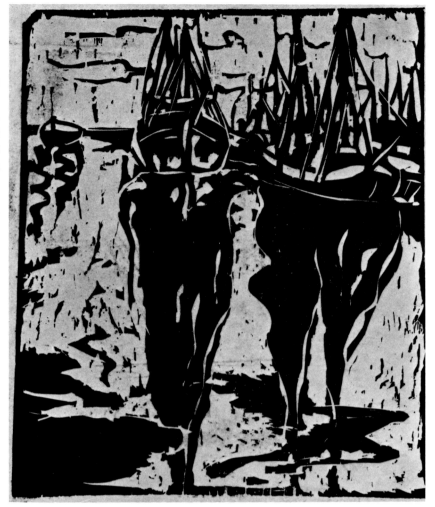

In September 1908 the fourth *Brücke* exhibition opened at the Kunstsalon Richter
(Plate 31). Since Heckel and Schmidt-Rottluff remained in Oldenburg until October (Plates
V and 32), Kirchner was the only member of the group present for the occasion.
Simultaneously with the *Brücke* exhibition, the Kunstsalon Richter was also showing
paintings by Matisse's *fauve* circle including van Dongen, Vlaminck, Marquet, Puy, Guérin
and Friesz. This was the first opportunity Kirchner had to study for himself the violent
execution and experimental colour of '*les Fauves*'. The result on Kirchner's own style was a
more radical elimination of detail combined with a stronger emphasis upon the flat, two
dimensional picture surface, and an even more startling and brash use of colour, almost as if
he was intent on beating the Paris artists at their own shocking game (Plate 33).

In November 1908 a selection of graphic work by the *Brücke* artists was included in the
Berlin Secession's '*Schwarz-Weiss*' exhibition. The Dresden group's infiltration of this
national bastion of liberalism on the Kurfürstendamm was not suffered gladly by some of its
more cliquish members. In his autobiography, Lovis Corinth doyen of the Berlin circle of
so-called Impressionist painters, laid the blame for the Secession's subsequent decline on the
doorstep of those responsible for admitting new, and potentially harmful exhibitors—harm-
ful because they did not conform to any recognizable standard of artistic criteria.

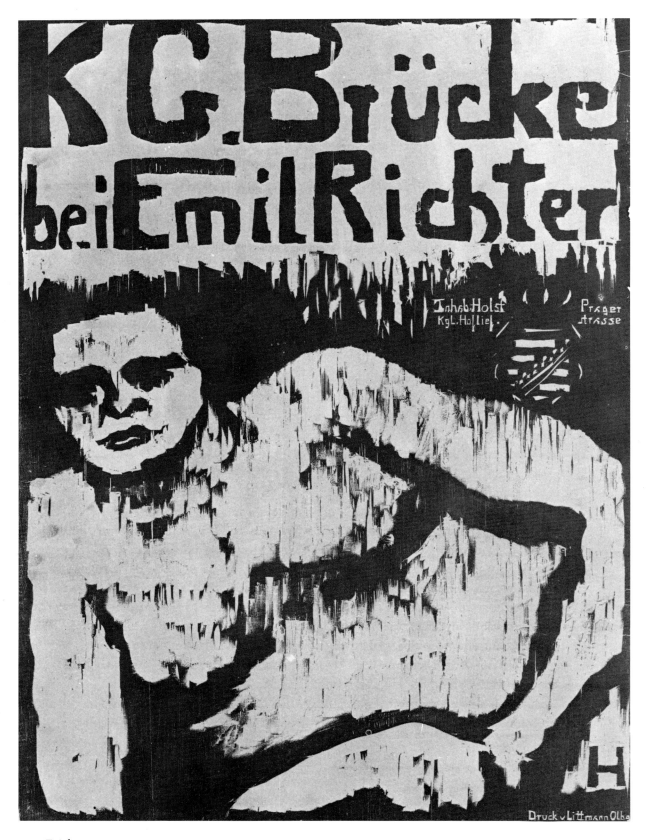

31 Erich HECKEL

K. G. Brücke bei Emil Richter DETROIT, Detroit Institute of Arts (gift of The Drawing and Print Club of the Founders Society). 1908. Exhibition poster. Colour woodcut in red on green paper 84 × 59.6 cm (Dube H 150).

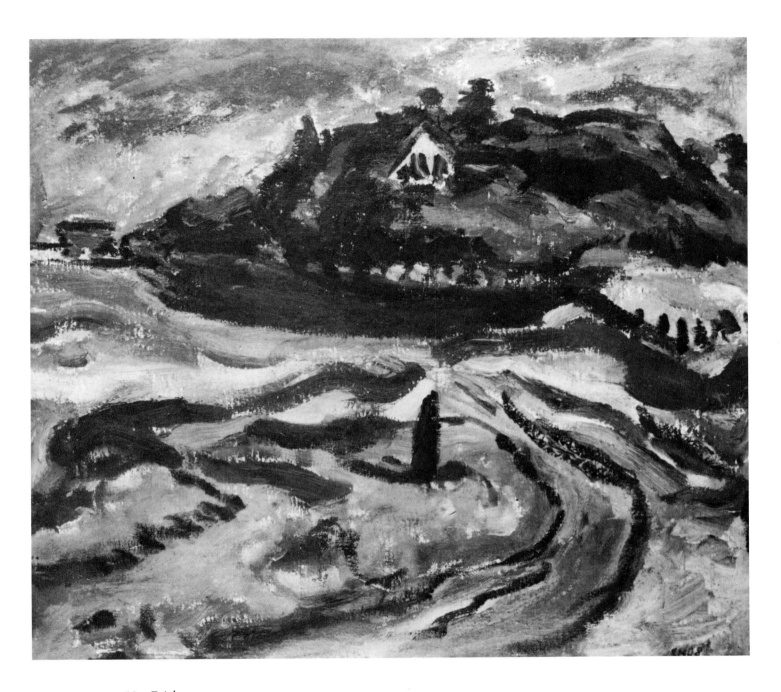

32 Erich HECKEL

Landscape in Dangast PRIVATE COLLECTION. 1908. Oil 63 × 71 cm. Initialled and dated: *EH 08*. (Vogt 1908/10).

By the summer of 1908 when Heckel visited Dangast for the second successive year, the undisciplined impetuosity of the preceding two years of initial trial and error was modified by a deeper understanding of technical method. The dense impasto technique used in *Sunset* (Plate 12) was replaced by a softer, more fluid brush stroke which, whilst still recognizably excited and spontaneous, is less self-willed than before in its response to the lunging diagonals and sweeping curves of the rugged terrain. As a result of Heckel's more relaxed and expansive mood, his style gained in credibility. Form became more intelligible, and the loud colour stresses, because they were given the freedom to cover the picture surface more thinly and evenly amplified this new spatial clarity. Like Schmidt-Rottluff, Heckel had been overwhelmed by the one hundred paintings by van Gogh exhibited in Dresden in April 1908, but his firmer handling and control of the oil medium enabled him to avoid the dangers inherent in his friend's vehement destruction of the subject.

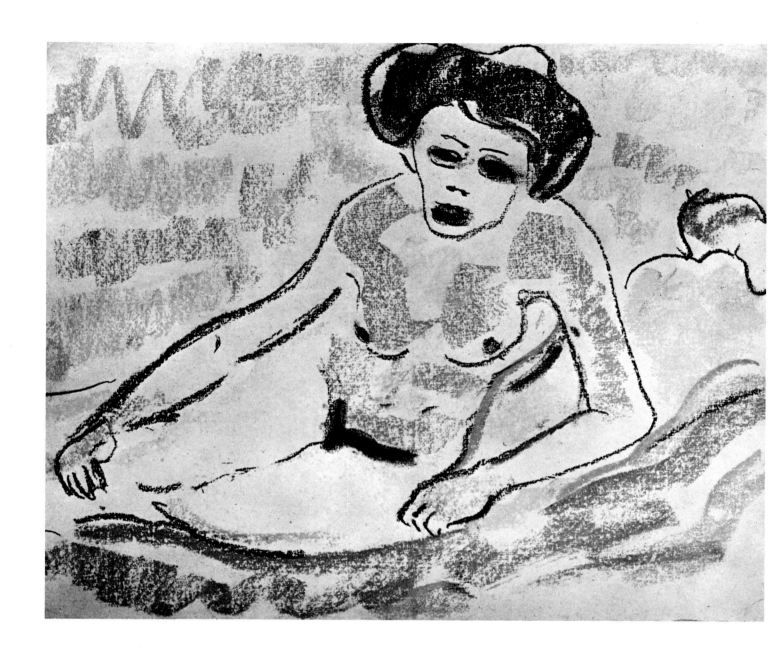

33 Ernst Ludwig KIRCHNER

Reclining Nude on a Sofa HAMBURG, Kunsthalle. *c*.1908–9. Coloured chalks 35 × 43 cm. Unsigned.
The strength and economy of line in this drawing date it to soon after Kirchner's first major encounter
with the *Fauves'* technique, at the time of the Kunstsalon Richter exhibition during September 1908.
The startling ugliness and brutality of the woman's skull-like face is in marked contrast to the sensual
provocativeness of her nude body and is typical of the visual shock tactics favoured by Kirchner in his
determination to challenge the spectator's complacency.

Because of this restrictive partisan attitude Hans Purrmann had failed to persuade the Secession to show Matisse's paintings. All seemed to be well, however, when Paul Cassirer, one of the Secession's directors, agreed to take over the controversial exhibition and display it in his commercial art gallery. But, as the time drew nearer to the official opening date, set just before the Christmas holidays, it became increasingly apparent to Purrmann that Cassirer's nerve had failed. The Berlin dealer's sudden reluctance to honour his commitment was no doubt the result of the antagonistic resentment directed by the city's territorially-minded art establishment against Matisse and his 'subversive' modernism. At the last moment Cassirer fobbed Purrmann off with what the latter considered to be his worst gallery, 'a sort of vestibule', for Matisse's work and, as a compromise gesture of appeasement to the local pressure groups, gave his main exhibition room to Count Kalkreuth. When the Matisse exhibition opened it inevitably attracted public ridicule and very little constructive critical attention. As soon as Purrmann and Matisse were safely out of the way, having left Berlin in disgust at the shoddy treatment meted out to them, Cassirer had the exhibition taken down. But probably not before Kirchner, who is known to have been in Berlin visiting Pechstein at this time, had seen it.

Nothing he had gleaned either from his discussions concerning the *Fauves* with Pechstein, or his recent introduction to Matisse's followers at the Kunstsalon Richter exhibition in Dresden, had quite prepared Kirchner for the revelation of Matisse's suppression of illusion and his radical simplification of style to a technique dominated by flat planes of luminous, sometimes anti-naturalistic colour. Most important of all, the artist's own unique personality sprang out from these flowing linear patterns and daring colour rhythms in a way which was irresistible to Kirchner (Plate 34).

Kirchner, who was the most original and perceptive member of the *Brücke* group, now deliberately set out to consolidate an independent style of painting based on the new model of subjective freedom demonstrated by Matisse's original example (Plate 35). The crucial difference between his approach and the manner of his *Fauve* exemplar was that whereas by 1908 Matisse was intent on attaining a style of 'purity and serenity devoid of troubling or depressing subject matter', Kirchner did not hesitate to inject strong emotional and psychological undercurrents into the already agitated surface qualities of his work. Seeking neither to comfort nor to reassure his audience Kirchner used the new technical vocabulary of bold, independent colour harmonies applied in rich, decoratively flattened areas to carry an equally potent emotional charge. Above all he wanted to intensify the spectator's awareness of and response to human life in all its complexity, uncertainty and excitement, and from now until the outbreak of war he brought to this desire a technique perfectly attuned to his own personal feelings of insecurity, nervous vitality and erotic energy (Plates VI and 36).

34 Henri MATISSE 1869–1954
Landscape at Collioure (study for *The Joy of Life*) COPENHAGEN, Statens Museum for Kunst. 1905.
Oil on canvas 46 × 55 cm.

(Opposite Top)
35 Ernst Ludwig KIRCHNER
Reclining Nude BOSTON, Museum of Fine Arts (Arthur Gordon Thompkins residuary fund). 1909.
Oil 74.5 × 151 cm. Signed and dated: *E L Kirchner 09*. (Gordon 55).

One of Kirchner's few reliably dated oil paintings from his Dresden period, this work was produced soon
after he had seen the exhibition of Matisse's *Fauve* pictures at Cassirer's Berlin gallery in January 1909.
By cramming his model's awkwardly posed body into a narrow, box-shaped space, Kirchner transformed
one of the most conventional studio subjects into an audaciously flattened and distorted image. The
heavy contours of the girl's hips and the position of her legs recall Matisse's *Blue Nude—Souvenir of
Biskra* of 1907 (Baltimore Museum of Art), but the body's startling proximity to the picture plane, and the
general atmosphere of sultry languor, are special to Kirchner's work at this time.

(Opposite Bottom)
36 Ernst Ludwig KIRCHNER
Black Stallion, Girl Rider and Clown FELDAFING, Lothar-Günther Buchheim collection. 1909.
Colour lithograph 50 × 59 cm. Unsigned. (Schiefler 86; Dube L 128).

Kirchner's circus subjects date from the last few months of 1908, after his return to Dresden from
Fehmarn. Like the cabarets which he also frequented, the circus represented a heightened form of reality,
and another way of overcoming the stifling conventions of middle-class society. Whilst Kirchner's initial
interest in the subject was probably fanned by the wide-spread enthusiasm for places of popular
entertainment at the turn of the century, represented most notably by Toulouse-Lautrec, stylistically
this richly coloured lithograph suggests his current involvement with the gracefully curving lines and
spontaneous vitality of Matisse's graphic style. Kirchner's usual lack of restraint was held in check by a
new refinement of line and form, qualities most powerfully rendered here in his sensitive realisation
of the velvety blue-black silhouette of the stallion's head and shoulders which fill one half of the
composition, its rhythmically flowing contour having all the immediacy and empathy of a free sketch.

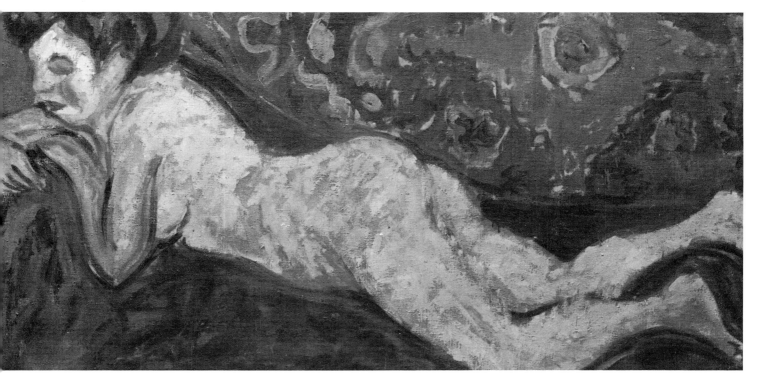

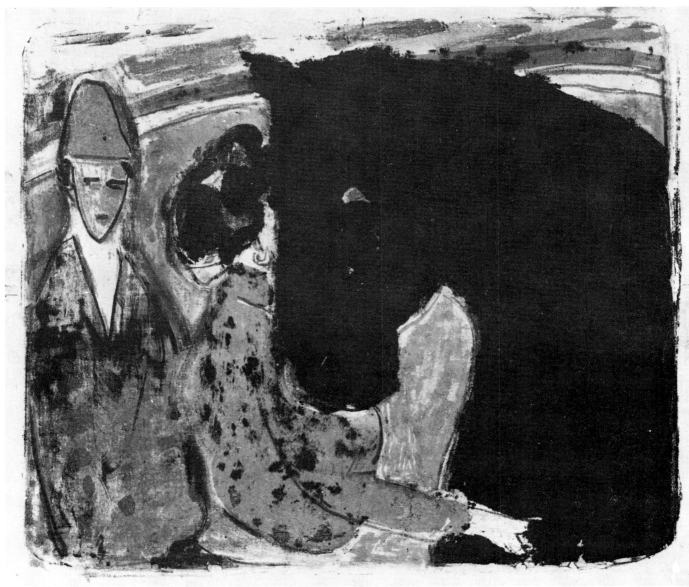

VI 1909

> The nude—the foundation of all living art—in all its freedom and artlessness.
>
> Ernst Ludwig Kirchner, *Chronicle of the Brücke*, 1913

On his arrival in Tahiti in 1891 Gauguin, seeking escape from European corruption and materialism, discovered that the primitive innocence he had hoped to find there had, in fact, already been tainted by western 'civilization' as introduced by the Christian missionaries and government officials already established in Oceania. Faced with little more than the illusion of a tropical paradise, Gauguin settled for that illusion rather than for its alternative—the rediscovery of Europe with all its vices and follies. 'I am a savage', he wrote defiantly to Charles Morice in 1903, the year of his death, in the last letter he sent back to France. His South Sea canvases, filled with a solemn and impassive grandeur, expressed a yearning regret for a lost way of life, its naturalness, its fears, its love of liberty (Plate 77).

The *Brücke* artists too were obsessed by a similar need to pit themselves against the suffocating traditions and moral hypocrisies of a European social code of behaviour which seemed to threaten the very well-spring of life itself. The city was no longer a cause for celebration as Paris had been thirty years before when Monet and Renoir had transformed its urban panoramas into a shimmering, effervescent vision of light, colour and movement. Kirchner was one of the first modern artists to give pictorial expression to the impersonal, artificial atmosphere generated by the twentieth century city in paintings such as *Street* (Plate IV). Behind the dazzling, fast-moving rhythms of the streets crowded with people and vehicles he recognized the disquieting sense of alienation that gripped human beings who were swept along by forces over which they had little or no control. Whilst fascinated by this passing scene, Kirchner felt simultaneously threatened by the modern urban paradox of energy and enervation, and began to seek release from these pressures in a manner at once characteristically personal yet in step with the times (Plate 37).

In the summer months of 1909 Kirchner and Heckel, accompanied by a few girl friends who they used as models, left the city and travelled a short distance north of Dresden to the isolated lake district region of Moritzburg, for the express purpose of painting nudes moving freely about in the open air. Like Gauguin's retreat to the South Seas, their action was both a way of forgetting oneself, albeit temporarily, and an expression of their longing for renewal through a direct and spontaneous contact with nature. The *Brücke* canvases, however, shared none of Gauguin's serene gravity and impassivity, but exploded with an aggressive, urgent subjectivity that brooked no delay between the experience as it unfolded before them, and the need to give it heightened pictorial representation. Kirchner and Heckel's paintings from this first Moritzburg visit were amongst their most violently distorted works. The bodies of the women have been caught 'on the run' without any concession to either nicety of form or finish. Painted at great speed in response to the artists' inner restlessness and craving for instantaneous release, their forms are strident, brutal and garishly coloured. Patches of white canvas were left unpainted, adding their own startling emphasis to the agitated picture surface which shocked the public by its denial of what passed as aesthetic good taste (Plate 38).

Landscape painting had always been a vital part of the *Brücke* group's thematic

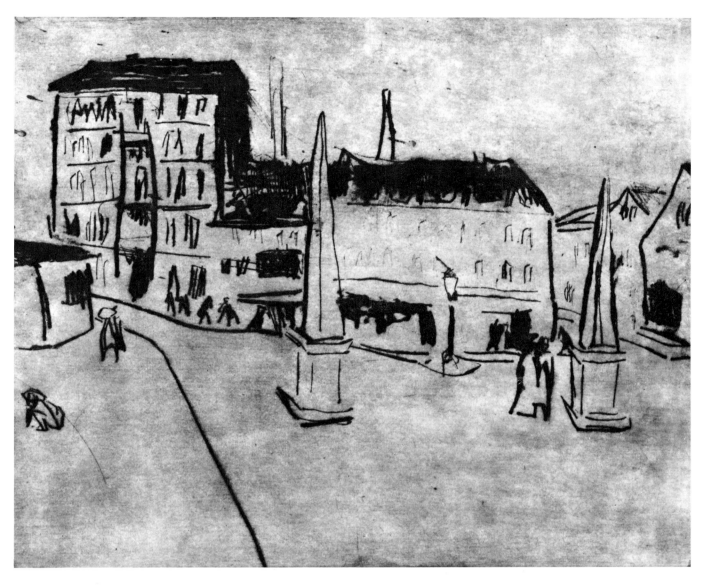

37 Ernst Ludwig KIRCHNER
Street Scene with Obelisks FELDAFING, Lothar-Günther Buchheim collection. 1909. Drypoint etching
21.6 × 26.5 cm. Signed: *E. L. Kirchner.* (Schiefler 112; Dube R 61).

Like all the *Brücke* artists Kirchner sketched wherever he happened to be, whether in the studio or in the
street, taking note of what he saw and catching life on the wing as it happened. Quite often these sketches
were made directly onto an etching plate which he would carry with him, but only the most successful of
these impressions would be later worked up for dissemination to the public. 'The force which attracts an
artist to graphic work is perhaps an attempt to exert a tighter control on the essential looseness of
drawing', Kirchner said when describing the specific importance of graphic art to his work in general.
'The technical processes demand disciplines from the artist which are not called upon in the comparatively
effortless operation of drawing and painting. The mechanics of printing bring together all the separate
stages and the creative work can carry on for as long as one chooses. There is a fascination in retouching
work over a period of weeks or even months in order to achieve the ultimate in expression and form
without the plate losing its freshness'. An expressive variety of line and the staccato rhythm of the
densely etched accents, give this work a vitality and delicacy that attest Kirchner's judgement that
'nowhere else can you get to know an artist better than in his graphic work'.

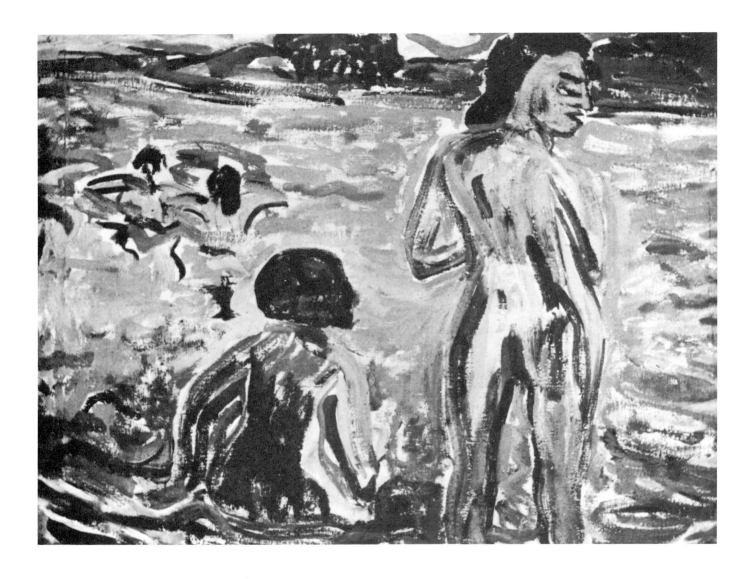

38 Erich HECKEL

Bathers in a Lake PRIVATE COLLECTION. *c.*1909. Oil 75 × 95 cm. Initialled and dated (later): *EH 08*. (Vogt 1908/4).

Painted during Heckel's first visit to the Moritzburg Lakes with Kirchner in the summer of 1909, immediately before he joined Schmidt-Rottluff at Dangast in August, this is one of the artist's most radically abbreviated exercises in the *Fauve* inspired style which absorbed the *Brücke* at this time. The art of selection and omission here reaches an advanced level of pictorial brevity and is an excellent illustration of what Kirchner later described in reference to his own work of this period as 'hieroglyphs . . . in the sense that they represent natural forms in a simplified, two dimensional method, and suggest their meaning to the spectator'.

The aggressively unaesthetic forms of the bathers are sketched in with streaky applications of pure yellow, green and red, against an equally economical background of shore and lake into which the figures merge, creating a totally unified, almost patterned surface. Described by one of the group's critics as 'a half barbaric, half refined manner', this German reworking of the *Fauve* style marked an important step forward in their progress towards an articulate modern art form that was the direct expression of inner necessity.

repertory, beginning with Kirchner's neo-impressionistic treatment of local Dresden views, and the 'monumental impressionism' of Schmidt-Rottluff's first extensive working visit to Dangast. Now the cult of open-air nudism added a fresh, positively scabrous dimension to their work, challenging the outmoded convention of tastefully decorous studio nudes with the unrestrained animal freedom of their naked women. Pechstein quickly followed the example set by Kirchner and Heckel when he joined them on their second visit to Moritzburg in the summer of 1910. 'We would set out early in the morning loaded down with equipment, the models following on behind with bags filled with good things to eat and drink', he wrote. 'If a male model was needed to balance a picture, one or the other of us would step into the breach. We lived in complete harmony together, working and bathing . . . producing a great number of drawings, sketches and paintings'. Some of Pechstein's best work resulted from this period of concentrated activity (Plate X), at once innocent and romantic yet with a tingling air of provocation. In the meantime Schmidt-Rottluff continued his own, more solitary and austere path. Figure subjects did not become a feature of his landscape paintings until several years later.

In the summer of 1909 Pechstein enjoyed his first taste of success when he sold two paintings—a flowerpiece and a landscape—at the annual Berlin Secession. Critics were quick to refer to the names of such illustrious forerunners as Cézanne, van Gogh and Matisse in describing his work. Pechstein's sudden rise to prominence in the capital led to the widespread belief in art circles that he, and not Kirchner, was the main creative driving force behind the *Brücke* group's inflammatory style (Plates VII and 40). Only Paul Fechter, the art critic for the *Dresdener neueste Nachrichten*, who had been reviewing the *Brücke* exhibitions over the past three years, recognized the real truth of the matter.

In his review of the group's third annual exhibition which opened at the Kunstsalon Ernst Richter in June 1909, Fechter named Kirchner as the most original talent amongst the various members, and suggested that Pechstein's recent work was little better than spurious 'bluff'. But Fechter was also to revert to the prevailing opinion five years later when in his book *Der Expressionismus* (1914), one of the first critical evaluations to be written on the contemporary Expressionist movement in German art, he judged Pechstein to be the leading exponent of emotional expressionism, the kind which was primarily concerned with establishing an intensified relationship between the artist and his response to the outside world, equating Pechstein's achievement with that of Kandinsky, whom he saw as the major representative of the other, more mysterious and abstract kind of expressionism which sought to demonstrate the artist's inner world of experience.

This consistent magnification of Pechstein's accomplishments at the expense of his own reputation was a constant source of irritation to Kirchner, particularly after the traumatic period of his military service in 1916 and the consequent breakdown in both his physical and mental health. Obsessed by an ever growing need to assert his rightful claim to a place amongst the handful of German artists who had created a new pictorial language, Kirchner resorted to the desperate measure of predating many of his early pictures, often reworking them at the same time to give a bolder, more radically expressive look to their surface appearance—*Street* (Plate IV), and *Self Portrait with Model* (Plate 41) were both subjected to this post-war transformation. Kirchner's unnecessary and ill-advised ploy to win credit for himself was not so much the calculated deceit of a self-aggrandizing impostor, but the last

desperate attempt of a highly strung, hypersensitive artist driven to extremity by an injustice he could not accept for fear of seeing his life's work constantly underestimated in favour of a colleague's more modestly gifted talent.

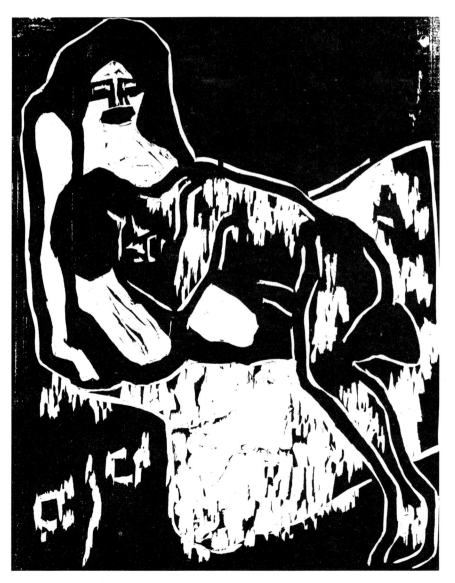

39 Karl SCHMIDT-ROTTLUFF
Two Lovers

BREMEN, Kunsthalle. 1909. Woodcut 55 × 41.8 cm. Sig and dated: *S. Rottluff 1909*. (Schapire H 25).

Examples of Munch's graphic work may have been acce to the *Brücke* artists in visiting exhibitions to the priva galleries in Dresden. In both form and content this woo by Schmidt-Rottluff displays a remarkable affinity to th Norwegian artist's work, suggesting a mood of destru sexuality and personal anguish. The naked bodies of the and woman are more heavily distorted than anything i Munch's work, but the moment has been rendered sens and its explicitness intensified by strong, powerfully cu black and white shapes interlaced with broad, jagged g marks through which the emotive properties of the woo medium are allowed to speak for themselves.

(Opposite Top)

40 Max PECHSTEIN
Nude on a Carpet

FELDAFING, Lothar-Günther Buchheim collection. 1909. Lithograph 43 × 33 cm. Signed and dated: *M. Pechstein* (Fechter L 58).

Pechstein's first lithographs dated from 1908, two years Schmidt-Rottluff's earliest works in this medium. Alth energetically worked, the results are never as expressivel emotionally synchronized in their impact as in the best graphic work of his *Brücke* colleagues. The overly deco appeal of Pechstein's work often impeded an effective tive thrust away from a reassuringly naturalistic repres tion of the subject.

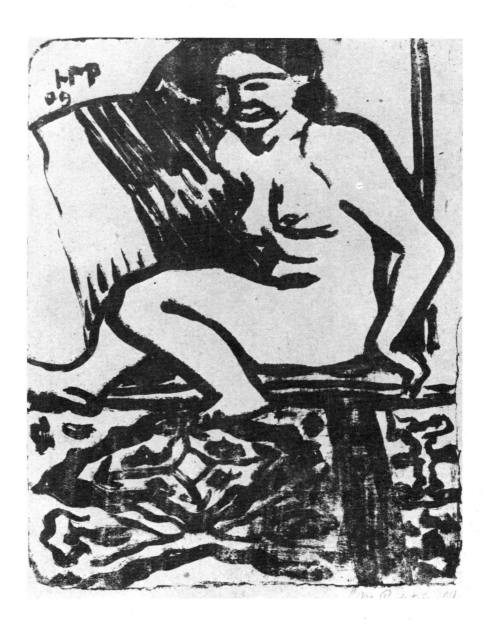

(Overleaf)

41 Ernst Ludwig KIRCHNER

Self-Portrait with Model HAMBURG, Kunsthalle. 1910. Oil 150.4 × 100 cm. Signed and dated (later) on verso: *E L Kirchner 07*. (Gordon 121).

As well as adapting Matisse's *Fauve* painting style to suit his own intense and neurotic vision of life, Kirchner also appropriated from the French artist's subject-matter. The ultimate source of this highly-charged self-portrait with his model Dodo appears to have been Matisse's *Carmelina*, painted in 1903 (Boston, Museum of Fine Arts, Arthur Gordon Thompkins Residuary Fund). Dodo's seated position against the back wall of the studio echoes the arrangement of Matisse's model against an architectural background of converging vertical and horizontal rectangular shapes, and Kirchner's own monumentally flamboyant self-portrait corresponds, at least in its structural role, to the much smaller image of the artist at work, seen in a mirror immediately behind the girl's shoulder, in Matisse's composition. But where Matisse deliberately set out to create an elaborate, artificial illusion, an exercise in the art of picture making, without any room for personal feelings or involvement with the subject beyond its technical requirements, Kirchner converted a commonplace studio scene into a full-scale psychological drama, heavy with enigmatic sexual undercurrents. Furthermore, he transformed Matisse's fully-modelled forms into a loosely flowing pattern of flat, unbroken colours, whose brilliance contrasted sharply to the largely monochrome palette used in *Carmelina*. Kirchner's later obsession with his reputation as an innovator led him to overpaint this canvas in 1926, eliminating certain details and strengthening the picture's extreme lack of spatial perspective to create an even greater impression of flatness.

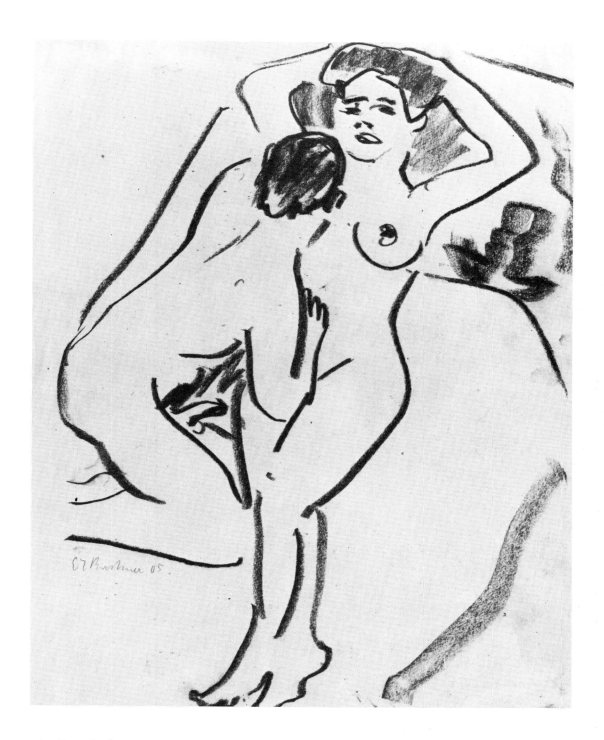

42 Ernst Ludwig KIRCHNER

Two Lovers

FELDAFING, Lothar-Günther Buchheim collection. *c.*1909.
Crayon 44.2 × 34.5 cm. Signed and dated (later): *E L
Kirchner 05.*

Kirchner's frankly erotic drawing embodied his belief that life
was enriched and vitalized by the acceptance of man's
sexuality.

VII 1910

> The Museum of Ethnology here is open again . . . One or two things by the Pueblo
> Indians from Mexico art still on display, and some Negro sculptures.
> <div align="right">Ernst Ludwig Kirchner, Letter, 31 March 1910</div>

The *Brücke* artists' early habit of furnishing and decorating their first communal studio in
the Berlinerstrasse with their own hand-carved furniture and fabric designs sprang from the
group's formative interest in the dominant *Jugendstil* tendency towards a totally integrated
and independent artistic life style. Socially conscious artists throughout Europe, repulsed by
the impoverished, utilitarian standards of modern industrial design, fought to restore a more
caring, more intensely personal aesthetic form, one combining a simplicity of structure and
design with a decorative expressiveness at once pleasing to both eye and mind.

Whilst strongly committed to the *Jugendstil* ideal improving the quality of con-
temporary life in a society dominated by a rapidly expanding and technological culture,
Kirchner and his friends had little time for the international arts and crafts movement's more
esoteric traits. In fact it was a necessary part of their original function as they saw it 'to clear
a way for the efforts of the new German art', (from Kirchner's introduction to the
exhibition catalogue of the *Brücke* Exhibition, Galerie Arnold, September 1910).

In order to achieve the realization of a deeply felt and immediately accessible style of
painting which, by the very nature of its spontaneity and directness of expression would
narrow the gulf between life and art, they had proved themselves willing to experiment
with, and to assimilate, the most radical artistic means at their disposal. Once the vital
influence had been mastered, whether it came from van Gogh, Munch or Matisse, the *Brücke*
artists displayed an urgent propensity to carry their latest discoveries to far greater extremes
than ever existed in their original model. By 1910 the brightly coloured impasto brushwork
of the group's initial style, an exuberant combination of Neo-Impressionist colour technique
and van Gogh's more subjective dynamism, had matured, via the economic vitality of
Matisse's Fauvism, into a ruthlessly simplified, violently distorted—in both form and
colour—two dimensional treatment of the picture surface (Plates 41, 43, 45 and 46).

'A greater clarity is becoming evident [in their work]', Fechter wrote in his review of
the group's new *Fauve*-style painting in the exhibition of 1909, 'a stronger sense of their
having understood their goals . . . No previous *Brücke* exhibition has produced so unified an
effect . . .'

Few people at the time could have predicted the next phase in the group's evolution as,
propelled by an ever present feeling of artistic discontent, they turned their attention to an
art form even more controversial than any that had so far inspired them. Since 1897 the
Museum of Ethnology in Dresden had acquired a substantial collection of primitive carvings
and sculpture taken from such German colonial territories as New Guinea and Cameroon
(Plate 47). Kirchner first began to take serious notice of them sometime during the winter
months of 1908 and 1909 when he carved the African style chair which appears in the
painting *Fränzi in a carved Chair* of 1910 (Plate IX). This was followed by other wood
sculptures, based primarily on Cameroon prototypes, which the members of the group
began to produce in increasing numbers in 1910, the year in which the stylistic properties of

African sculpture—its greater angularity and spareness of form—began to emerge in the generally tighter, more geometric arrangements of their pictorial compositions. The energizing influence of these primitive art forms upon the *Brücke* artists' prints, drawings and paintings sprang from their absolute originality and a directness of individual creative expression that had not been spoilt by contact with the debased values of European civilization (Plates 48 and 49).

If further confirmation was needed that revolutionary changes could be brought about in European painting by turning to the primitive and exotic world of native cultures, it arrived in the form of an exhibition of twenty-six paintings by Gauguin which opened at the Galerie Arnold in September 1910. This was the first opportunity the *Brücke* artists in Dresden had been given to see examples of Gauguin's Tahitian and Marquesan subject matter, in which he filled his pictures with subtle, half-suggested allusions and meanings culled from a broad spectrum of different religious cultures: Oceanic and Buddhist, Christian as well as pagan (Plate 77: *Barbaric Tales*). The Post-Impressionist artist's compelling synthesis of primitive, oriental, and other non-Western art forms gave a new and positive artistic impetus to the young Germans' conviction that the very sources of a humanistic modern style capable of realizing the direct social and cultural links they were seeking lay, not in European orthodoxy, but in such primordial native forces as these. As if to emphasize their affinity with Gauguin's liberating role in breaking with the great Western classical tradition, the *Brücke* group's annual exhibition ran concurrently with the Gauguin display at the Galerie Arnold on the Schlossstrasse, the first time their work had been seen at this gallery, probably Dresden's most prestigious venue for contemporary art. The point, which was further hammered home by Kirchner's woodcut poster design for the Gauguin exhibition, was not lost on the more perceptive critics. Fechter, writing in the *Dresdener neueste Nachrichten*, observed that as 'one wanders through the *Brücke* exhibition upstairs . . . one sees how contemporary tendencies are here at home', and that 'the endeavours of today's generation are still basically concerned with the same problems that interested Gauguin and his generation twenty and more years ago.'

Professionally gratifying as it must have been to the young German artists to have their work publicly shown alongside Gauguin's, the general response to this exhibition, their most ambitious and important one to date, was profoundly disappointing. The significance of the occasion had been marked by the preparation of an elaborately produced exhibition catalogue, a perfect illustration not only of the *Brücke* 'style', but equally of the principles of good book design upheld by their *Jugendstil* predecessors with each page a work of art in its own right. All the lettering, as well as the eighteen illustrations, were hand cut in wood by Kirchner, Heckel and the others.

A brief introductory statement, written by Kirchner, described the group's activities and its development since its formation, which with typical lack of reliability as far as dates were concerned was given as 1903. All the exhibits were listed—eighty-eight in total including forty oils, twenty-one drawings and twenty-seven graphics from Kirchner, Heckel, Schmidt-Rottluff, Pechstein, Amiet and the group's most recent recruit Otto Mueller (Plate 50). Another list named all the affiliated, non-professional members of the *Brücke*, now sixty-eight in number, a substantial increase on the handful which had existed in 1906. They included Otto Gussmann, who had taught Pechstein at the Dresden

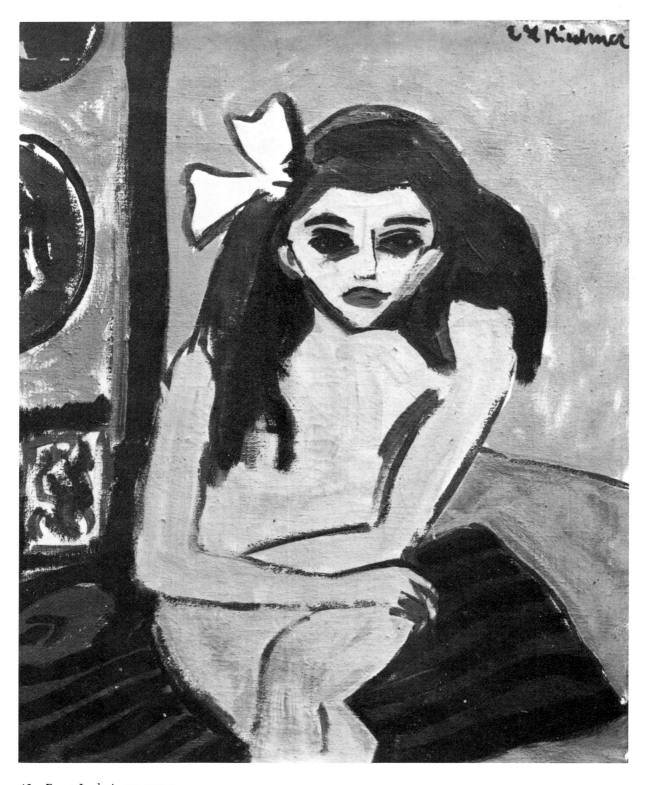

43 Ernst Ludwig KIRCHNER

Marcella STOCKHOLM, Moderna Museet. 1909–10. Oil 71.5 × 61 cm. Signed: *E L Kirchner*. (Gordon 113).

Marcella and her younger sister Fränzi (see Plates IX and 49: *Fränzi in a carved Chair* and *Fränzi lying down*) were adolescent orphans who, from 1909 until 1911 when Kirchner and Heckel left Dresden for Berlin, worked regularly as *Brücke* models, both in the studio and on the artists' visits to the lakes or sea-shore. Kirchner's portrait of Marcella, painted during the winter months of 1909 and 1910, is a striking example of the radical creative metamorphosis to which the artist subjected the various influences upon which he was drawing at this time in pursuit of his own unique pictorial vision of modern life. The picture's theme of pubescent sexuality had its origin in Munch's *Puberty* of 1894 (Oslo, Nasjonalgalleriet), whilst stylistically its simplification of form and purification of colour were an intensified expression of Matisse's

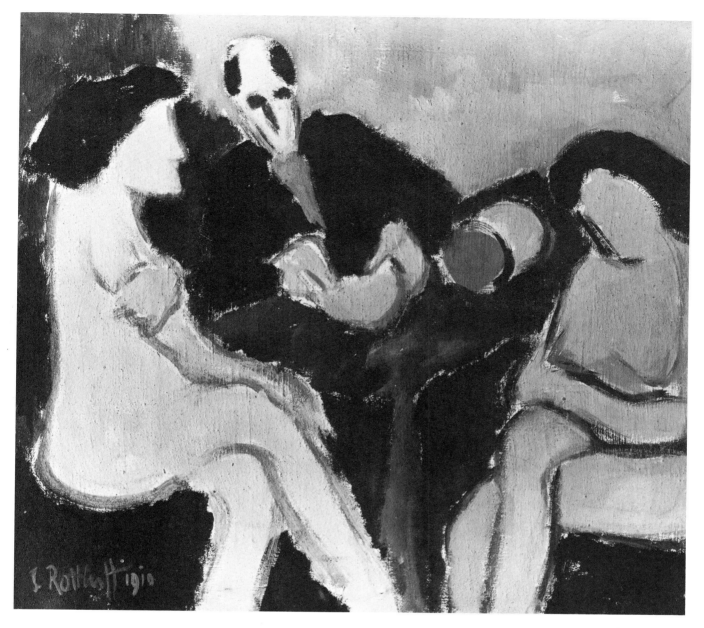

44 Karl SCHMIDT-ROTTLUFF

Rest in the Studio HAMBURG, Kunsthalle. 1910. Oil 76 × 84 cm. Signed and dated: *S. Rottluff 1910*
(Grohmann p. 282).

One of Schmidt-Rottluff's rare figure compositions in oil prior to 1912, this everyday studio scene replaces
the earlier extravagances of the artist's van Gogh inspired style with a more structural use of large,
simplified, sketchily painted colour complexes, loosely held together by a darker contour outline.
Schmidt-Rottluff's choice of colours was frequently based on the combination of red, blue and yellow
used in this work, which was probably painted in his rented studio in the Kleiner Johanisstrasse in
Hamburg, where he was living from January 1910. In the same year he had a number of one-man
exhibitions in the city, the first *Brücke* artist to show by himself until Pechstein's Berlin career gathered
momentum.

decorative, two dimensional Fauvism. Kirchner fused the two elements together, imposing his own
heightened awareness of the girl's emotional awakening through a more distorted representation of her
casually relaxed figure, and a summary application of the thin paint layers—white patches of the canvas are
visible beneath the colours and between some of the brush strokes. *Marcella* was included in the important
Brücke exhibition held at the Galerie Arnold in September 1910. It was also illustrated in the exhibition
catalogue, in a woodcut by Heckel, following the established *Brücke* practice whereby paintings by one
artist were faithfully translated into the woodcut medium by one of his colleagues.

45 Erich HECKEL

Suburb DÜSSELDORF, Galerie Wilhelm Grosshennig. 1910. Oil 48 × 68.5 cm. Signed and dated: *E Heckel 10*. (Vogt 1910/21).

Heckel's quiet suburban street scene is in direct contrast to Kirchner's intensely neurotic vision of a big city thoroughfare painted two years before (Plate IV). Now totally at ease with the more relaxed style of painting which he had been cultivating since his return from Italy, and his closer involvement with Kirchner's highly subjective interpretation of Fauvism, Heckel's unaffected delight in the passing world revealed itself in several engagingly cheerful studies of a lightly social kind.

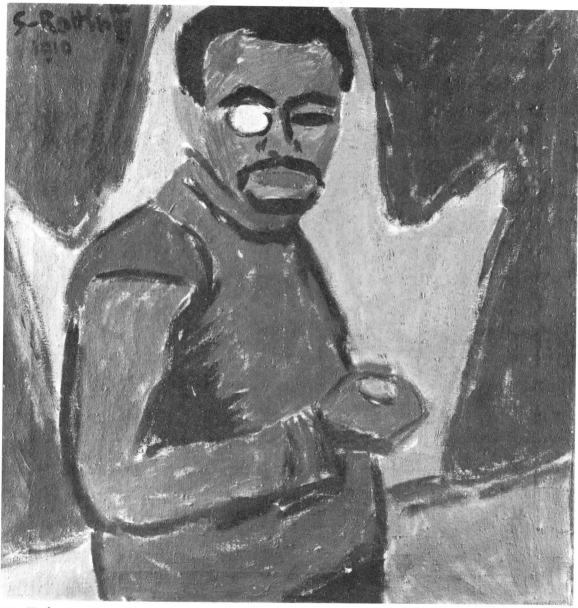

46 Karl SCHMIDT-ROTTLUFF
Self-Portrait with Monocle BERLIN, Nationalgalerie. 1910. Oil 84 × 76.5 cm. Signed and dated:
S-Rottluff 1910. (Grohmann p. 283).

This powerfully conceived, spontaneously executed self-portrait, painted in the characteristically flat,
unbroken, heavily outlined bright colours which the *Brücke* artists adapted from the *Fauve* style, rivals
Kirchner's contemporary self-portrait with Dodo (Plate 41) in terms of its emotional intensity and bold,
generalized treatment of the flat picture surface. As in Kirchner's canvas, the dominant figure of the
painter bursts out of the picture area at top and bottom, and is projected forward towards the spectator
by the use of thick black lines. The jagged, flame-like shape of the surrounding wall-pattern strengthens
the figure's startling appearance, as well as reinforcing the overall surface flatness of the pictorial design.
Significantly, the painting's emotionalism finally comes to rest on the excitement generated by the
artist's choice of colour—pure yellow, green, orange and red, applied in large vigorously brushed in areas.
The brilliant opaque whiteness of the monocle adds a dramatically effective note of self-analysis,
contrasting Schmidt-Rottluff's more withdrawn, reserved personality to Kirchner's self-conscious and
extrovert appearance in a dazzlingly striped blue and orange robe.

47 Nineteenth-century Cameroon chair (detail)
LONDON, collection of Tom Phillips. Wood.

48 Ernst Ludwig KIRCHNER
Seated Nude
FELDAFING, Lothar-Günther Buchheim collection. 1910.
Woodcut 52.7 × 28 cm. Unsigned. (Schiefler 166;
Dube H 155).

By the time Kirchner came to carve this woodcut he had
transformed the curvilinear shapes of his earlier style into a
system of straight-edged lines and angles originating from his
interest in Cameroon sculpture. The figure's pointed hands
and feet, the sharply angled shoulders, elbows and heels
and the swelling convexities of the hips and stomach all
combine to create a primitively unorthodox image. The
African style chair on which the woman is squatting was
another of Kirchner's hand-carved pieces of studio furniture,
and adds its own anthropomorphic character to the subject.

49 Erich HECKEL

Fränzi lying down FELDAFING, Lothar-Günther Buchheim collection. 1910. Colour woodcut in red and black 23/20.7 × 40.5/41.6 cm. Signed: *Heckel 1910*. (Dube H 188a).

Soon after the group began to take a serious interest in the primitive sculptures on display in the Dresden Ethnological Museum, a typical *Brücke* figure was characterized by its negroid looking features and its rigorously angular elbows and knees. The triangular, thick-lipped face with black sockets instead of eyes which Heckel has given Fränzi, was also used by Kirchner to describe his own self-portrait (Plate 41) in 1910. This gradual development of an African figure type was first tried out in the woodcut medium, where the rough, instantaneous technique encouraged an appropriately savage expressiveness to emerge in the more severely geometrical forms. When introduced into their paintings these angularities produced a greater tightness and compression of form (see Plate 51: Kirchner, *Portrait of Erich Heckel*, 1910).

50 Otto MUELLER 1874–1930

The Large Bathers BIELEFELD, Kunsthalle. *c*.1910–1914. Distemper 183 × 128 cm. Initialled: *OM*.

Mueller was thirty-six years old when he joined the *Brücke* in 1910, six years older than Kirchner. He was the group's last significant recruit, if one discounts Bohumil Kubišta, a Czech artist who Kirchner and Mueller met on a visit to Prague the following year and who became a member in theory rather than in practice. Mueller's background history was suitably colourful. The reputed grandson of a gipsy, he had close family ties with the playwright Gerhardt Hauptmann who supported Mueller in his decision to become an artist. In 1898 Mueller had studied briefly in Stuck's class at the Munich Academy, but soon afterwards he returned to Dresden, where he had studied four years earlier, and moved into the studio provided for him by the Hauptmann family. Between then and 1908 when he moved to Berlin, Mueller spent a good deal of time working in the remote country regions of the Riesengebirge, in Bohemia and around Dresden. By the time he reached Berlin, Mueller had perfected his own personal style, the essential theme of which was to portray man's harmonious relationship with nature. 'The ultimate goal of my struggle is to express my feelings for landscapes and for men with the greatest possible simplicity', he declared. The *Brücke* artists were immediately taken with his large-scale, voluptuously rounded nudes when they saw his work for the first time at the New Secession exhibition of 1910. Kirchner and Heckel had, of course, been pursuing similar, if more emotionally violent, ends at Moritzburg the year before, 'so that it was a matter of course that he joined the *Brücke* there and then', Heckel announced. Most of Mueller's works are undated, and apart from a tendency towards more angular forms and a tighter organization of the picture surface under the influence of his *Brücke* colleagues' interest in African art forms, his style during the three years he belonged to the group remained basically the same: a poetic vision of a fantasy dream world incorporating influences that ranged from ancient Egypt to Ludwig von Hofmann, one of Germany's leading *Jugendstil* painters, from Lucas Cranach's ambiguously erotic female nudes (Mueller kept a reproduction of Cranach's *Venus* on his studio wall) to the work of Wilhelm Lehmbruck whose 'limb architecture' was generally considered to be the best contemporary Expressionist sculpture. Mueller always painted in the distemper medium, a matt finish technique with a bias towards gentle, peaceful colour harmonies, far removed from the emotional intensity of the leading *Brücke* artists' brilliant hues.

51 Ernst Ludwig KIRCHNER
Portrait of Erich Heckel
HAGEN, Karl-Ernst-Osthaus-Museum. 1910. Oil
195.7 × 65.2 cm. Signed and dated (later): *E L Kirchner 08*
(Gordon 167).

This full-length portrait of Heckel is one of the first oil
paintings to manifest signs of Kirchner's conversion away
from the curved lines and smoothly flowing forms of his
German *Fauve* style to the more angular forms and straight
lines which were first seen in his woodcuts of this year.
The ultimate source of this subject was Munch's pene-
tratingly psychological portrait of Walter Rathenau, the
powerful German industrialist, painted in 1907 (Bergen,
Rasmus Meyer Collection), and exhibited at the Berlin
Secession in 1908 where it was seen by Kirchner. There is
nothing like the same degree of characterization in Kirchner's
simplified treatment of Heckel's features, however, even
though the rather grim jaw-line and the set of the oval shaped
head above the starched collar bear a remarkable similarity
to the Rathenau portrait. In almost every other respect,
Kirchner has adapted Munch's original to meet the demands
of a more rigorously schematic and exaggerated design.
Heckel's tall, narrow figure is stretched out from top to
bottom of the picture area, one leg widely separated from
the other as if to emphasise its disproportionate length, whilst
the steeply descending diagonal line of the path creates an
even greater sense of imbalance, in contrast to the measured
horizontals and verticals of Munch's interior setting.

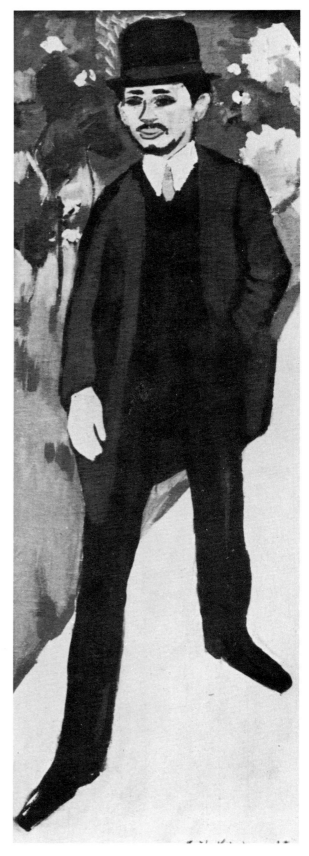

Academy, Hans Fehr, a close friend and early benefactor of Nolde, Ada Nolde, Paul Schmidt, curator from the Kaiser Friedrich Museum in Magdeburg, and such long-serving stalwarts as Rosa Schapire and Gustav Schiefler. Thus the membership of their supporters now stretched from the early patrons and friends to professional and academic people from the art world.

Despite all the obvious care and effort which the artists put into the exhibition—and it was undoubtedly seen by them as a peak in their evolution both as a group and as individuals —it was a bitter failure. Richard Stiller writing a long and vitriolic attack in the *Dresdener Anzeiger*, criticized their failure to reconcile their obvious dependence on foreign influences (the *Fauves*) with any characteristically German profundity of inner meaning. He scorned the very idea that such 'slovenly deformities' could possibly represent a new German art as the artists stated in the catalogue, and dismissed the whole affair as 'a grotesque joke, or as blatant self-deception on the part of ill-advised artists'.

Kirchner, Heckel and Schmidt-Rottluff although still largely based in Dresden would probably have moved to Berlin even without the incentive provided by this calculated attack on their local pride and stature as one of Germany's most vigorous and forceful progressive groups. In May 1910 the first important step towards establishing their national reputation had been made when their work was represented at the first exhibition of the *Neue Sezession* (New Secession) in Berlin. Organized by Pechstein in protest against the exclusiveness of the old Berlin Secession, whose selection Committee had rejected the work of several controversial artists, including Pechstein and Nolde, from its annual summer exhibition, the *Salon der Refusierten* or, as it became more generally known, *Die neue Sezession* became the latest rallying-point for the young German avant-garde.

Fully conscious of the prestige attached to a major exhibition of the new forces in the capital, the *Brücke* artists insisted on exhibiting as a group, and were given a room to themselves when the New Secession exhibition opened at the Galerie Maximilian Macht on the Rankestrasse on 10th May, only a few weeks after the official Secession. Of the ten *Brücke* paintings on display four were by Pechstein, and his name alone was singled out by the critics of *Die Kunst* and *Der Sturm* for special praise. Pechstein was now permanently based in Berlin, and this fact, combined with the more easily accessible nature of his individual style, led most critics at the time to magnify Pechstein's importance at the expense of his Dresden colleagues.

Even so the exhibition served as a timely showcase for their talents, eliciting several highly flattering critical observations, such as 'forceful and original' (*Kunst Chronik* XXI, 13 May 1910). It also introduced them to the work of Otto Mueller, whose gaunt, strangely dream-like paintings of young female nudes in gentle landscape settings appealed strongly to their own erotic flights of fancy. Mueller joined Kirchner, Heckel and Pechstein at the Moritzburg Lakes during the summer months of 1910. The pull exerted by Berlin had thus already assumed a possible importance in Kirchner and Heckel's plans for the group's future, several months before the failure of the Galerie Arnold exhibition helped to make it seem not only desirable but necessary. Quite simply they could not afford to risk their recently established national status by remaining in a city which was unable to assess the artistic significance of their achievement over the past five years.

VIII 1911

In this time of the great struggle for a new art we fight like disorganized 'savages'
against an old established power . . . Who are these 'savages' in Germany? For the most
part they are both well known and widely discredited: the *Brücke* in Dresden, the New
Secession in Berlin, and the New Artists' Association in Munich.
 Franz Marc, *Der Blaue Reiter Almanac*, 1912

Berlin was very different from Dresden. Architecturally it had many fine streets such as the
Unter den Linden, the fashionable Kurfürstendamm, the Wilhelmstrasse and the
Tiergartenstrasse, yet it had nothing comparable in beauty to Dresden's Baroque
architecture or the tranquillity of the Brühlesche Terrasse on the south bank of the Elbe, and
the Grosser Garten public park. Berlin's spectacular industrial growth in the nineteenth
century, combined with its appointment as the capital of the new German Empire in 1871,
had transformed it into a thriving cosmopolitan centre of business and commerce, where a
brilliant world of high fashion rubbed shoulders with working class socialism in an equally
mixed setting of grandiose modern architectural design and drab urbanization.

In 1901 the Berlin art critic Hans Rosenhagen, writing in *Tag*, predicted that the
capital city was already beginning to supplant Munich's traditional pre-eminence as
Germany's 'city of art'. Revolutionary writers and painters of the calibre of Ibsen, Munch,
Strindberg, Kokoschka and Hauptmann had challenged and provoked Berlin's Prussian code
of militaristic respectability and philistinism, clearing the way for a multifarious assortment
of artists and intellectuals intent on pursuing new ideas and sensations. The metropolis
generated an atmosphere of electric excitement, energy and movement that could not fail to
stimulate the *Brücke* artists after the mellow peace and charm of provincial Dresden.

After they became involved with the New Secession Kirchner and the others were
frequent visitors to Berlin, meeting at Nolde's studio in the Tauentzienstrasse. As a result of
their strong showing at the Galerie Macht the previous year they had become the subject of
considerable interest and curiosity in the Berlin art world. Pechstein in particular was
beginning to achieve real success. When one of his woodcuts was used as the frontispiece in
the radical weekly arts periodical *Der Sturm* (21 January 1911) it not only introduced the
Brücke style to a vast, new and hitherto untapped audience, but also tacitly affirmed the
group's place at the forefront of the contemporary German avant-garde. During the spring
Nolde was invited to contribute illustrations to *Der Sturm*, followed soon after by Kirchner
(Plate 52), Heckel and Schmidt-Rottluff.

Herwarth Walden, the founder and editor of *Der Sturm*, had an infallible gift for
recognizing artistic talent, and promoted his discoveries quite fearlessly, more often than not
in the face of strong opposition and even moral disapproval. In August 1911 he was obliged
to withdraw the current edition of the periodical when official complaints were made
concerning the explicit sexual imagery in a Kirchner woodcut illustration. Naturally, one of
the factors which had drawn Walden's attention to the *Brücke* artists in the first instance had
been the public shock value of their work. The periodical's weekly circulation figure of
30,000 readers in Germany, France and Holland was proof enough that when it came to
propagating the latest modern artistic phenomena Walden was also an extremely astute and

hard-headed business man.

On the strength of their newly found status in the capital, Kirchner and Heckel both decided to leave Dresden. They moved to Berlin during the autumn, when in the usual order of things they would have been preparing for the group's annual exhibition. There was no *Brücke* exhibition in 1911. In fact there would be only two more group shows before the *Brücke* collapsed beneath the strain of internal tensions and a growing disenchantment with having to put personal ambitions in second place to the corporate image.

Kirchner's new studio was on the Durlacherstrasse in Wilmersdorf, whilst Heckel moved into Mueller's old studio on the Mommsenstrasse in Steglitz. Schmidt-Rottluff soon followed them, but he saw his colleagues less frequently than before, and continued to remain aloof from their communal working trips to Moritzburg.

Soon after Kirchner's arrival in Berlin, in October 1911, he and Pechstein established their own art school, the *MUIM Institut* (*Moderner Unterricht in Malerie*/Modern Instruction in Painting). A woodcut poster designed by Kirchner advertising the school was reproduced regularly in *Der Sturm* between October 1911 and the summer of 1912, when the two co-directors abandoned the project due to lack of support. In the official prospectus which they produced, Kirchner and Pechstein listed courses of instruction in both the fine and applied arts: painting, graphics, sculpture, glass and metal work, and painting in connection with architecture. In addition they offered students instruction in the methods of contemporary art, and the opportunity to discuss the aims of the latest developments in art in order to appreciate and understand their relevance to modern life. The school's programme was closely bound up with the two *Brücke* artists' personal working habits. For instance during the summer months they announced that open-air paintings sessions would be held by the sea-side.

In the meantime the *Brücke* group as a whole had continued to exhibit at the New Secession, always insisting upon their own room in order to isolate their work from that of the other artists taking part. An exhibition of graphic work during the autumn of 1910 was followed in the spring of 1911 by the New Secession's third, and most significant show. For the first time, the Dresden artists' group was thrown into contact with Kandinsky, Jawlensky and Marc, the three most advanced members of the Munich New Artists' Association, whose reputation as a showcase for modern French, German and Russian art had, under Kandinsky's direction, set a formidable standard since its foundation in 1909.

The challenging diversity of the Munich artists' paintings not only impressed Kirchner and his friends, but also highlighted the generally unadventurous level of work produced by many of the regular participants in the New Secession exhibitions. In December 1911 the *Brücke* group resigned from the New Secession. The decision to withdraw their support from an organization no longer able to maintain its original revolutionary promise coincided almost to the day with the resignation on 2nd December of Kandinsky and Marc from the New Artists' Association in protest against the cautionary policies of their more moderate colleagues. Less than a month later, when Marc came to Berlin on a New Year visit to see his wife's family, he made a special point of calling on Kirchner, Heckel, Pechstein, Mueller and Nolde in order to invite them to take part in the second exhibition of *Der Blaue Reiter* which he and Kandinsky were organizing in Munich. This demonstration of confidence in the *Brücke* group's artistic prominence in Germany, coming as it did only a few months after

the artists' departure from Dresden, confirmed the rightness of their decision to move to the capital, and climaxed their long struggle for national recognition.

52 Ernst Ludwig KIRCHNER
Panama Girls FELDAFING, Lothar-Günther Buchheim collection. 1910. Ink 37.5 × 51.5 cm.
Signed and dated: *E L Kirchner 10*.
This is one of several drawings of dancers made by Kirchner on a visit to Hamburg with Heckel in 1910, when they made a special study of the city's music-hall world (see Plate 53). Kirchner's dance quartet carries distant echoes of Toulouse-Lautrec's *Dance Troupe of Mademoiselle Eglantine* (1896), but he was less concerned with portraying the girls as individual performers than with the problem of transforming the group as a whole into a vehicle of primitive expression. The angularity of the distorted limbs, the profiles drawn in straight lines and the harsh, staccato rhythm of the group's frieze-like movement from right to left equals in force the savagely unaesthetic woodcuts produced earlier that year. *Panama Girls* was illustrated in Herwarth Walden's *Der Sturm* magazine on 29 April 1911.

53 Erich HECKEL

The Rehearsal FELDAFING, Lothar-Günther Buchheim collection. 1910. Watercolour and bodycolour 39 × 59.3 cm. Signed and dated: *Erich Heckel 10*.

Heckel shared Kirchner's enthusiasm for places of popular entertainment. Fascinated by all extreme manifestations of life some of their most cheerfully exaggerated subjects stemmed from their strong interest in the world of music-hall, circus and cabaret. Toulouse-Lautrec's influence can often be detected in their treatment of these themes. But where the Parisian artist excelled in celebrating the individual personality of the performer, the German artists invariably suppressed individual characterization in order to concentrate upon and to magnify the raw vitality of physical movement and energy, as in this extremely economic, aggressively dashed off watercolour drawing of a Hamburg dancer going through her paces.

54 Max PECHSTEIN

Carnival IX FELDAFING, Lothar-Günther Buchheim collection. 1910. Lithograph 28 × 38 cm. Signed and dated: *Pechstein 1910*. (Fechter L 112).

In 1910 Pechstein produced a series of ten lithographs on a carnival theme. Like Kirchner and Heckel, he spent a good deal of time absorbing the artificially heightened atmosphere of show business, and was a regular visitor to Max Reinhardt's Deutsches Theater. Another graphic series by Pechstein, this time on *Dance*, also came out in 1910 followed two years later by *Acrobats* and *Russian Ballet*.

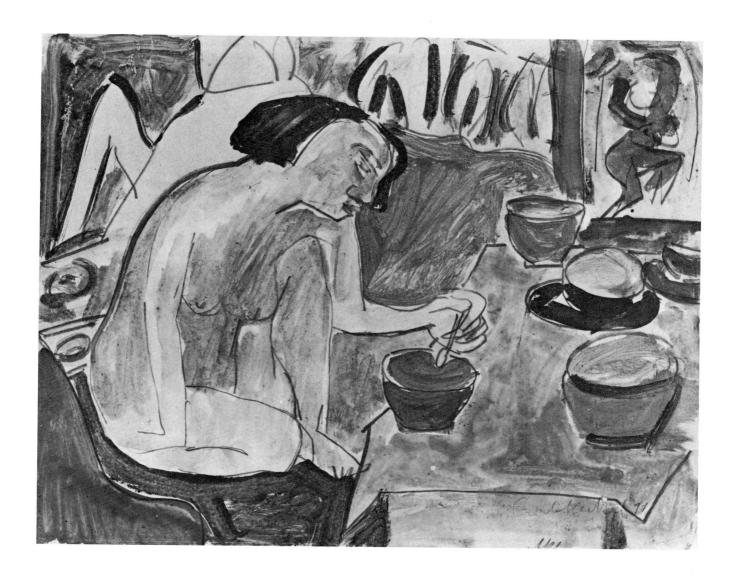

55 Erich HECKEL

Crouching Nude in the Studio FELDAFING, Lothar-Günther Buchheim collection. 1911. Pencil and watercolour 27.1 × 34.3 cm. Signed and dated: *Erich Heckel 11.*

Possibly inspired by one of Gauguin's paintings of a crouching Tahitian girl seen at the Galerie Arnold exhibition in September 1910, Heckel's watercolour drawing is a remarkably free rendition of his original source material. The calligraphic spontaneity of the pencil combines with the irregular patches of non-objective colour to produce a self-consciously primitive interpretation of a commonplace studio incident.

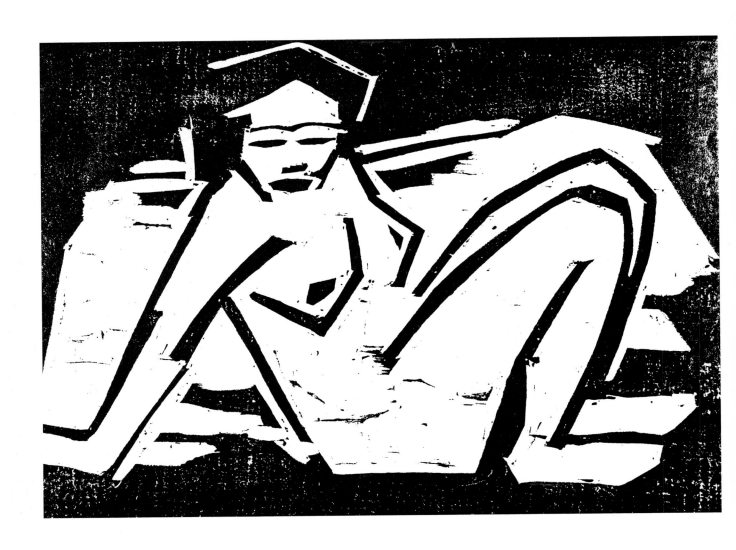

56 Karl SCHMIDT-ROTTLUFF
Girl with outstretched Arm LEICESTER, Leicestershire Museums and Art Galleries. 1911.
Woodcut 23.2 × 31.3 cm. Signed and dated: *S Rottluff 1911*. (Schapire H 56).
Schmidt-Rottluff was strongly influenced by Cameroon figure sculpture at this time. The woodcut
medium frequently served as an ideal ground for experiment in the expressive simplification of strong,
angular planes before the artist went on to develop his ideas in oil paint (see Plate 58: *Two Women*). By
1911 this kind of African figure type was a well-established *Brücke* trademark.

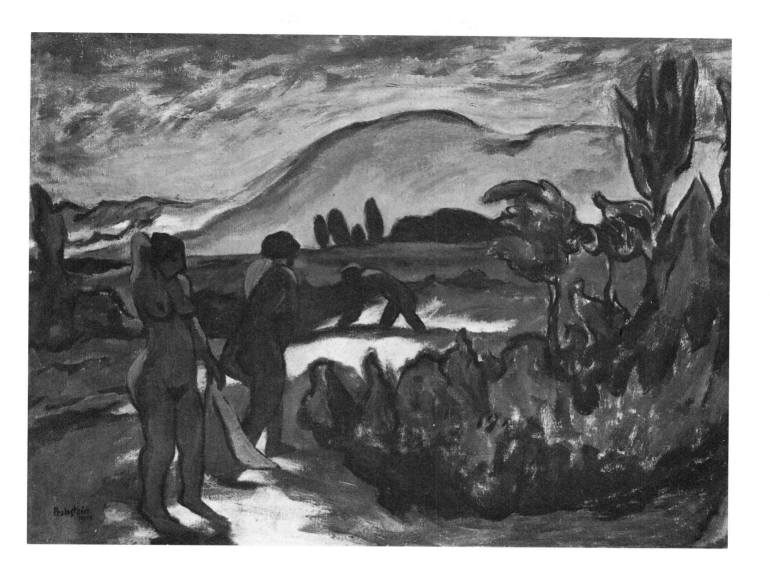

57 Max PECHSTEIN

Summer in the Dunes BERLIN, Nationalgalerie. 1911. Oil 75 × 100 cm. Signed and dated: *Pechstein 1911.*
After his initial enthusiasm for Fauvism, Pechstein's style quickly subsided into a relatively conventional,
naturalistic manner. It is probably no coincidence that he produced his best work when the other *Brücke*
artists were there to stretch and stimulate him by their example, as happened at Moritzburg in 1910
(Plate X: *Horsemarket at Moritzburg*). The following summer Pechstein returned to Nidden once again 'to
paint nudes in the open air without being molested', only this time by himself. Compared to
Kirchner and Heckel's grotesquely distorted and foreshortened nudes of this year, Pechstein's women'
have an almost academic look about them, whilst the stereotyped landscape setting seems equally lacking
in imagination. 'The limit of Pechstein's talent seems to be in his inability to find full agreement between
the spontaneous freshness of optical experience, and the considered form demanded by a painting',
Paul Schmidt wrote in 1912.

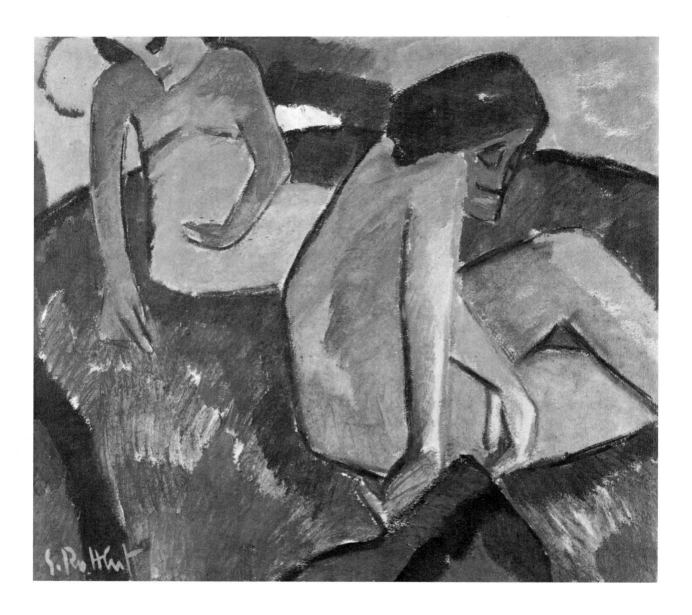

58 Karl SCHMIDT-ROTTLUFF

Two Women LONDON, Tate Gallery. 1912. Oil 76.5 × 84.5 cm. Signed and dated: *S. Rottluff 1912.* (Grohmann p. 285).

Painted in the artist's Hamburg studio, this is one of the few pictures in which Schmidt-Rottluff consciously experimented with the Cubists' method, with a view to strengthening the monumental expressiveness of his style. Possibly because he came to realize that his emphatic kind of art form depended much more fundamentally on the intuitive response to nature which he had always maintained, and less on the kind of intellectual theorizing practised by Picasso and Braque and their admirers, Schmidt-Rottluff soon abandoned Cubism as a solution to his particular problems. *Two Women* was exhibited in the *Brücke* show at the Galerie Fritz Gurlitt in Berlin in April 1912. It later belonged to Rosa Schapire who bequeathed it to the Tate Gallery.

IX 1912

The majority of the *Brücke* members are now in Berlin. Even here the group has maintained its identity. Its spiritual unity radiates the new values of artistic creation throughout contemporary German art.

Ernst Ludwig Kirchner, *Chronicle of the Brücke*, 1913

1912 was the year in which the *Brücke* artists were finally rewarded for their years of struggle in Dresden by the kind of publicity and attention about which they had always dreamed. Between February and September their work could be seen in four major exhibitions, beginning in Munich with the second exhibition of *Der Blaue Reiter* (February-April), followed by the Galerie Fritz Gurlitt in Berlin (April, Plate 58), the *Sonderbund* exhibition in Cologne (May-September), and the Galerie Commeter in Hamburg (August-September). Two of these exhibitions were large international shows representing a broad survey of the most outstanding achievements in contemporary European art. Fully aware that their presence in both the *Blaue Reiter* and the *Sonderbund* exhibitions was proof of their growing stature as one of the undisputed leaders of the new German avant-garde, the *Brücke* artists provided ample evidence of their prolific talent.

From the 'gigantic stock of material' which Marc had seen during his round of visits to their Berlin studios in January, Kirchner, Heckel, Pechstein and Mueller between them sent no fewer than 114 miscellaneous prints, drawings and watercolours to Munich. Schmidt-Rottluff did not participate in the *Blaue Reiter* exhibition as he had not been in Berlin to meet Marc, but Nolde was represented by seventeen items, and was probably still classified as a *Brücke* artist, at least in temperament, by Marc and Kandinsky even though he had not been a member of the group for five years.

A number of works by Kirchner, Nolde, Heckel, Pechstein and Mueller were illustrated in *Der Blaue Reiter Almanac*. Compiled and edited by Kandinsky and Marc the book was a didactic synthesis of the arts, bringing together a wide variety of art objects and styles which set out to show an underlying affinity between modern art and that of the so-called primitive cultures. This relationship was seen as one of expressive content rather than external form. Kandinsky had been less than happy about including the *Brücke* artists' work in the exhibition, and had only conceded finally out of respect for Marc's arguments in their defence. But when the question arose of reproducing *Brücke* prints and drawings in the almanac, Kandinsky firmly stated that they should be kept to the smallest size of illustration. The difference in the size of the reproductions which appeared in the almanac indicated the editors' final decision as to their importance.

Kandinsky's doubts concerning the *Brücke* artists' claim to a place in the forefront of the European avant-garde scene were not shared by the organizers of the International Exhibition of the *Sonderbund*. Composed of artists, dealers, museum officials, art historians and representatives of Cologne's city council, the working committee commissioned Kirchner and Heckel to decorate the walls of a chapel, specially built in the Kunsthalle where the exhibition was held. Schmidt-Rottluff also received a commission to provide four bronze relief figures of the apostles for display within the chapel.

Johannes Thorn Prikker, a member of the small group of Dutch symbolist painters,

who had worked with Henri van de Velde as a decorative artist, was invited to design the chapel's stained glass windows. Rising to the challenge of collaborating on this religious project with someone as well qualified in the treatment of such subjects as Thorn Prikker, Kirchner and Heckel adopted a 'modern Gothic' style for their series of murals painted on jute canvas. This unique decorative scheme no longer exists but according to Paul Schmidt, one of the group's affiliated members who saw the finished result, it was not a total success, owing to the uncharacteristic nature of the subject matter and, most particularly, to the unusually large scale on which Kirchner and Heckel had to work for their effects (the chapel itself stood fifty-feet high).

Whatever its shortcomings, the chapel was one of the exhibition's most controversial attractions. Furthermore, it occupied a central position, surrounded on all sides by a superlative display of contemporary art from nine countries, including an impressive retrospective survey of the modern movement's three direct forerunners: van Gogh, Cézanne and Gauguin. The *Brücke* artists could not have asked for a more positive vindication of their achievement in extending the boundaries of modern painting, freeing it from all constraint and laying bare the existential dilemma of modern life by carrying the expressionist concept of emotional experience to far greater extremes than had ever occurred in France. Yet there were still those who either doubted or resisted their visual expressions of a tense, hectic and deeply disturbed social order.

When Arthur B. Davies, President of the Association of American Painters and Sculptors sent his representative Walt Kuhn to see the *Sonderbund* with a view to perhaps borrowing some of its ideas for the association's next exhibition in New York, Kuhn tended to play down the German achievement as, at best, a nationalistic reworking of original French sources. The outcome of this prejudice in favour of the Paris avant-garde was that when the International Exhibition of Modern Art opened at the 69th Regiment Armory building in New York in February 1913, there were only two works out of more than 1600 exhibits to represent the modern German school. One of these paintings was by Kandinsky, the other by Kirchner who, for once during this period, was not overlooked in favour of Pechstein.

The Berlin critics, however, continued to magnify Pechstein's importance. In April when the group's first communal exhibition since leaving Dresden opened at the Galerie Gurlitt, Kirchner and the others were once again treated to a generally mixed press, whilst Pechstein was rewarded with much greater approval and enthusiasm. As a popular forerunner of the *Brücke* style Pechstein had fulfilled a valuable function in preparing the way for his colleagues before they decided to make the move to Berlin, but no one within the group itself was under any doubt as to who possessed the boldest talent. Kirchner's astute, highly intelligent and, above all, intensely personal response to the large and diverse number of external influences which had served to inaugurate a unique German style of painting was remarkable by any standard for its sustained growth and consistency of stylistic development during the past seven years.

Kirchner was also passionately loyal to the original spirit of independence and self-determination which characterized the *Brücke*. His pride in their endeavour as a group brooked no division of interests on the part of any single member, himself included, if their action in any way discredited or diminished the reputation of the group as a whole. Great as

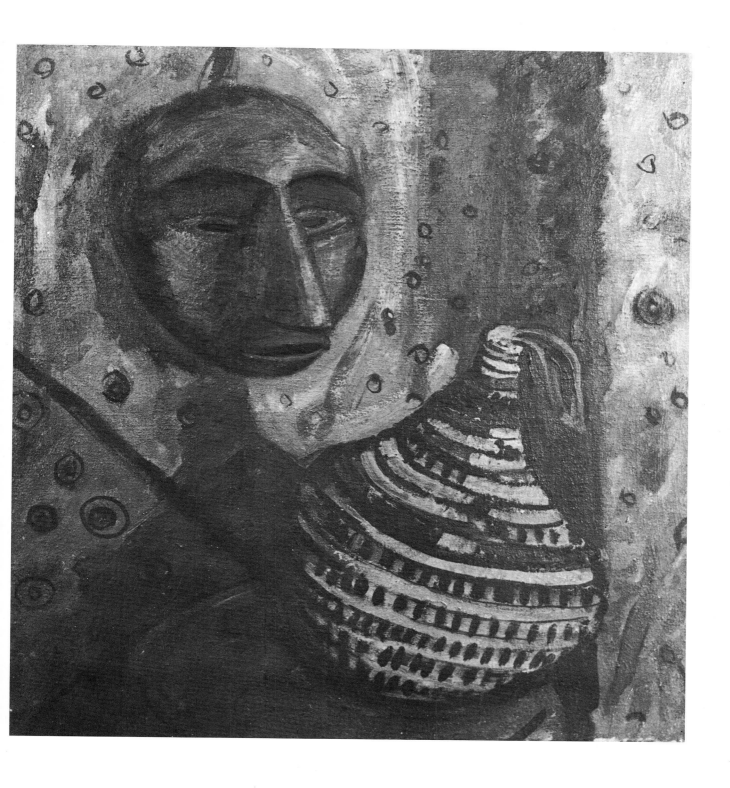

59 Erich HECKEL
Still Life with an African Mask SAARBRÜCKEN, Saarland-Museum. 1912. Oil 69 × 63 cm.
Signed and dated: *E Heckel 12*. (Vogt 1912/48).

Kirchner's disappointment must have been to see his own significance continually under-rated, he did not begrudge Pechstein his success—and in 1912 this was considerable, including three important one-man shows in Mannheim, Munich and Berlin—so long as he remained loyal to his allegiance to the *Brücke*. Two years earlier, when they had broken with the Berlin Secession, a mutual agreement had been made whereby it was decided not to show their work there ever again except as a group. In the summer of 1912 Pechstein deliberately chose to ignore this ruling and exhibited independently of the others at the Secession.

Kirchner's response was swift and irrevocable. He expelled Pechstein from the *Brücke*, and ordered the immediate withdrawal of the 1912 portfolio, which was devoted to Pechstein's graphic work before it could be distributed to the associated members. As a result of his expulsion Pechstein was not allowed to take part in the last of the exhibitions with which the *Brücke* consolidated a year of triumphs when it opened at the Galerie Commeter in August. In spite of his professed indifference Pechstein's pride suffered at the treatment meted out to him by Kirchner and the group's other members, all of whom supported the decision. Many years later he preferred to say that he had withdrawn of his own volition, rather than admit to having been thrown out.

X 1913

'Since the *Brücke* never had anything to do with my artistic development, any reference to it in an article concerning my work is quite unnecessary.'

Ernst Ludwig Kirchner, *Letter to Gustav Schiefler*, 1919.

From the moment of their arrival in Berlin the *Brücke* artists each set out to consolidate a more personal and independent style. In the case of Schmidt-Rottluff, the most reserved and introverted member of the group, the solution was found in his increasing isolation from the hustle and bustle of the city, and the continued search for catharsis through prolonged contact with nature. A journey to Norway during the summer months of 1911 enabled him to achieve even greater monumentality and simplification in his treatment of landscape through an almost abstract language of colour and form that expressed a passionate sense of liberation, even of purgation. This ruthless elimination of all extraneous detail was developed over the next two years, during which Schmidt-Rottluff experimented briefly with the Cubists' method, whilst never abandoning those emotive forms of nature which illuminated his intense vision of life. In 1912 the human figure, specifically the naked female body, began to play an increasingly significant role in his work which until now had been almost entirely restricted to pure landscape. The figures received equal weight with the landscape elements, both being reduced to an emphatically two dimensional image. The result was a symbolic unity of form and colour that expressed the artist's concept of harmony between man and nature with a powerful, but unrefined, universality (Plate 60).

Certainly in comparison to Pechstein's voluptuously naturalistic young women (Plate 57: *Summer in the Dunes*, 1911) Schmidt-Rottluff's nudes exude the primeval essence of man, a savage and elemental force like nature itself. Small wonder then that the critics who acclaimed Pechstein's generally emasculated adaptations of his friends' uncompromisingly vigorous experiments with conventional aesthetic form and colour, should have recoiled in uncomprehending disbelief from Schmidt-Rottluff's aggressively disturbing interpretation of the open-air cult of the nude.

In Berlin, Heckel's growing tendency towards a more serious, self-disciplined view of life assumed a much greater importance. Like Schmidt-Rottluff he had largely abandoned the early *Brücke* obsession with communicating the emotional expressiveness of a moment in favour of a more generalized and, in his case, more compassionate approach to the subject (Plate XIII). Social conditions in the capital directed his attention more and more strongly towards a closer study of the human condition. After his meeting in 1912 with Franz Marc and August Macke, the two young German painters most directly influenced by Delaunay's rhythmic interplay of contrasting colours, and his subsequent friendship with Lyonel Feininger, Heckel made expressive use of the new discoveries of Cubism to give fresh dynamism to his personal vision of a society in utter confusion. Even so, the valued efficacy of nature as a restorative remained central to Heckel's overall concept.

In *Day of Glass* (Plate XVII) for instance he made the elements of air, earth and water as much a tangible presence by the means of interrelated prismatic shapes as the fully rounded, sculptural body of the female bather. In this way Heckel was able to elaborate upon a

60 Karl SCHMIDT-ROTTLUFF
Three Nudes BERLIN, Nationalgalerie. 1913. Oil 98 × 106.5 cm. Signed and dated: *S. Rottluff 1913*.
(Grohmann p. 286).
During the summer months of 1913 Schmidt-Rottluff worked at Nidden. Whilst Kirchner and Heckel
were becoming increasingly absorbed in various aspects of social and psychological *angst* in Berlin, he
studiously avoided the depiction of city life, and continued to strive for the all-consuming freedom
through nature that nourished his creative imagination.

familiar *Brücke* theme, investing it with new cosmic meaning through the use of more overtly symbolic effects.

The year 1913 also saw the full realization of Kirchner's mature artistic power in a bitingly neurotic style, based on his assimilation of non-Western art influences, in particular the sixth century Buddhist wall paintings of Ajanta which he knew through book illustrations discovered in the Dresden Museum Art Library in 1910, and their reinterpretation in the light of his complex response to Berlin. Kirchner's reaction to big city life remained a mixture of fascination and horror. On the one hand he was drawn compulsively towards its seamy night life of whores, cabaret dancers and circus entertainment, but on the other he was overwhelmed by its artificiality and brutishness. This conflict eventually resolved itself in a series of disquietingly psychological street scenes, where the artist's extreme state of nervous tension and excitement communicated itself to the spectator in luridly unnatural colours and his edgy use of sharply serrated brush strokes.

In the first of these modern urban nightmares, *Five Women on the Street* (Plate XIX), the dehumanized, attenuated figures of the prostitutes, garishly arrayed in the inhibiting, unflattering fashions of the day are trapped in a radically distorted and flattened space, and stalk the street like monstrous birds of prey. The atmosphere of depravity and claustrophobia generated by such scenes contrasts dramatically with an open-air nude subject like *Striding into the Sea* (Plate XIV) painted during Kirchner's summer visit to Fehmarn in 1912. In that canvas the sculptural elegance and sensuality of the two principal figures—the woman was modelled by Erna Schilling, Kirchner's common law wife—combined with a softer, more subtle range of colours, demonstrated a desperate need to believe in the healing power of nature as an antidote to the 'chaos of the age'.

Following Pechstein's dismissal from the *Brücke*, Kirchner felt it was of paramount importance to protect the group from further acrimony by producing irrefutable evidence of its continuing unity. It was decided therefore that instead of publishing an annual portfolio as they had been doing since 1906, they would issue an illustrated chronicle describing the group's history from its foundation to the present day.

In order to affirm the group's cohesion, each member contributed original lithographs and woodcuts. Six woodcut illustrations, two each by Kirchner, Heckel and Schmidt-Rottluff, the three remaining founder members, were to accompany the main body of text in which Kirchner gave his account of the group's history.

Kirchner's unusual presentation of the facts, however, failed to meet with the approval of his colleagues. In particular they strongly objected to the suggestion it gave that their activities had been programmatically worked out.

'His text did not correspond to the facts as seen by Schmidt-Rottluff, Mueller and myself', Heckel explained many years later, 'and was opposed to our rejection of programmes in general. So we decided not to publish the Chronicle. Each artist received his prints and part of the text. Later, Kirchner cut the title page with the four portraits [i.e. of Kirchner, Heckel, Schmidt-Rottluff and Mueller, see Plate 61] and brought out a few copies in Switzerland'.

Kirchner's zealous devotion to the original concept of the *Brücke* as an artistic partnership failed to prolong its spent life force. Unable to resolve their differences of opinion, which the disagreement over the *Chronicle* had merely served to bring to a head, it was

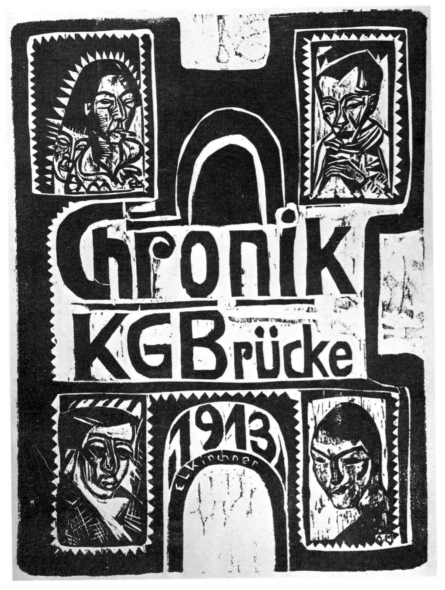

61 Ernst Ludwig KIRCHNER
Chronicle of the Brücke Group of Artists, title
HANNOVER, Kestner-Museum. 1913. Woodcut
45.7 × 33.2 cm. (Dube H 710).

decided to disband. In May 1913 the affiliated members of the *Brücke* each received printed
cards informing them that the group had been dissolved by mutual consent of all concerned.

Released from their former duties to the group, the *Brücke* artists wasted no time in
utilizing their new found freedom to launch out on their own course. In October 1913
Kirchner's first one-man exhibition opened at the Folkwang Museum in Hagen. During the
winter months of 1913 and 1914 Fritz Gurlitt arranged one-man shows for each *Brücke* artist
in turn at his Berlin gallery, whilst Heckel shared a joint exhibition venue with Vlaminck at
the Galerie Neumann in Berlin, also in 1913. Another exhibition devoted entirely to
Kirchner's work was held at the Kunstverein in Jena from February to March 1914.

Yet they still seemed almost reluctant to break completely with the co-operative pattern
which had bound them so closely together for the past eight years. After exhibiting at the
Berlin Secession summer show in 1913, in April 1914 they all joined the recently established
Freie Sezession (Free Secession). Earlier that year Kirchner and Heckel had accepted

2 Ernst Ludwig KIRCHNER
treet Scene
LDAFING, Lothar-Günther Buchheim collection. 1914.
rush 51.5 × 38.6 cm. Signed and dated: *E L Kirchner 13*.
a few rapidly executed lines of the brush Kirchner has
vidly suggested the bustling, disorganized movement of
eople along a crowded city pavement. At the same time,
e radically compressed sense of space and the slashing
rokes communicate a tremendous degree of nervous
nsion and unease in the artist.

commissions to produce decorative schemes for the *Werkbund* exhibition in Cologne. Without the protective support of their combined efforts a professional void was created in their lives from which, it might be argued, they never wholly recovered. For Kirchner in particular his war-time period of service, beginning as an 'involuntary volunteer' in training for an artillery regiment at Halle from 1915 to 1916, precipitated a complete mental and physical breakdown. Thanks to Hans Fehr, his commanding officer and a former non-professional member of the *Brücke*, Kirchner was released from his military duties, and entered the Kohnstamm Sanatorium at Königstein. In 1917 he left Germany and moved to the Binswanger Sanatorium at Kreuzlingen in Switzerland, where he was still living when he received his official discharge a year later. From late 1918 until 1923 Kirchner made his permanent home in an alpine mountain cabin, 'Die Lärchen' at Längmatte on the Wildboden above the village of Frauenkirch near Davos.

Heckel, who had been declared unfit for military service, served as a medical orderly in Flanders from 1915 until armistice day on 11 November 1918. Walter Kaesbach, his commanding officer and an art connoisseur of some distinction, arranged Heckel's duties to allow him to continue his painting. Schmidt-Rottluff saw active service at the eastern front in Russia, and afterwards sought to cauterize his experiences by making woodcuts and

woodcarvings with specifically religious themes. In 1919 he was appointed president of the Berlin Secession, only nine years after the *Brücke* had disassociated itself from that august body in order to support Pechstein's New Secession. In the same year Mueller accepted a teaching post at Breslau Academy (Plate 63).

For many years Kirchner maintained a proud and reserved silence in his mountain retreat. In 1926 he declined to take part in a *Brücke* exhibition organized by J. B. Neumann and Karl Nierendorf in Berlin. By that time he could afford to pick and choose his own exhibitions, as he demonstrated in the winter of that year by holding three one-man shows, at Paul Cassirer's in Berlin, at the Kunstsalon Fides in Dresden, and at a local gallery in Davos. In Berlin he met Schmidt-Rottluff and Mueller again for the first time in almost a decade.

On his return to Switzerland Kirchner painted from memory a definitive group portrait of the *Brücke* in which he documented with unflinching honesty and integrity the final dramatic confrontation between himself, Heckel, Schmidt-Rottluff and Mueller over the offending *Chronicle* he had written in 1913. (Plate 64). In the portrait the three original founder members tower monumentally above the hunched, seated figure of Mueller who appears to be quite detached from, and unmoved by, the drama raging above his head. Kirchner has represented himself half-hidden by a hanging fabric, the text of the *Chronicle* in his hand, towards which he gesticulates with the other as if in defence of his work. Heckel's face is averted however, and the eloquent appeal of his friend rejected, whilst Schmidt-Rottluff stares impassively into space, his tall figure blocking off the right hand side of the composition, forming a wall of resistance to Kirchner's grim-faced tenacity.

Each artist had, in his own way, been fanatically devoted to the group cause. Their toughness of moral and artistic fibre in their united struggle against the apathetic philistinism of the middle-classes and their desire to create a new world for themselves, based on a commitment to both art and life, and the spirit of communal living, had served them well for eight years.

'There is no living art without emotion, only craft', Kirchner wrote in 1927. The art of *Die Brücke* looked at life with a passionate intensity, sometimes with an almost unbearable degree of emotionalism, in an effort to pinpoint that exact moment when personal meaning cut through all the inessentials to reveal life in its most fundamental, characteristic form. 'They seem to us now to have been dancing on a volcano whose eruptions were anticipated in violent rhythms and inner excitement', Jakob Rosenberg the art historian wrote in 1948. 'Burdened with such a fateful mission, their art excites rather than gives comfort'. In June 1938, stricken by the National Socialists' condemnation and confiscation of his life's work, and the realization that Europe was soon to be plunged into another holocaust, Kirchner shot himself. Forty years had passed since that all-important school trip to Nuremberg had first awakened in him 'the entirely naive and unadulterated need to bring art and life into harmony' again. In over a thousand paintings, in prints, drawings, watercolours, in hand-carved furniture and wood sculpture, in batiks and book-illustrations he had striven to turn his dream into a reality, but it was perhaps during the years between 1905 and 1913 when the *Brücke* artists were portraying the turbulent and feverish spirit of the age with such unflinching resolution and accuracy that Kirchner saw his purpose most fully expressed and realized.

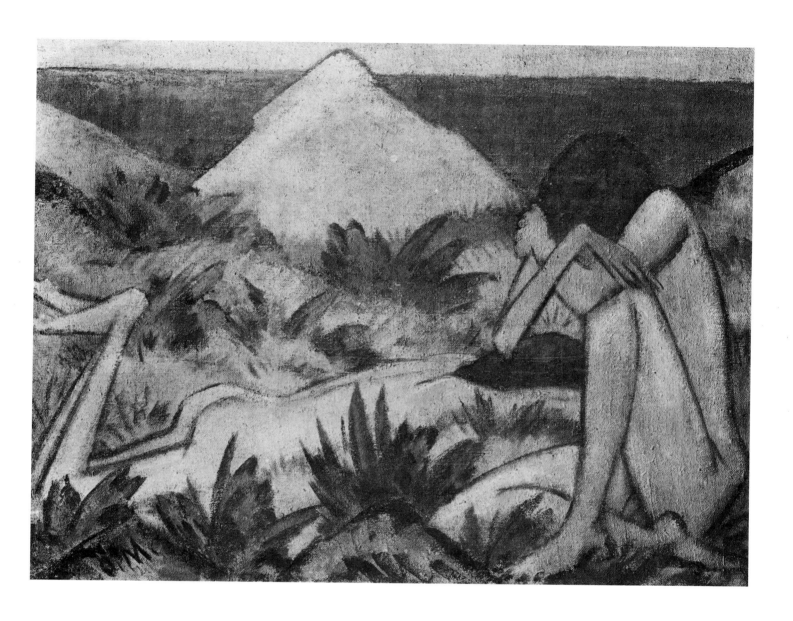

63 Otto MUELLER

Nudes among the Dunes HAMBURG, Kunsthalle. *c.*1919. Distemper 100 × 130 cm. Signed: *O.M.*
Apart from an increased angularity in the impassively languid forms of his nude bathers, and a more
resolved treatment of their landscape setting, Mueller's post-war paintings retained very much the same
air of muted, melancholy primitivism that had first attracted the attention of the *Brücke* artists to his
work at the New Secession in 1910. Mueller's self-sufficient world of sensual fantasy survived the harsh
realities of social change and political upheaval ushered in by the war, and after two years on active
service from 1916–18, Mueller resumed his way of life as before, re-working old themes and revisiting
his old haunts.

64 Ernst Ludwig KIRCHNER
A Group of Artists COLOGNE, Wallraf-Richartz-Museum. 1926. Oil 168 × 126 cm. Signed and dated on verso: *E L Kirchner 25*. (Gordon 855).

THE BRÜCKE ANNUAL PORTFOLIOS

In 1906 the *Brücke* artists decided to enlarge their group by recruiting members who were not themselves artists but who were enthusiastic about their work and willing to support them. In return for an annual subscription of twelve marks, later raised to twenty-five marks, these non-active members, of whom there were sixty-eight in 1910, received a membership card in the form of an original print, an annual report which sometimes was also illustrated and a portfolio containing three or four original prints. The latter are the now famous and very rare *Jahresmappen* which were distributed at the beginning of each year. The first three portfolios were unpretentiously produced without any protective wrapper and each contained the work of different artists. The four portfolios produced from 1909 to 1912 were more elaborate, having a title page and containing more prints. Each one was devoted to the work of an individual *Brücke* artist, for which the cover was designed by one of his colleagues. The portfolio for 1912, which was devoted to Pechstein's work, was printed but never distributed to the non-professional members. In 1913 the *Brücke* planned to publish a chronicle with an illustrated text relating the group's history. Because of the disagreement over Kirchner's presentation of the facts, the chronicle was never officially published, although a few limited copies, each slightly different from one another, were assembled by Kirchner in Switzerland and distributed privately.

Portfolio 1906

Fritz BLEYL
House with Steps
1905. Woodcut 22.5 × 17.5 cm.
(Bolliger-Kornfeld 3)

Erich HECKEL
The Sisters
1905. Woodcut 19 × 14 cm.
(Dube H 78; Bolliger-Kornfeld 4)

Ernst Ludwig KIRCHNER
Crouching Nude seen from the Back
1905. Woodcut 13 × 10 cm.
(Schiefler 120; Dube H 52; Bolliger-Kornfeld 5)

Portfolio 1907

Cuno AMIET
Giovanni Giacometti Reading
1907. Woodcut 29 × 25 cm.
(Mandach 25; Bolliger-Kornfeld 6)

Akseli GALLEN-KALLELA
Girl and Death in the Forest
1895. Woodcut 16.5 × 11.7 cm.
(Bolliger-Kornfeld 7)

Emil NOLDE
Female Nude
1906. Etching 19.4 × 14.8 cm.
(Schiefler-Mosel R 34/11; Bolliger-Kornfeld 8)

Karl SCHMIDT-ROTTLUFF
Holbeinplatz in Dresden
1906. Lithograph 22 × 36 cm.
(Schapire S 8; Bolliger-Kornfeld 9)

Portfolio 1908

Erich HECKEL
Sailing-ship in Rough Sea
1907. Woodcut 16.2 × 22.3 cm.
(Dube H 143 1B; Bolliger-Kornfeld 10)

Ernst Ludwig KIRCHNER
Still Life with Flowers and Jug
1907. Colour woodcut in yellow, green
and red 20.2 × 17 cm.
(Schiefler 43b; Dube H 112;
Bolliger-Kornfeld 11)

Max PECHSTEIN
Our Lady
1908. Woodcut 23 × 12.5 cm.
(Fechter H 33; Bolliger-Kornfeld 12)

Portfolio 1909
Karl Schmidt-Rottluff

Ernst Ludwig KIRCHNER
Portrait of Karl Schmidt-Rottluff
1909. Title woodcut in red on white paper
40 × 30 cm.
(Dube H 706; Bolliger-Kornfeld 13)

Karl SCHMIDT-ROTTLUFF
Portrait of Erich Heckel
1909. Lithograph 39.5 × 32.5 cm.
(Schapire S 56; Bolliger-Kornfeld 14)

Houses in Old Dresden
1908. Etching 13.6 × 18.5 cm.
(Schapire R 9; Bolliger-Kornfeld 16)

Berlinerstrasse in Dresden
1909. Lithograph 40 × 34 cm.
(Schapire S 57; Bolliger-Kornfeld 15)

Portfolio 1910
Ernst Ludwig Kirchner

Erich HECKEL
Kneeling Couple
1910. Title woodcut 30 × 40.2 cm.
(Dube H 181; Bolliger-Kornfeld 17)

Ernst Ludwig KIRCHNER
Bathers Among the Reeds
1910. Colour woodcut in black, red and
green 20 × 29 cm.
(Schiefler 121; Dube H 160;
Bolliger-Kornfeld 18)

Dancer with Skirt Raised
1910. Woodcut 25 × 34 cm.
(Schiefler 126b; Dube H 141 11;
Bolliger-Kornfeld 19)

Three Bathers in the Moritzburg Lake
1909. Etching 18 × 20.5 cm.
(Schiefler 52; Dube R 69;
Bolliger-Kornfeld 20)

Portfolio 1911
Erich Heckel

Max PECHSTEIN
Kneeling Nude Woman with Fruit-Bowl
1911. Title woodcut in black on blue
paper 38 × 30.5 cm.
(Not in Fechter; Bolliger-Kornfeld 21)

Erich HECKEL
Child Standing
1910. Colour woodcut in black, green
and red 37.5 × 27.5 cm.
(Dube H 204b2; Bolliger-Kornfeld 22)

Woodland Scene
1910. Lithograph 27.5 × 34 cm.
(Dube L 153; Bolliger-Kornfeld 23)

Street with Houses, Trees and Pedestrians
1910. Etching 17.2 × 20.1 cm.
(Dube R 91; Bolliger-Kornfeld 24)

Portfolio 1912
Max Pechstein

Otto MUELLER
Nude Seated in a Meadow
1912. Title woodcut in gold on black paper
38 × 30.5 cm.
(Karsch H 5; Bolliger-Kornfeld 25)

Max PECHSTEIN
Russian Ballet I
1912. Etching 30 × 25 cm.
(Fechter R 65; Bolliger-Kornfeld 26)

Nude Women Dancing by a Wooded Lake
1912. Lithograph with blue and green
watercolour 43.5 × 33 cm.
(Not in Fechter; Bolliger-Kornfeld 27)

Head of a Fisherman VII
1911. Woodcut 29.5 × 24.5 cm.
(Fechter H 79; Bolliger-Kornfeld 28)

BRÜCKE EXHIBITIONS 1906–1913

1906

October: Dresden; Löbtau, Seifert Lamp Factory.
December-January 1907: Dresden; Löbtau, Seifert Lamp Factory (graphic art only).

1907

February-November: Travelling exhibition of graphic art to Bonn, Kunstsalon Cohen; Göttingen, Kunstsalon Werner; Königsberg; Hagen, Folkwang Museum; Solothurn, Museum; Freiburg in Breisgau, Kunstverein.
July-August: Travelling exhibition of graphic art to Flensburg, Museum; Hamburg, Galerie Clematis; Magdeburg.
September: Dresden, Kunstsalon Emil Richter.

1908

January onwards: Travelling exhibition of graphic art to Kiel; Copenhagen; Christiania; Rostock; Nuremberg.
May-June: Travelling exhibition of graphic art to Karlsruhe; Krefeld, Museum; Gotha, Kunstverein; Erfurt; Dortmund.
September: Dresden, Kunstsalon Emil Richter.
November: Berlin, Secession (graphic art only).
Undated: Travelling exhibition of graphic art to Dresden, Kunstsalon Emil Richter; Zittau.

1909

June: Dresden, Kunstsalon Emil Richter.
July-September: Travelling exhibition of graphic art to Altenburg in Thüringia, Lindenau Museum; Dresden, Kunstsalon Emil Richter; Braunschweig.
Undated: Travelling exhibition of graphic art to Frankfurt-on-the-Oder; Gera; Dessau; Speyer; Frankfurt-on-Main; Aachen.

1910

May-June: Berlin, Galerie Maximilian Macht, 'Salon der Refusierten' (New Secession).
16 July-9 October: Düsseldorf, Kunstpalast, 'Association of West German Artists and Guests'.
September: Dresden, Galerie Ernst Arnold.
October-November: Berlin, Galerie Maximilian Macht, second New Secession exhibition (graphic art only).
October: Travelling exhibition of graphic art to Dresden, Galerie Ernst Arnold; Weimar, Grossherzogliches Museum.
Undated: Travelling exhibition of graphic art to Danzig; Schwerin; Lübeck; Düren; Hagen, Folkwang Museum; Mönchengladbach.

1911

January-October: Travelling exhibition of graphic art to Leipzig, Galerie Del Vecchio; Jena; Hannover; Frankfurt-on-Main, Galerie Bangel; Düren; Düsseldorf, Galerie Tietz.
February-March: Berlin, Galerie Maximilian Macht, third New Secession exhibition.
18 November-1 January 1912: Berlin, Potsdammer Strasse 122, fourth New Secession exhibition (graphic art only).

1912

12 February-April: Munich, Galerie Hans Goltz, second *Der Blaue Reiter* exhibition.
April: Berlin, Galerie Fritz Gurlitt.
25 May-30 September: Cologne, Kunsthalle, *Sonderbund* exhibition.
June onwards: Travelling exhibition of graphic art to Frankfurt-on-Main, Galerie Bangel; Prague; Chemnitz.
August-September: Hamburg, Galerie Commeter.

1913

January: Munich, Neuer Kunstsalon.
Undated: Berlin, Galerie Hugo Moses (graphic art only).

CHRONIK DER KÜNSTLERGEMEINSCHAFT BRÜCKE (CHRONICLE OF THE BRÜCKE ARTISTS' GROUP)

by Ernst Ludwig Kirchner, 1913.

In 1902 the painters Bleyl and Kirchner met in Dresden. Heckel was introduced to them by his brother, who was a friend of Kirchner. Heckel brought along Schmidt-Rottluff whom he had known in Chemnitz. They got together to work in Kirchner's studio. There was nothing here to hinder them from studying the nude—the foundation of all visual art—in all its freedom and artlessness. They all shared the same feelings about using life to inspire their creativity and they submitted themselves wholeheartedly to the experience of creating in this atmosphere of freedom. Each of the artists contributed their own drawings and writings to the notebook *Odi profanum*; by doing this they could compare the originality of one set of ideas against another. This led quite spontaneously to their forming a group which was given the name *Die Brücke*. Each member of the group provided inspiration for the rest. Kirchner brought the woodcut technique from south Germany in which he had shown a renewed interest after seeing the old woodcuts in Nuremberg. Heckel once again carved wooden figures; Kirchner incorporated this technique into his own field by colouring them and sought the rhythm of the solid form in stone and cast pewter. Schmidt-Rottluff printed the first lithographs from stone. The group's first exhibition was held in their own rooms in Dresden; it met with no approval. However, Dresden's scenic charm and old culture was a great source of inspiration. Here, too, *Die Brücke* found its first links with the art of the past in Cranach, Beham and other medieval German masters. After an exhibition by Amiet he was invited to become a member of *Die Brücke*. He was followed in 1905 by Nolde. His visionary originality introduced a new character to *Die Brücke*; his interesting etching technique enriched our exhibitions and he, in turn, became acquainted with our woodcut technique. At Nolde's invitation Schmidt-Rottluff went to Alsen. Later Schmidt-Rottluff and Heckel went to Dangast. The harsh North Sea air produced a monumental impressionism, especially in Schmidt-Rottluff. During this time Kirchner continued to work on his sculpture in Dresden. In the Ethnographic Museum he found a parallel to his own creations in the African sculptures and the woodcarvings of the Pacific Ocean. Pechstein's endeavour to break free from academic sterility led him to *Die Brücke*. Kirchner and Pechstein went to Gollverode in order to work together. The exhibition of *Die Brücke* with its new members was held in the Salon Richter in Dresden. The exhibition made a great impression on the young artists of Dresden. Heckel and Kirchner tried to make the decor of the gallery complement the new painting. Kirchner furnished the rooms with murals and batiks, to which Heckel contributed. In 1907 Nolde withdrew from *Die Brücke*. Heckel and Kirchner went to the Moritzburg lakes to study the nude in landscape. In Dangast Schmidt-Rottluff worked to perfect his use of colour. Heckel went to Italy and returned to tell of the exciting qualities of Etruscan art. Pechstein went to Berlin to work on commissions for decorative painting. He attempted to get the new painting accepted by the Secession. In Dresden Kirchner discovered lithographic hand printing. In 1909 Bleyl, who had turned to teaching, left *Die Brücke*. Pechstein followed Heckel to Dangast. In the same year they joined Kirchner in Moritzburg to paint nudes by the lakeside. In 1910 the rejection of the young German artists by the old Secession gave rise to the formation of the 'New Secession'. In order to support Pechstein in the New Secession, Heckel, Kirchner and Schmidt-Rottluff also became members. At the first exhibition of the New Secession they got to know Mueller. In his studio they rediscovered Cranach's *Venus* by which they had always set great store themselves. The perceptible harmony between his life and his work made Mueller an obvious choice for *Die Brücke*. He introduced us to the charms of tempera. To safeguard the aspirations of the movement, the members of *Die Brücke* withdrew from the New Secession. They made a mutual promise only to exhibit jointly in the Berlin Secession. There followed an exhibition by *Die Brücke* which occupied all the rooms of the Kunstsalon Gurlitt. Pechstein

betrayed the trust of the group, became a member of the Secession and was expelled from *Die Brücke*. In 1912 the *Sonderbund* invited *Die Brücke* to its Cologne exhibition and assigned the painting of the chapel there to Heckel and Kirchner. The majority of the *Brücke* members are now in Berlin. Even here the group has maintained its identity. Its spiritual unity radiates the new values of artistic creation throughout contemporary German art. Uninfluenced by present trends such as Cubism, Futurism, etc., it is fighting for a humanitarian culture, which is the basis of true art. *Die Brücke* is indebted to these endeavours for its present position in the art world.

DIE BRÜCKE BIBLIOGRAPHY

GENERAL

Der Blaue Reiter Almanac (eds. Wassily Kandinsky and Franz Marc). Documentary edition by Klaus Lankheit, London, 1974.

Bleyl, Fritz, *Erinnerungen*, 1948, quoted in Hans Wentzel's *Bildisse Brücke-Künstler voneinander*. Stuttgart, 1961.

Bolliger, Hans and **Kornfeld,** E. W. *Ausstellung Künstlergruppe Brücke, Jahresmappen*, 1906–1912. Bern, 1958.

Buchheim, Lothar-Günther, *The Graphic Art of German Expressionism*. New York, 1960.

Buchheim, Lothar-Günther, *Die Künstlergruppe "Brücke" und der deutsche Expressionismus*. 2 vols. Munich, 1973.

Corinth, Lovis, *Selbstbiographie*. Leipzig, 1926.

Fechter, Paul. *Der Expressionismus*. Munich, 1914.

Gay, Peter, *Weimar Culture*. London, 1969.

Gogh, Vincent van, *The Complete Letters*. 3 vols. New York, 1958.

Goldwater, Robert, *Primitivism in Modern Painting*. New York, 1938.

Kuhn, Walt, *The Story of the Armory Show*. New York, 1938.

Matisse, Henri, 'Notes d'un peintre', first published in *La Grande Revue*, 25 December 1908. 'Notizen eines Malers', German translation by Greta Moll in *Kunst und Künstler*, VII May 1909. English translation by Margaret Scolari in *Henri Matisse*, Museum of Modern Art, New York, 1931.

Myers, Bernard S., *The German Expressionists*. New York, 1957; British edition, *Expressionism*. London, 1957.

Roethel, Hans Konrad, *Modern German Painting*. London, 1958.

Selz, Peter, *German Expressionist Painting*. Berkeley, Los Angeles and London, 1957.

Thoene, Peter (pseud.), *Modern German Art*. London, 1938.

Whitford, Frank, *Expressionism*. London, 1970.

Weitek, Gerd, *Maler der Brücke. Farbige Kartengrüsse an Rosa Schapire von Erich Heckel, Ernst Ludwig Kirchner, Max Pechstein, Karl Schmidt-Rottluff*. Wiesbaden, 1958.

MONOGRAPHS

Barr, Alfred H., Jr., *Henri Matisse. His Art and his Public.* New York, 1951; London, 1975.

Painters of the Brücke, Arts Council of Great Britain, Tate Gallery, London, exhibition catalogue, 1964.

Brücke, Kestner Gesellschaft, Hannover, exhibition catalogue, 1953.

Buchheim, Lothar-Günther, *Otto Mueller. Leben und Werk.* Feldafing, 1963. Includes the catalogue raisonné of the graphic work compiled by Florian Karsch.

Deknatel, Frederick, B., *Edvard Munch.* New York and London, 1950.

Dube, Annemarie and Wolf-Dieter, *Erich Heckel. Das graphische Werk.* 2 vols. New York, 1964–65.

Dube, Annemarie and Wolf-Dieter, *E. L. Kirchner. Das graphische Werk.* 2 vols. Stuttgart, 1967.

Dube-Heynig, Annemarie, *E. L. Kirchner. Graphik.* Munich, 1961.

Faille, J. B. de la, *L'oeuvre de Vincent van Gogh.* Paris and Brussels, 1928.

Fechter, Paul, *Das graphische Werk Max Pechsteins.* Berlin, 1921.

Fehr, Hans, *Erinnerungen und Ernst Ludwig Kirchner.* Bern. 1955.

Fehr, Hans, *Nolde.* Cologne, 1957.

German Expressionism. Watercolours, Prints and Drawings by the Painters of the Brücke. Art Council of Great Britain, London, exhibition catalogue, 1969.

Gordon, Donald E., 'Kirchner in Dresden', *The Art Bulletin,* vol. XLVIII 3–4, 1966.

Gordon, Donald E., *Ernst Ludwig Kirchner.* Cambridge, Massachusetts, 1968. Includes the catalogue raisonné of the paintings.

Grohmann, Will, *Karl Schmidt-Rottluff.* Stuttgart, 1956.

Grohmann, Will, *E. L. Kirchner.* New York, 1961.

Erich Heckel. Altonaer Museum, Hamburg, exhibition catalogue, 1973.

Die Arbeit E. L. Kirchners. Bern, exhibition catalogue, 1954–55.

Nolde, Emil, *Jahre der Kämpfe.* Berlin, 1934.

Emil Nolde. *Aquarelle und Handzeichnungen.* Nolde-Stiftung, Seebüll, exhibition catalogue, 1971.

Roters, Eberhard, 'Beiträge zur Geschichte der Künstlergruppe Brücke 1905–07', *Jahrbuch der Berliner Museen.* Vol. 2, 1960.

Schapire, Rosa, *Karl Schmidt-Rottluffs graphisches Werk bis 1923.* Berlin, 1924.

Schiefler, Gustav, *Verzeichnis des graphischen Werks Edvard Munch bis 1906.* Berlin, 1907.

Schiefler, Gustav, *Emil Nolde. Das Graphische Werk.* 2 vols. Berlin 1911–27. Republished (ed. C. Mosel), Cologne, 1966–67.

Schiefler, Gustav, *Die Graphik Ernst Ludwig Kirchners.* 2 vols. Berlin, 1927–31.

Schiefler, Gustav, *Edvard Munch. Das graphische Werk 1906–1926.* Berlin, 1928.

Schmidt-Rottluff. Altonaer Museum, Hamburg, exhibition catalogue, 1974.

Selz, Peter, *Emil Nolde.* New York, 1963.

Vogt, Paul, *Erich Heckel.* Recklinghausen, 1965.

THE COLOUR PLATES

I Karl SCHMIDT-ROTTLUFF

Self-Portrait

SEEBÜLL, Nolde-Stitftung. 1906. Oil on cardboard 44 × 32 cm. Signed, dated and inscribed: *Schmidt-Rottluff 1906: Ada und Emil Nolden.* (Grohmann p. 281).

Schmidt-Rottluff was deeply affected by the impact of van Gogh's art, as this intensely brooding self-portrait shows. At the same time the obsessive agitation and self-conscious vehemence of the thick impasto brushstrokes was partly the result of his period of close working contact with Nolde on the island of Alsen in the summer of 1906. Schmidt-Rottluff's reserved yet aggressive character breaks free in the galvanic dynamism of the brushwork which threatens to overwhelm the subject in restless, complex movement.

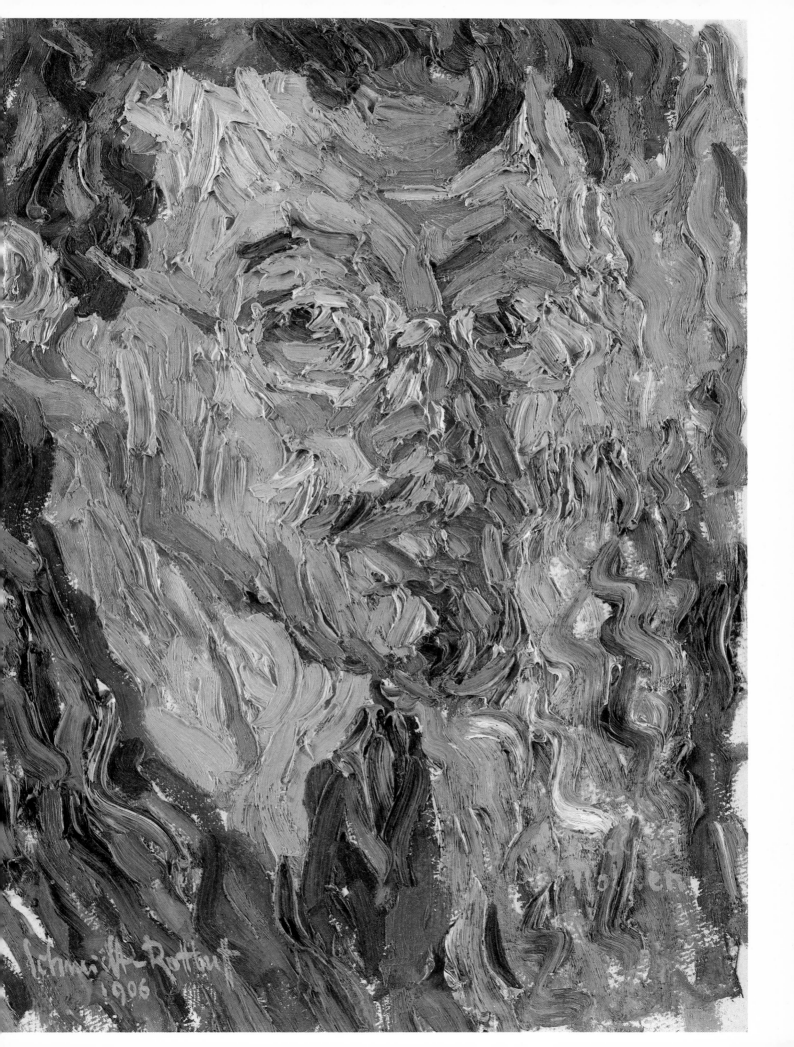

II Emil NOLDE

Portrait of Rosa Schapire

SEEBÜLL, Nolde-Stiftung. 1907. Watercolour 49 × 36 cm. Signed and dated: *Nolde 07.*

The compulsive need for spontaneity in his work made watercolour the perfect creative medium for Nolde's direct, instinctive approach. His fluid and radiant watercolour technique is one of the peaks of expressionist achievement. The importance of being able to maintain what he described as the 'pure sensual force of seeing' until the working process was completed was well-served by the immediacy of effect made possible by the watercolour's free-flowing properties. As in all his work this portrait is an expression of the artist's inner compulsion to grasp what lies at the very heart of his subject, rather than a rational attempt at objective description. Nolde was first introduced to Rosa Schapire by Martha Rauert, a Hamburg collector, in 1907. Although her friendship with Nolde subsequently broke down as a result of his abrupt departure from the group, it was initially through him that Rosa Schapire met and became an enthusiastic life-long supporter and friend of the *Brücke*. She was the first professional art historian to become an affiliated group member and, in addition to receiving the yearly portfolio, she was one of the most important recipients of the hand-illustrated postcards sent by Kirchner, Heckel, Schmidt-Rottluff and Pechstein. Her friendship with Schmidt-Rottluff was extremely close and lasted until her death in London in 1954. She frequently visited his summer home at Dangast and in 1924 published a catalogue, definitive at that time, of his graphic work. Her Hamburg flat was decorated throughout with furniture and fittings designed by Schmidt-Rottluff. In 1953 she was instrumental in setting up the first British one-man exhibition of his work at the Museum and Art Gallery in Leicester.

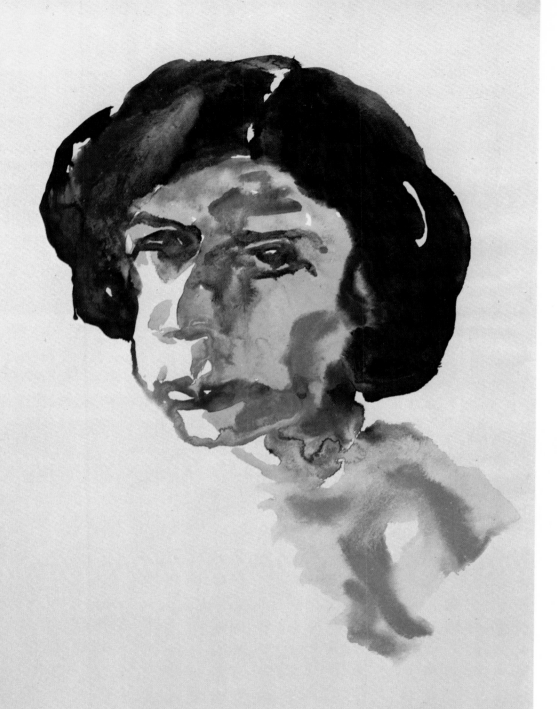

Nolde. 67.

III Karl SCHMIDT-ROTTLUFF

Windy Day

HAMBURG, Private Collection. 1907. Oil 71 × 91 cm. Signed and dated: *Schmidt-Rottluff 1907*. (Grohmann p. 281).

Schmidt-Rottluff's early period of 'monumental Impressionism' is dominated by this violently lyrical open-air landscape painting from his first summer visit to Oldenburg. Still largely indebted to van Gogh, the young German artist nevertheless succeeded in creating a highly subjective reinterpretation of his original model, the strong colours and dynamic strokes of paint producing an agitated sense of movement that overwhelms any formal distinction between the individual landscape forms. During their stay in Oldenburg Schmidt-Rottluff and Heckel took the precaution of joining both the North-West German Artists' Association and the Oldenburg Artists' Group, compelled no doubt by the failure of the first two *Brücke* exhibitions to look for more reliable venues for showing their work.

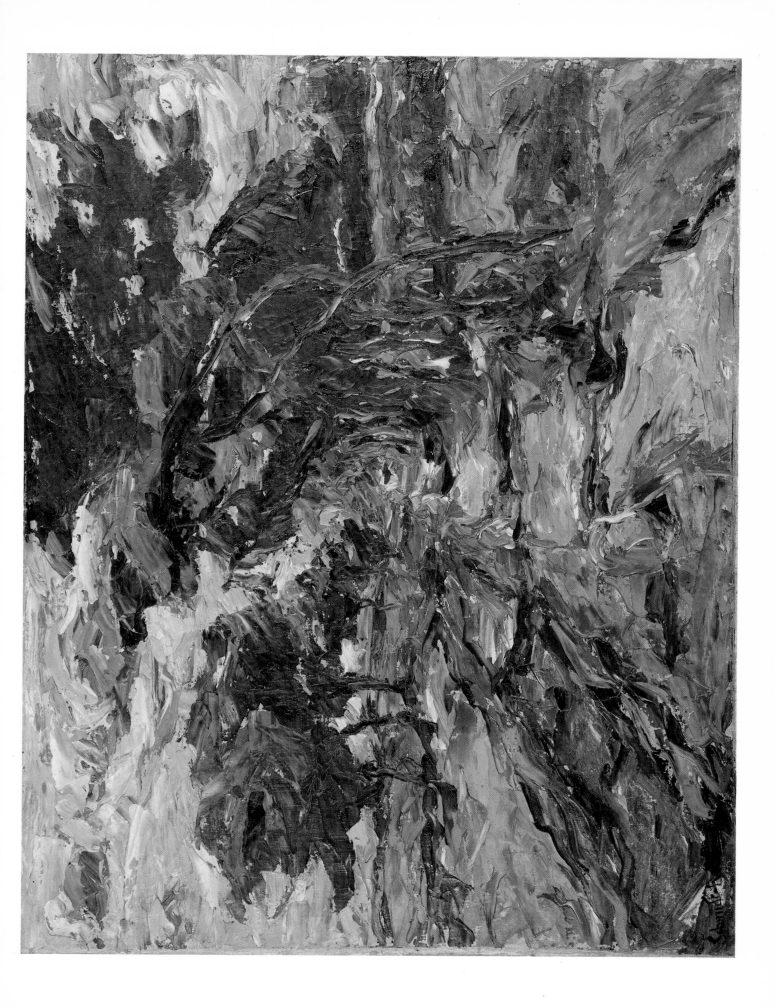

IV Ernst Ludwig KIRCHNER

Street

NEW YORK, Museum of Modern Art. 1908. Oil 150 × 200.4 cm. Signed and dated (later): *E. L. Kirchner 07*. (Gordon 53).

Kirchner's first major pictorial statement on the psychological pressures and spiritual enervation of contemporary urban life was this big city street scene, which he painted during the last few months of 1908 after his return from Fehmarn. This composition bears unmistakable affinities to Munch's quintessential embodiment of alienation in *Spring Evening on Karl-Johan Street* (Bergen, Rasmus Meyer Collection), and possibly to Toulouse-Lautrec's *Jane Avril leaving the Moulin Rouge* (Hartford, Wadsworth Atheneum), both painted in 1892. Kirchner's exaggeratedly flattened, distorted perspective and asymmetrical displacement of the crowded figures, combined with a peculiarly disquieting choice of colours—the large, empty area of pink pavement is noteworthy for its expressive shock value—forced such precedents to far greater extremes of subjective intensity in response to his own experience of the turbulent disorder and isolation of modern life.

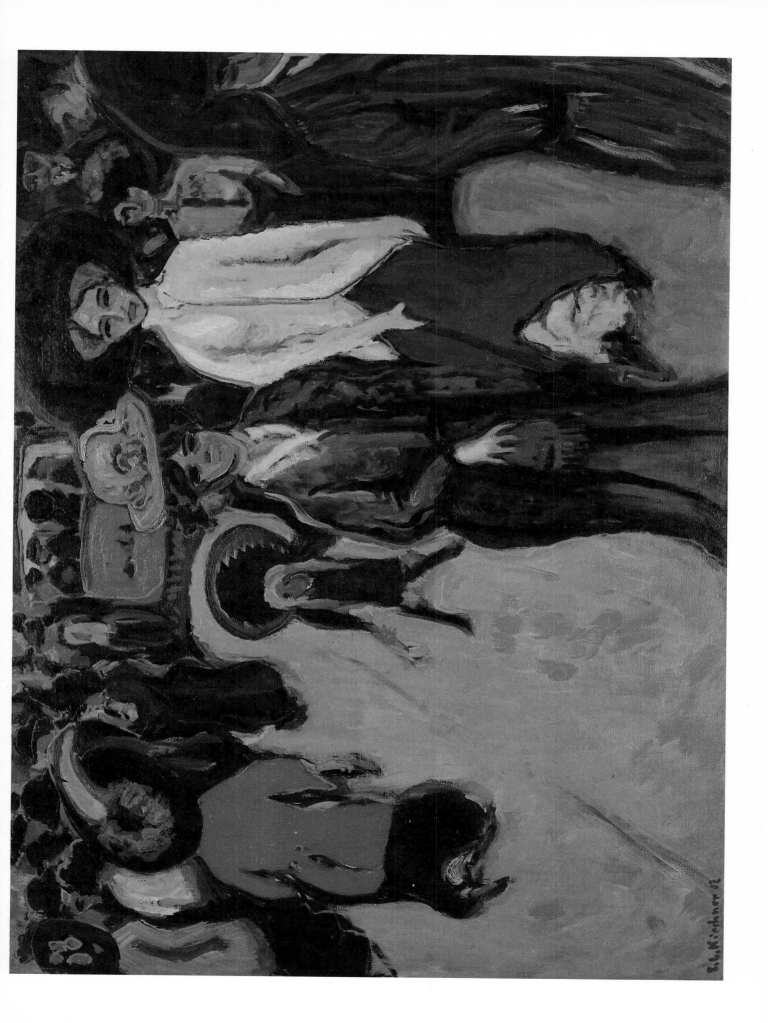

V Karl SCHMIDT-ROTTLUFF

Midday on the Moor

OLDENBURG, Landesmuseum für Kunst und Kulturgeschichte. 1908. Oil 69 × 81 cm. Signed and dated: *S. Rottluff 1908*. (Grohmann p. 282).

Between 1907 and 1908 the communal life of the studio in the Berlinerstrasse was gradually replaced by the pursuit of individual interests and the development of individual styles, and Schmidt-Rottluff was increasingly less active in Dresden. His summer visit to Dangast in 1908 lasted from May until October. Nevertheless he continued to keep abreast of the group's current experiments which at this stage saw the final flowering of their enthusiastic response to van Gogh, one hundred of whose paintings were shown at the Salon Richter in April 1908. Heightening and exaggerating his definition of the landscape elements with dynamic impasto brush strokes Schmidt-Rottluff stressed the most subjective aspects of van Gogh's late manner, creating a richly textured surface in which expressive intensity constantly threatens to destroy the definition of the subject.

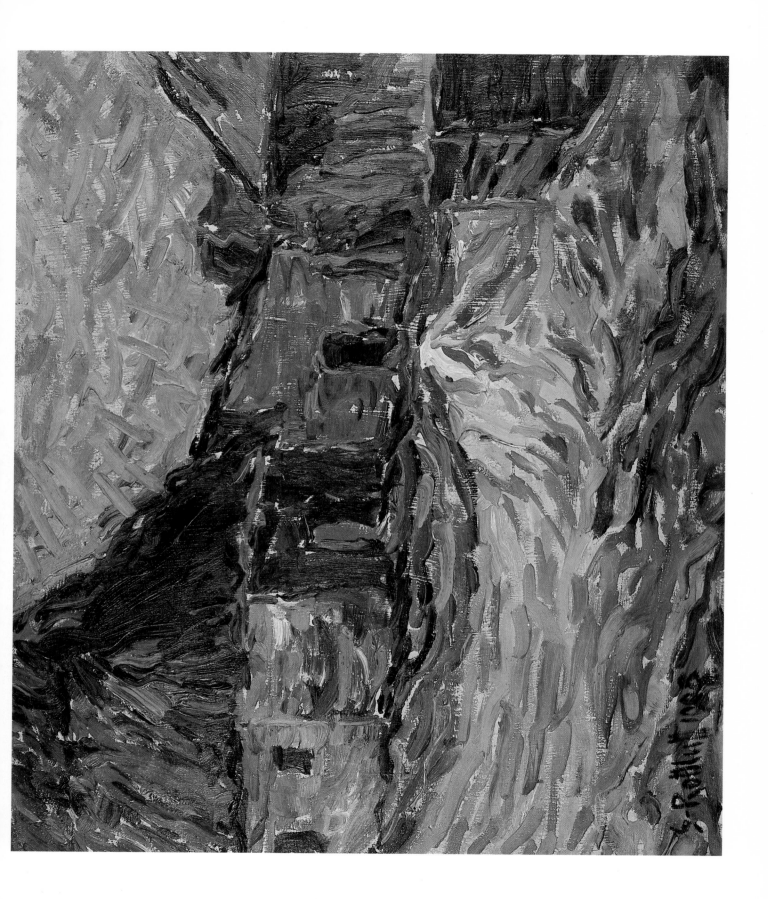

VI Ernst Ludwig KIRCHNER

Girl under a Japanese Umbrella

DÜSSELDORF, Kunstsammlung Nordrhein-Westfalen. 1909. Oil 92 × 80 cm. Signed and dated (later): *E L Kirchner 06*. (Gordon 57).

Probably painted soon after Kirchner had seen the exhibition of Matisse's paintings at Paul Cassirer's Berlin gallery between December 1908 and January 1909, this boldly sensuous portrait of his girl-friend Dodo has obvious parallels with the French artist's *Fauve* style in its radically flattened planes of splodgily applied luminous colour. However, Kirchner's own unique creative personality asserts itself in the aggressively distorted forms of the model's body, awkwardly squeezed into a tight, confined space, and in the violent excitability of the lurid colour patterns. Dodo's yellow, pink and blue flesh tones are deliberately set off against other, equally intense, chromatic devices—the high-key dynamics of the parasol, the heavy, dark blue outline of her hair and the shadows moulding her body—which thrust the girl towards the picture surface in an emphatically erotic manner. Kirchner signed and dated this painting more than a decade later when he was living in Switzerland.

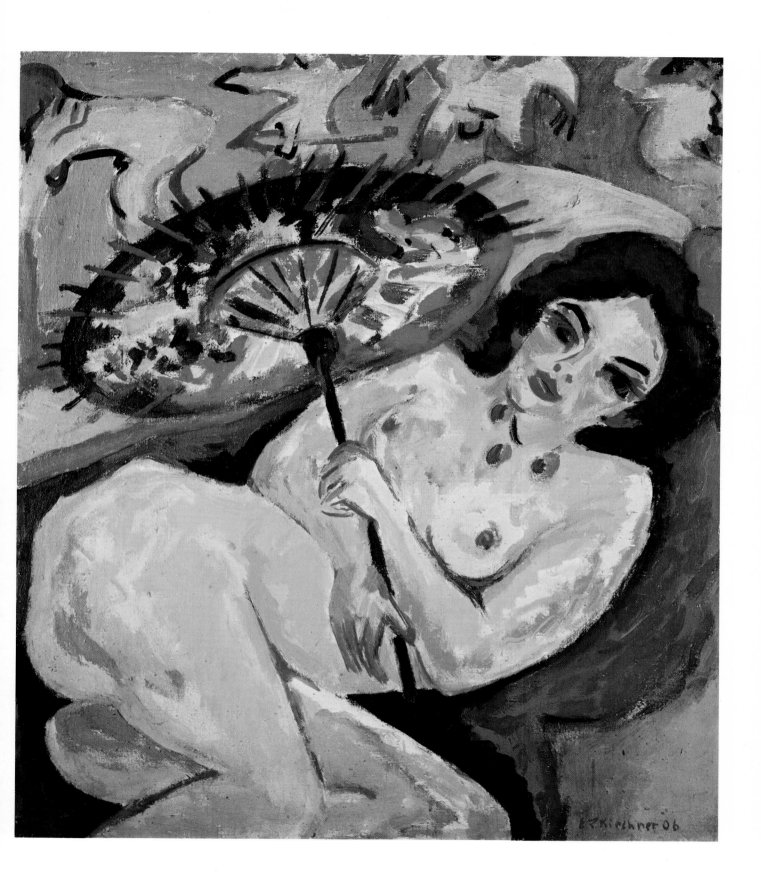

VII Max PECHSTEIN

Nidden Coast-line with Fishing Boats

LEICESTER, Leicestershire Museums and Art Galleries. 1909. Oil 51 × 51 cm. Initialled and dated: *HMP 09*.

After his success at the summer exhibition of the Berlin Secession in 1909, Pechstein—responding to the same need to escape from urban life as the other members of the group—made his first visit to Nidden, a small, remote fishing village situated on the long spit of land known as the Kurische Nehrung on the Baltic coast of East Prussia. There he painted the local fishermen, and their small coasting vessels and fishing boats. Pechstein's academic training is reflected in the greater formality and attention to detail which distinguishes this composition, like so much of his work, from the much looser, more exaggerated work of his colleagues. Like many of the *Fauves'* paintings, however, this Nidden seascape is not consistent in style. Natural local colours alternate with purely arbitrary tones. The result is colourful and decorative, and not at all disturbing, and is a perfect illustration of the reason why Pechstein found favour with the critics long before any of the other *Brücke* artists.

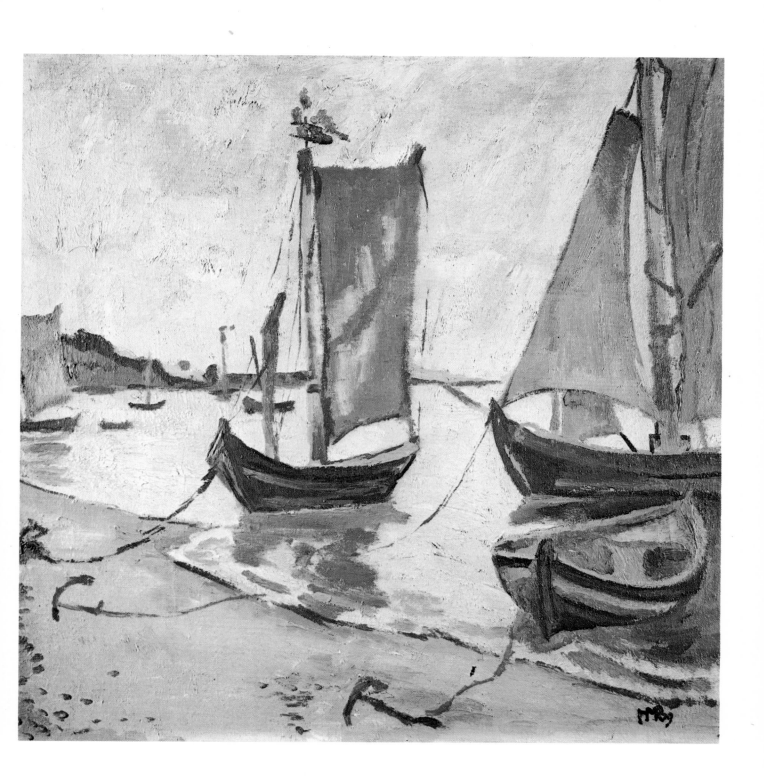

VIII Erich HECKEL

Girl on a Sofa

MUNICH, Staatsgalerie Moderner Kunst. 1909. Oil 96 × 120 cm. Signed and dated: *Heckel 1909*. (Vogt 1909/8).

Heckel visited northern Italy from the end of 1908 until June 1909, travelling to Rome via Verona, Padua, Venice and Ravenna. He was particularly impressed by Etruscan art and Italian trecento painting, and claimed that it was the influence of the former which encouraged him to adopt a more simple, economical style which, in turn, he transmitted to Kirchner on his return to Dresden. Instead of covering the canvas with densely worked, individual brush strokes, Heckel now filled it with increasingly large, flat areas of paint thinned with a liberal use of turpentine. The result was much more felicitous to the eye, suggesting the happy and relaxed spontaneity of a free-hand sketch. As in contemporary canvases by Kirchner and Schmidt-Rottluff, Heckel left substantial areas of the primed canvas unpainted to convey greater simplicity and immediacy. In several important ways this picture marked the assimilation of Matisse's lessons into Heckel's *Fauve* style: bold, flowing lines and areas of darker tonal value model the girl's figure and project her image firmly forward. Overtly naturalistic details, such as the girl's face, hands and feet, are deliberately suppressed in order to strengthen the general mood of euphoric excitement.

IX Ernst Ludwig KIRCHNER
Fränzi in a carved Chair
LUGANO, Thyssen-Bornemisza Collection. 1910. Oil 70.5 × 50 cm. Signed: *E L Kirchner*. (Gordon 122).

Fränzi in a carved Chair is an important transitional work in Kirchner's gradual development away from a *Fauve* inspired painting technique to a more severely angular treatment of form. The significance of this painting, however, is not so much one of style as of content. The flowing curves and flat areas of thinly painted colour are still characteristic of Matisse's influence at this stage. But the chair in which Fränzi is sitting was handcarved and painted by Kirchner, using linden planks, sometime during the winter of 1908/1909, after he had seen examples of Cameroon figure-sculpture in the local Museum of Ethnology. About two years later the *Brücke* artists all began to produce hand carved wooden figures inspired by African prototypes. Kirchner placed great stress on the empathy which the studio atmosphere generated between the artist, his model and these handmade artefacts. Writing in his diary for 1923 Kirchner explained how 'the love of the painter for the girl who was his mistress and model was communicated to the carved figure or painting, and in the painting it gave in turn an emotional quality to the particular shape of chair or table associated with the figure'.

X Max PECHSTEIN

Horse Market at Moritzburg

LUGANO, Thyssen-Bornemisza Collection. 1910. Oil 69.5 × 80 cm. Initialled and dated: *HMP 1910.*

Writing about the second communal painting trip to Moritzburg during the summer months of 1910 when he accompanied Kirchner and Heckel for the first time, Pechstein recalled 'We were fortunate with the weather during our stay, it didn't rain once. From time to time a horse market was held in Moritzburg and I made sketches as well as a painting of the crowd gathered round the animals' glossy bodies'. Pechstein's loose, vigorous colour rhythms communicate an intensely subjective response to this lively open-air scene. The result is one of his most felicitous and successful achievements, in which he sustains a heightened consciousness of reality to the point where narrative content becomes inseparable from autobiographical experience.

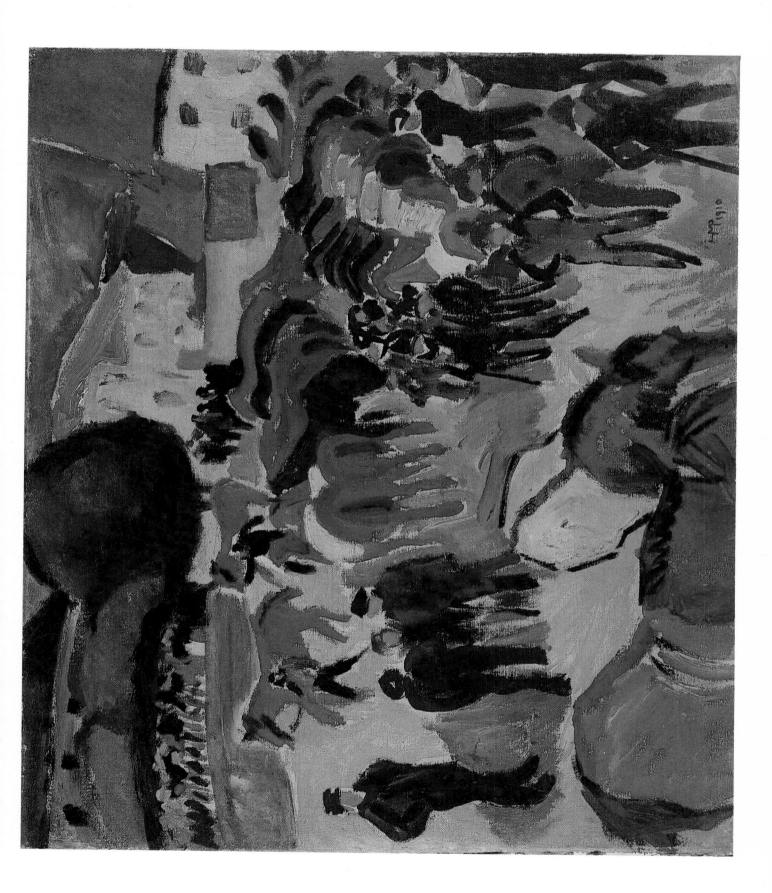

XI Karl SCHMIDT-ROTTLUFF

Breach in the Dike

BERLIN, Brücke-Museum. 1910. Oil 76 × 84 cm. Signed and dated: *S-Rottluff 1910*. (Grohmann p. 284).

Whilst Kirchner and Heckel, accompanied this time by Pechstein and Mueller, made their second successive visit to Moritzburg, Schmidt-Rottluff continued his independent habit of spending the summer months at Dangast, where this *Fauve* oriented landscape was painted. Schmidt-Rottluff's conversion to Fauvism was perhaps the most dramatic of all the *Brücke* artists. His work reached an extreme pitch of emotional intensity in its semi-abstract handling of form and colour without ever quite losing contact with tangible reality. The brilliantly coloured, loosely-applied paint communicates that feverish involvement with the subject that distinguished the young German artist's vision from the more impersonal approach favoured by Matisse, and identified him as, above all, a direct successor to van Gogh and Munch. As in *Windy Day* (Plate III), probably his finest Post-Impressionist inspired landscape, *Breach in the Dike* is so charged with inner meaning, it is almost like confronting a self-portrait. Schmidt-Rottluff remained in Dangast until November, and was therefore not present in Dresden to see the exhibition of paintings by Gauguin at the Galerie Arnold in September.

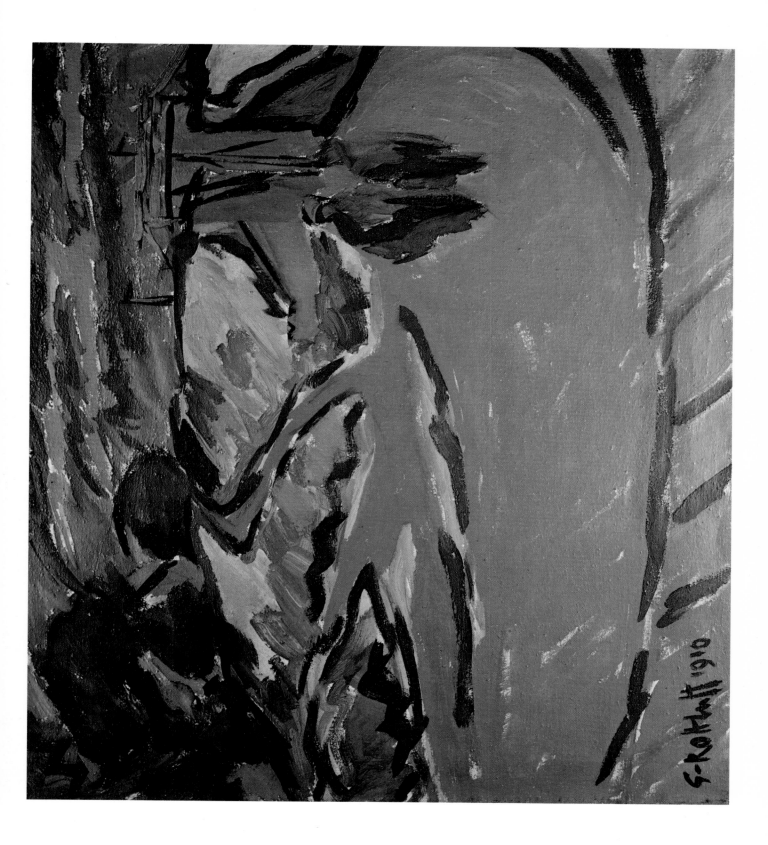

XII Max PECHSTEIN

Beach at Nidden

LOS ANGELES, Los Angeles County Museum of Art (gift of Mr. and Mrs. John C. Best). 1911. Oil 49.5 × 72.5 cm. Signed and dated: *Pechstein 1911*.

Painted with the kind of barely controlled exuberance which the other *Brücke* artists had by this time subjugated to a harsher, more abrasive and daringly primitive technique, Pechstein's beach scene is, nevertheless, one of his most directly felt subjects. The strong, violent colours and the fresh, spontaneous vigour of the brush strokes work brilliantly together to achieve a boldly sustained emotional excitement and creative intensity rare in this artist's work.

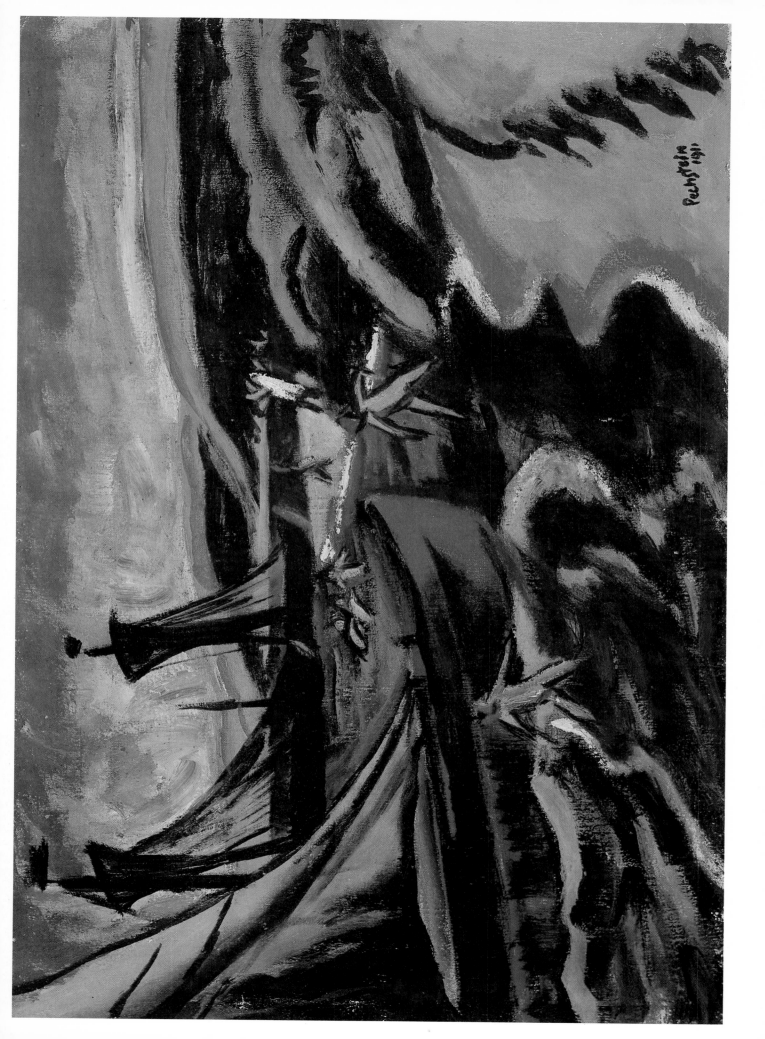

XIII Erich HECKEL

Walkers by the Grünewaldsee

ESSEN, Folkwang Museum. 1911. Oil 71 × 80.5 cm. Initialled and dated: *EH 11*. (Vogt 1911/11).

Painted soon after Heckel moved to Berlin in the winter months of 1911, this is one of several town landscapes in which from now on he began to direct his attention towards the visual phenomena of the changing seasons and to the human figure's role within the general order of things. Heckel took over Mueller's former studio in Mommsenstrasse in the Steglitz district, not far away from the pine forest of Grünewald which fringed the Havel lakes. This unspoilt woodland area was a favourite haven of retreat for Berliners escaping from the hurly-burly of life in the city. Heckel's animated depiction of the wintry scene expresses his deeply-felt happiness at the sight of urban man enjoying a peaceful relationship with this naturally beautiful setting.

XIV Ernst Ludwig KIRCHNER
Striding into the Sea
STUTTGART, Staatsgalerie. 1912. Oil 146 × 200 cm. Signed: *E L Kirchner*. (Gordon 262).

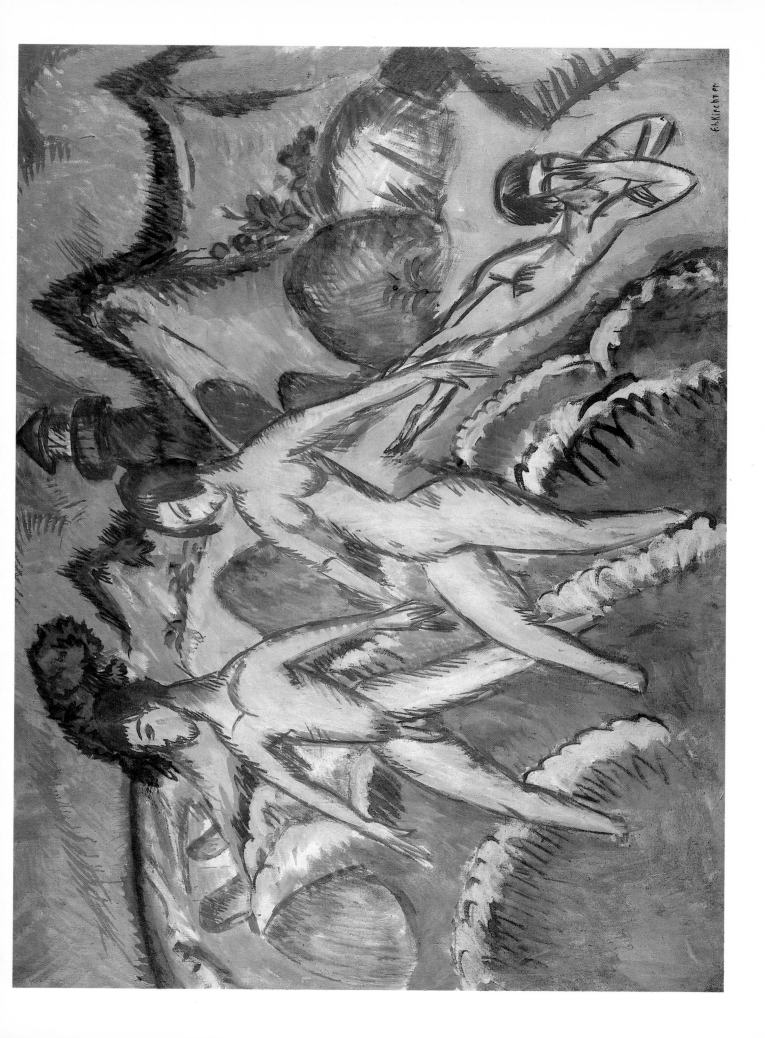

XV Ernst Ludwig KIRCHNER

Castle on Fehmarn

MÜNSTER, Landesmuseum für Kunst und Kulturgeschichte. 1912. Oil 122 × 91 cm. Signed: *EL Kirchner*. (Gordon 242)

Kirchner believed that he did not reach full artistic maturity until his summer visit to the Baltic island of Fehmarn in 1912, four years after his original journey there in search of a romantic union with an unspoilt natural landscape. The architectonic discipline of this early Fehmarn subject was almost certainly a result of Kirchner's first major opportunity to see important examples of Cézanne's work in the retrospective exhibition devoted to the French artist at the Cologne *Sonderbund*, which had opened before Kirchner left for his summer sojourn. Kirchner's volatile temperament was too fundamental a part of his creative vocabulary, however, for him to order and combine Nature through the Cézannesque method of cylinder, sphere and cone, and the impulse to improvise continually threatens any principle of balanced organization.

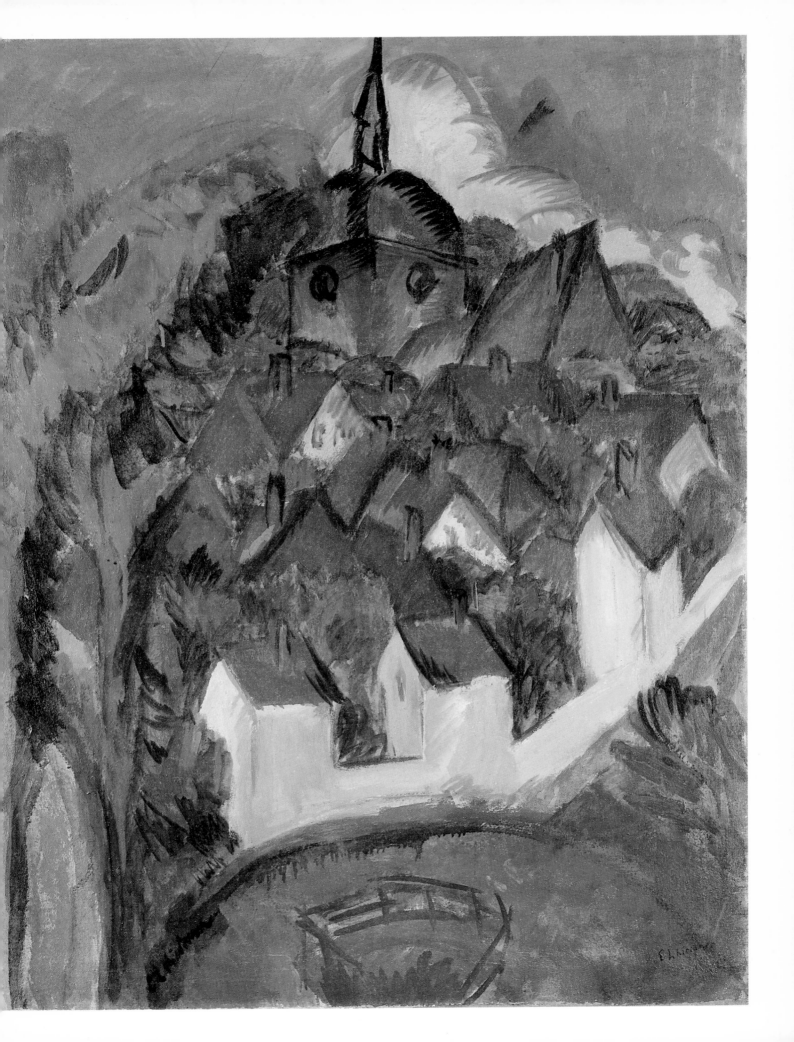

XVI Ernst Ludwig KIRCHNER
Yellow Angelbank, Berlin
MANNHEIM, Städtische Kunsthalle. 1913. Oil 71.5 × 80.5 cm. Unsigned. (Gordon 306)

Before he started to paint the major series of Berlin street scenes (Plate XIX *Five Women on the Street*) with which he established his unique artistic significance, Kirchner painted a number of more cheerfully colourful and open views of the outer suburbs. Yellow Angelbank was the local name give to an area of Berlin adjacent to the River Spree.

XVII Erich HECKEL

Day of Glass

BERLIN, collection of M. Kruss (on loan to Staatsgalerie Moderner Kunst, Munich). 1913. Oil 120 × 96 cm. Signed on verso: *Erich Heckel*. (Vogt 1913/21).

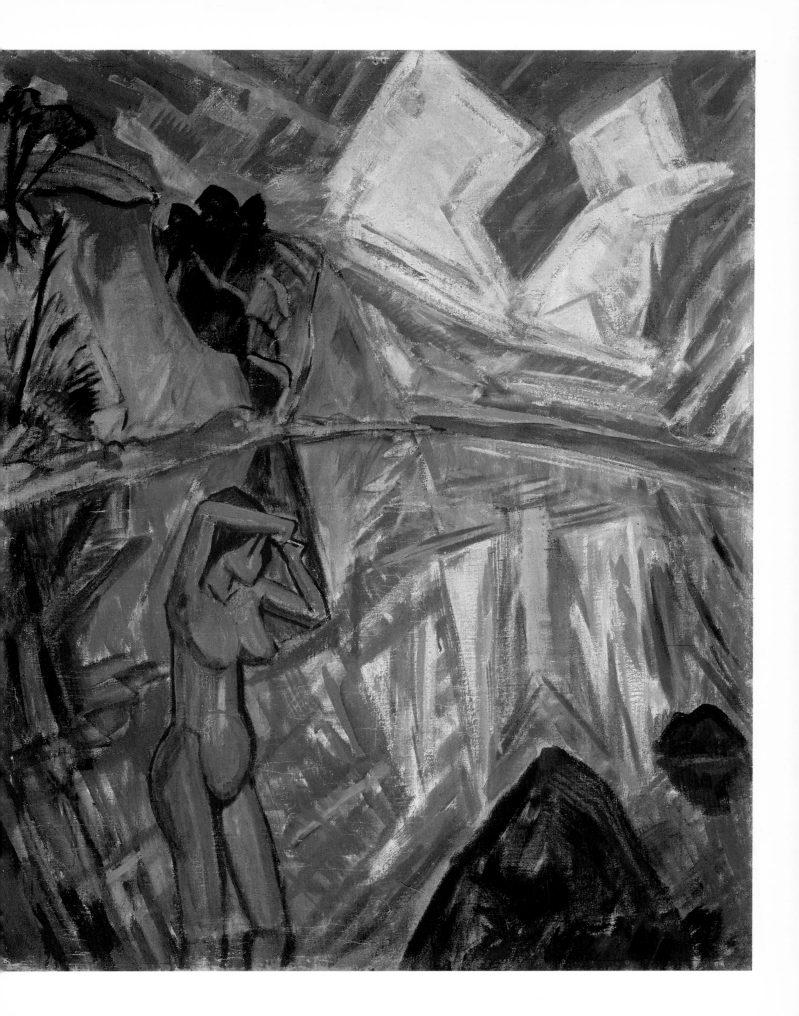

XVIII Karl SCHMIDT-ROTTLUFF

Sun in the Pine Forest

LUGANO, Thyssen-Bornemisza Collection. 1913. Oil 76.5 × 90 cm. Signed and dated: *S. Rottluff 1913*. (Grohmann p. 286).

Like van Gogh and Munch before him, Schmidt-Rottluff revelled in the intoxicating emotionalism which overwhelmed him in the face of nature. His Nidden landscapes represent a peak in his painterly representation of a symbolic idea through an expressive form. By creating a monumentally cosmic vision of the world, he was able to celebrate those mysterious and indestructible forces that gave universal meaning to life and which fed his imagination. When questioned about his thoughts on the new art form current in Germany, and the sources of his own creativity, by the magazine *Kunst und Künstler* in 1914, Schmidt-Rottluff replied: 'Personally, I don't have any programme, only an unaccountable longing to take hold of what I see and feel, and to find the most direct means of expression for such an experience. I only know that there are some things which cannot be grasped by either intellect or words'.

XIX Ernst Ludwig KIRCHNER
Five Women on the Street
COLOGNE, Wallraf-Richartz-Museum. 1913. Oil 120 × 90 cm. Unsigned. (Gordon 362).

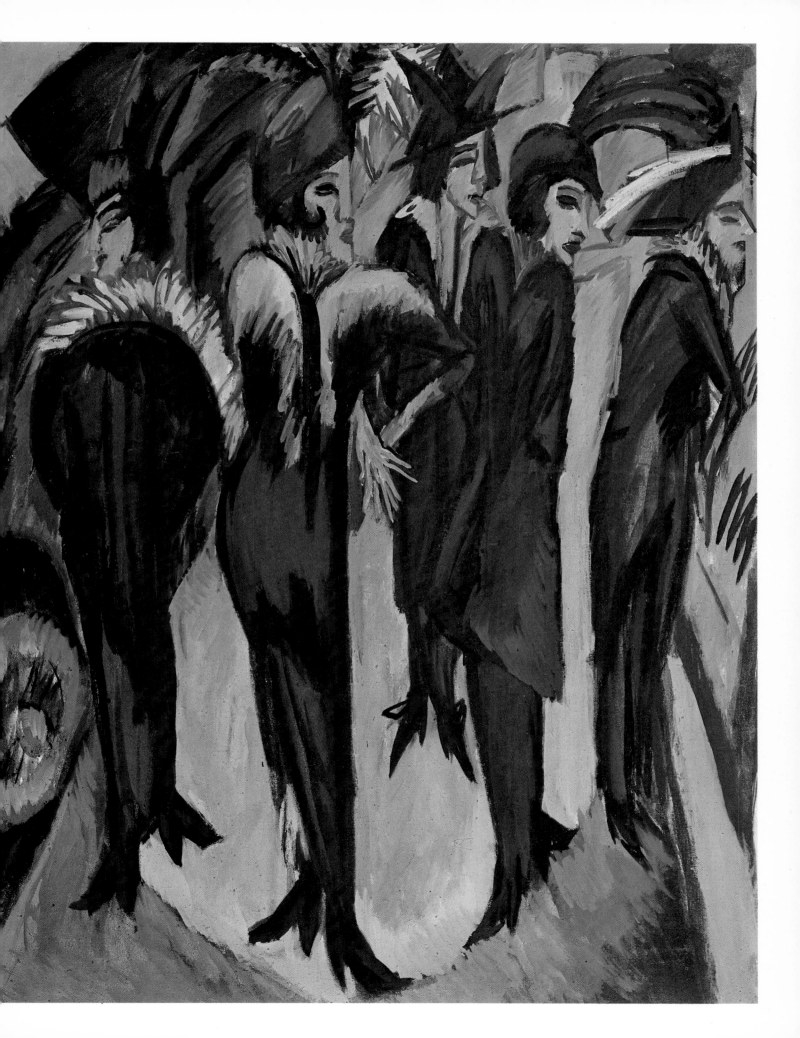

XX Wassily KANDINSKY
Couple on Horseback

MUNICH, Städtische Galerie. 1907. Oil on canvas 55 × 50.5 cm. Signed: *Kandinsky*.

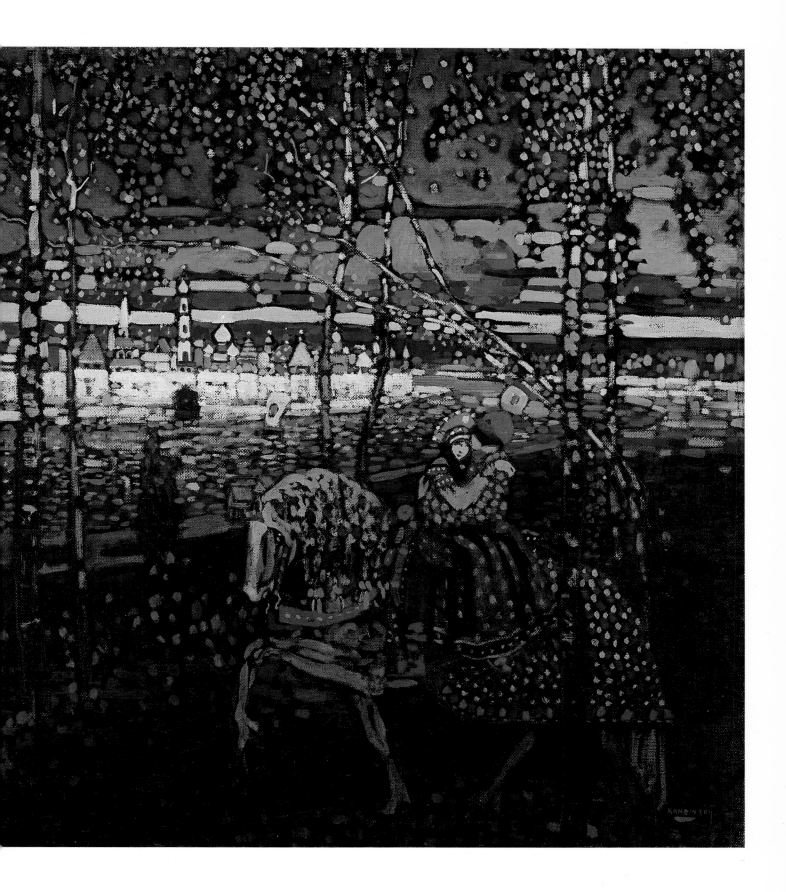

XXI Gabriele MÜNTER
Portrait of Marianne von Werefkin
MUNICH, Städtische Galerie. 1909. Oil on cardboard 81 × 55 cm. Signed: *Münter.*

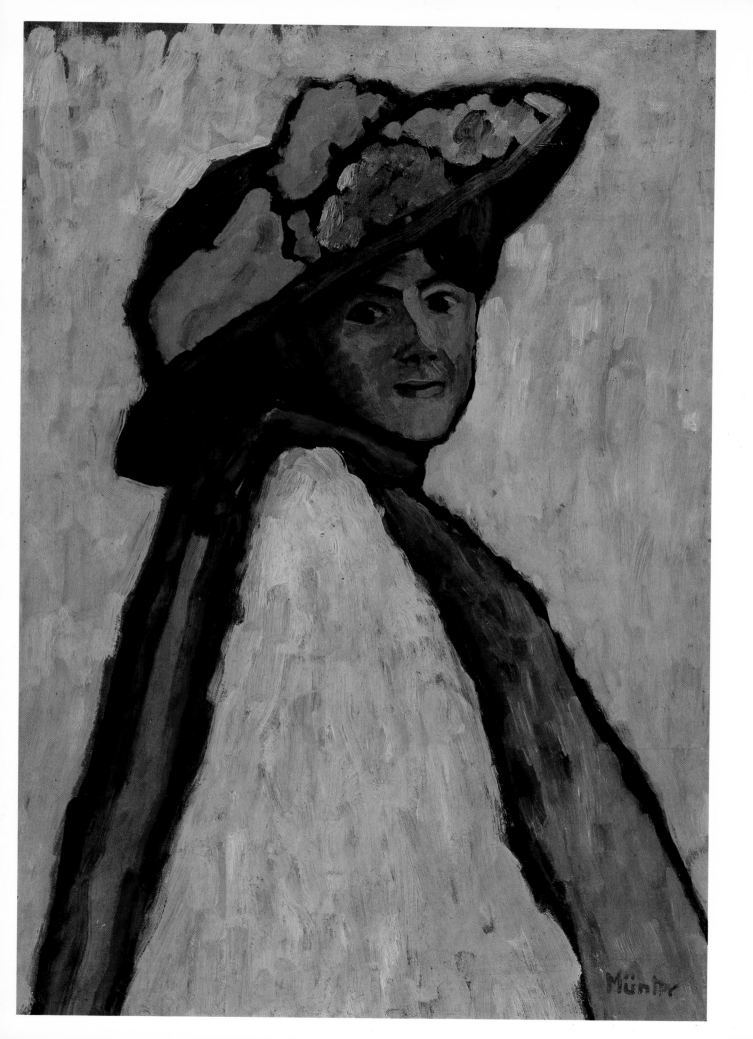

XXII Alexei von JAWLENSKY
Portrait of Alexander Sacharov
MUNICH, Städtische Galerie. 1909. Oil on cardboard 69.5 × 66.8 cm. Not signed.

After studying to be a painter in Paris, Alexander Sacharov (1886–1963), whom Jawlensky described in his memoirs as 'an intelligent, witty, sensitive and talented human being', later devoted himself to dancing instead. He moved to Munich in 1904, and was one of the original founder members of the *Neue Künstlervereinigung* in 1909. Kandinsky may have had Sacharov in mind to perform the expressive dance by the white figure in the middle of scene five in *Der gelbe Klang*. Jawlensky's outrageously theatrical portrait is also an expressive 'tour-de-force', outdoing even the *Brücke* artists' exaggerated and heightened relationship to their models in terms of its distortion of natural form and the emotive use of discordant colour contrasts. The sharply pointed face and unnaturally large eyes became a predominant feature of Jawlensky's later, more generalized portrait heads.

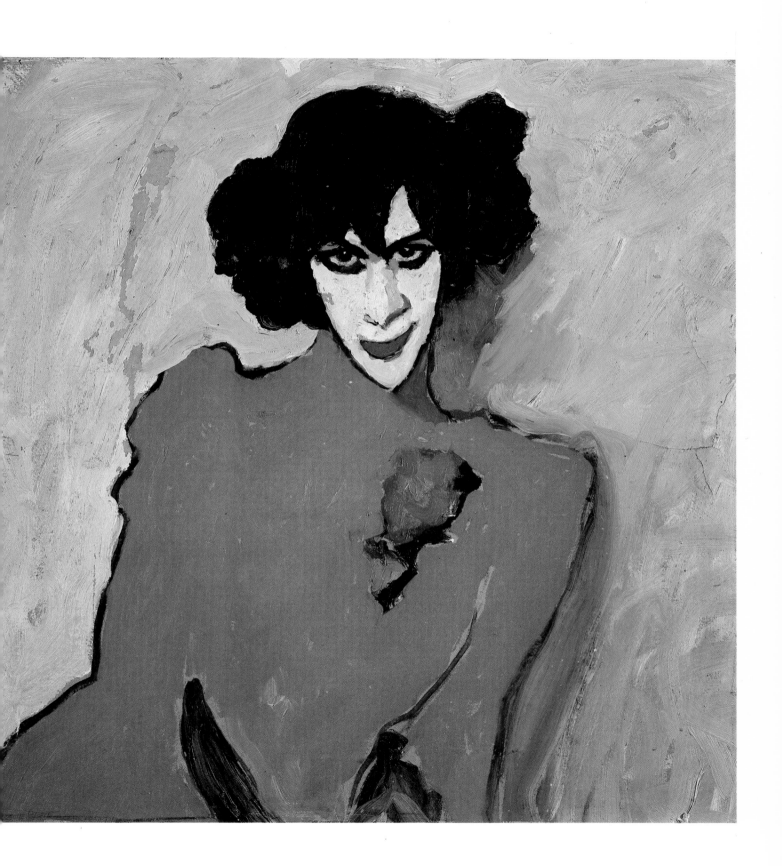

XXIII Franz MARC
Larch Tree
COLOGNE, Wallraf-Richartz-Museum. 1908. Oil on canvas 100 × 71 cm. Not signed. (Lankheit 68).

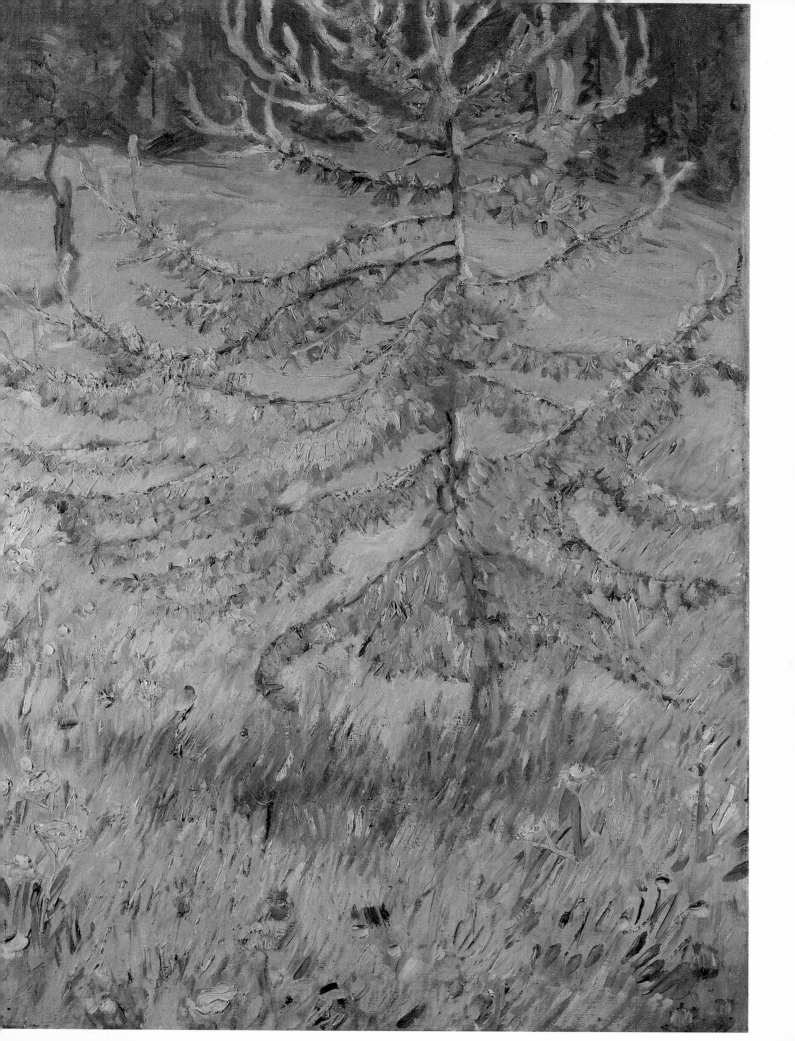

XXIV Wassily KANDINSKY

Study for Composition II

NEW YORK, The Solomon R. Guggenheim Museum. 1910. Oil on canvas 97.5 × 130.5 cm. Signed and dated: *Kandinsky 1910.*

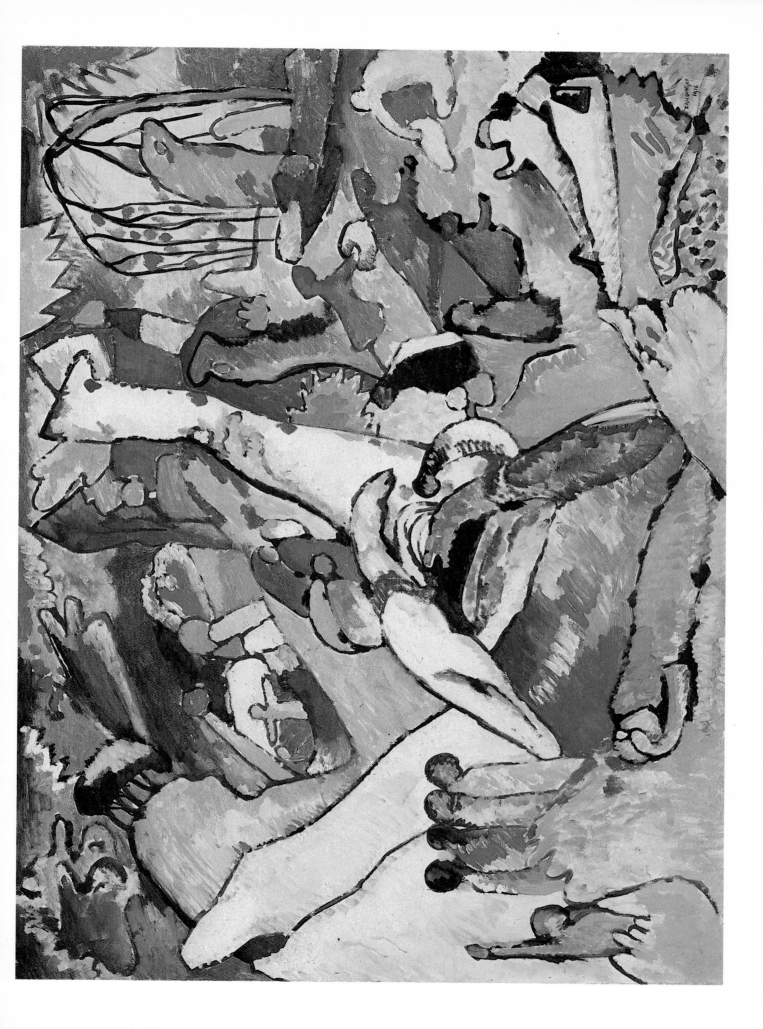

XXV Franz MARC

Horse in a Landscape

ESSEN, Folkwang Museum. 1910. Oil on canvas 85 × 112 cm. Not signed. (Lankheit 130).

'A warm red tone will materially alter in inner value when it is no longer considered as an isolated colour, as something abstract, but is applied as an element of some other object, and combined with natural form', Kandinsky said in *Über das Geistige in der Kunst*. 'The very words—a red horse —put us in another atmosphere. The impossibility of a red horse demands an unreal world . . . To set this red horse in a careful naturalistic landscape would create such a discord as to produce neither appeal nor coherence. The need for coherence is the essential of harmony, whether founded on conventional discord or concord. The new harmony demands that the inner value of a picture should remain unified whatever the variations or contrasts of outward form or colour'.

XXVI Wassily KANDINSKY

Composition 4

DÜSSELDORF, Nordrhein-Westfalen Museum. 1911. Oil on canvas 160 × 250 cm. Signed and dated: *Kandinsky 1911*.

In the amended version of *Rückblicke* (Reminiscences), which he prepared for the book's first Russian edition in 1918, Kandinsky emphasized even more strongly than in the original German text that his 'Compositions' were the unadulterated outward expression of deep inner feeling:

> It became the great ambition of my life to paint a composition. They came to me in my dreams—indistinct, fragmentary visions, often frightening in their intensity. Sometimes I saw whole paintings, but on waking only the vaguest details, a faint glimmer remained.

Originally entitled *Schlacht* (Battle), *Composition 4* hovers between the fairy tale settings of Kandinsky's early medieval subject pictures and his burgeoning interest in abstraction. Despite the radical simplification of form and the vivid unreality of the colours, familiar motifs such as a mountain, a valley bridged by the symbolic arch of a rainbow, and fighting lancers on horseback, can easily be made out.

XXVII August MACKE

Ballets Russes I

BREMEN, Kunsthalle. 1912. Oil on cardboard 103 × 81 cm. Not signed. (Vriesen 328).

Macke saw Diaghilev's *Ballets Russes* during its appearance at the Stadttheater in Cologne beginning on 30 October 1912. This painting is one of two works in oil which resulted from the large number of rapid sketches he produced during the performance of Fokine's *Carnaval* in which Nijinsky and Karsavina danced the roles of Harlequin and Columbine with Adolf Bolm as Pierrot. The set designs and costumes were by Leon Bakst. Using one of his favourite framing devices to throw the central action into relief, Macke contrasted the predominantly darker, richer tones of the audience with the lavishness and magnificence of the costumes and decor. A brilliant fantasy of colour, light and movement fills the stage. The ballet has become an instrument of beauty and pleasure, a harmony of form and colour whereby the movements of the dance determine the whole mood of the picture in which everything has been integrated to delight the eye and the mind.

XXVIII August MACKE

Turkish Cafe II

MUNICH, Städtische Galerie. 1914. Oil on panel 60 × 35 cm. Signed and dated: *Aug. Macke 1914*. (Vriesen 469).

Macke set sail for Tunis from Marseilles on 6 April 1914, accompanied by Klee and Louis Moilliet. During their two week stay in Tunisia, Macke produced thirty-seven watercolour sketches of the North African landscape and towns, several of which were later translated into oil paintings on his return to Germany. In all these works colour alone is used to define both form and space without the structural support of line. 'The sun had a dark power', Klee wrote on their arrival. 'On shore the clarity is full of promise. Macke feels it too'. The Turkish Cafe was situated in Sidi-bu-Said, the first Arab town the three artists could see as their ship approached the African coast.

XXIX August MACKE
Farewell

COLOGNE, Wallraf-Richartz-Museum (Haubrich Collection). 1914. Oil on canvas 100.5 × 130.5 cm. Signed and dated on reverse: *August Macke 1914*. (Vriesen 504).

XXX Franz MARC

The Fate of the Animals

BASEL, Kunstmuseum. 1913. Oil on canvas 196 × 266 cm. Signed: *M.* (Lankheit 209).

Marc's final masterpiece was one of the seven paintings which represented him at the first German Autumn Salon in 1913, organized by Herwarth Walden. In 1918 the painting was lovingly restored by Paul Klee after it had been damaged in a fire.

XXXI Wassily KANDINSKY

Fugue

NEW YORK, The Solomon R. Guggenheim Museum. 1914. Oil on canvas 129.5 × 129.5 cm. Not signed.

'Painting is a violent and thunderous collision between different worlds that are destined to create a new world by fighting one another, the new world being a work of art', Kandinsky wrote in his reminiscences. 'Technically each work comes into being in the same way as the universe—through catastrophes, which out of the cacophony of all the instruments ultimately creates that symphony we call the music of the spheres. The creation of a work of art is like the creation of the world'.

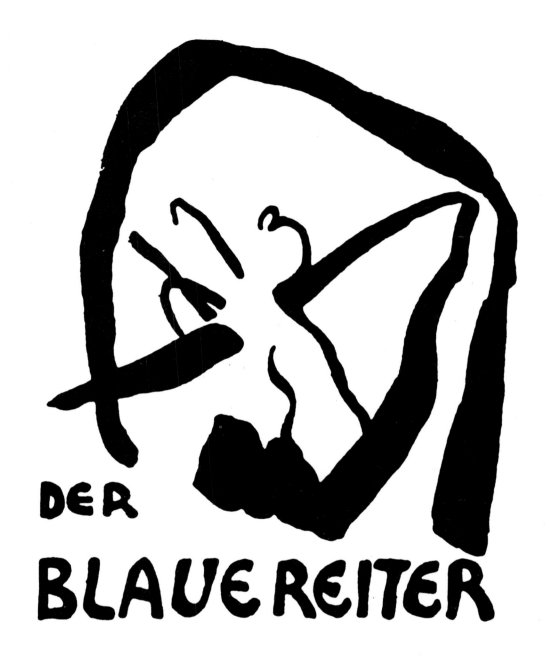

DER

BLAUE REITER

DER BLAUE REITER

I INTRODUCTION

The true work of art leads us from that which exists only once and never again, i.e. the individual, to that which exists perpetually and time and time again in innumerable manifestations, the pure form or Idea.

Arthur Schopenhauer, *Parerga und Paralipomena*, 1851

Der Blaue Reiter—The Blue Rider—was essentially the brain-child of one remarkable, highly gifted man. Wassily Kandinsky came to Munich from Russia in 1896 to become a painter. Endowed with great intellectual power and seemingly inexhaustible energy he instigated a succession of radical, internationally orientated artists' associations, whose exhibitions reflected all that was new, exciting and provocative in German, French and Russian contemporary painting. The two major exhibitions and the unique encyclopaedic book dealing with the 'correspondence between different art forms', which he organized and co-edited with the faithful assistance of his friend Franz Marc, under the all-embracing title of *Der Blaue Reiter*, represented the crowning achievement of Kandinsky's Munich career during the years immediately prior to the outbreak of war in 1914.

In contrast to the stormy communal working relationship of the *Brücke* artists, the painters associated with the *Blaue Reiter*, although closely knit, were never so mutually dependent. Each of them was strongly individualistic, and enjoyed total freedom of self-expression in his work. Franz Marc's mature paintings were an ambitious pictorialisation of the world as he imagined it to be when seen through the eyes of an animal. Horses, deer, cats, dogs, a tiger, Marc invested them all with a larger-than-life significance, turning them into a symbolic visual metaphor for his own particular religious/spiritual creed, but always painting them with a flawless sense of their flesh and blood reality. On the other hand his young friend August Macke quietly celebrated those small, uncomplicated incidents of everyday life, seemingly insignificant in themselves, yet rich in poetic meaning to anyone with an eye for penetrating beneath the surface details to a more subtle, elusive world imbued with deep human emotions. In her unaffected landscapes, portraits and still-life subjects Gabriele Münter evoked a moody and at times a melancholic sentiment, simultaneously suggestive of her own impetuous and darkly romantic temperament. Kandinsky struggled for fifteen years to free his painting from a directly representational style in a determined effort to invest the visual arts with a more purposeful and uplifting importance, to enhance life in a manner comparable to the healing qualities of music. By 1911 he was generally identified as the Russian artist who painted pictures without objects, and three years later he believed himself to be standing on the brink of abstract art.

[98]

Stylistically these artists had very little in common except for their use of pure, sometimes intensely sensual colour. As in the more violently hued paintings of the *Brücke* artists, colour was the most immediate means by which Kandinsky and his friends hoped to transcend and overcome the soul-destroying influence of a materialistic, technological culture. But their particular fight went much deeper. In *Der Blaue Reiter* almanac Marc clearly set out their didactic, missionary purpose when he spoke of wanting 'to create symbols for their own time, symbols that will take their place on the altars of a future spiritual religion'. Through the exploration and pictorial expression of inner experience, these artists sought to address themselves directly to the hearts and minds of their audience, appealing to its emotional and intellectual responses with feelings and ideas couched in the most dynamic visual language of the day, in styles commensurate with the new tempo of the twentieth century. To this end Kandinsky, Marc and the others embraced a sometimes bewildering variety of formative influences in order to refine their own personal style. From the simple, naive paintings on glass by Bavarian peasants, to the most sophisticated Parisian colouristic techniques of Matisse, and Delaunay's rhythmical interplay of fragmented Cubist forms, they borrowed whatever enabled them to strengthen and purify their paintings' expressive force.

Der Blaue Reiter cannot be neatly pigeon-holed. It was neither an artists' society in the conventional sense nor did it produce a uniform style by which all its painters might be readily identified, as was the case with *Die Brücke*, at least during the period when the activities of the Dresden group's first communal studio were at their height. Perhaps more than anything else *Der Blaue Reiter* represented a state of mind, a chivalric quest to restore harmony to a world divided against itself by seeking a spiritualized concord between life and art. Not unlike van Gogh in a rather different cultural and social context, the *Blaue Reiter* painters also wanted to bring back to art 'that element of the eternal which the halo once symbolized', but in a pictorial vocabulary in keeping with the more complex demands of the new age.

In *Über das Geistige in der Kunst* (Concerning the Spiritual in Art), his pioneering essay on the movement to free painting from its traditional bonds to material reality, Kandinsky crystallized his emotional longing for a spiritual revolution in art in these words:

A painter who finds no satisfaction in mere representation, however artistic, in his desire to express his inner life, cannot but envy the ease with which music, the most non-material of today's art forms, achieves this end. Naturally, he looks for a way to apply the methods of music to his own art, and from this results that modern desire for rhythm in painting, for mathematical, abstract construction, for repeated colour notes, for setting colour in motion.

To give pictorial expression to universal truth, to unify by means of those abstract elements in painting which Seurat and Gauguin before them had come to recognise as the most meaningful of all, was the ambitious goal towards the attainment of which Kandinsky and the other *Blaue Reiter* artists dedicated themselves without stinting. Their vision was abruptly cut off by the First World War, but the crusading, revolutionary spirit of Kandinsky and Marc's 'blue rider' haunted Germany down the years, long after the artists themselves had either been killed or driven to seek refuge abroad. 'I doubt whether many of

the new and strange forms which we created before the war will take root', Marc wrote in 1915. 'But when Germany is able to relax again, it will also want to know about its art, something that she has always possessed in her moments of greatness'.

II THE MUNICH EXPERIENCE

If I had a son who wanted to be a painter I wouldn't send him to Paris . . . but to Munich . . . where painting is studied seriously without fixed ideas of any sort.

<div align="right">Pablo Picasso, 1897</div>

Munich at the end of the nineteenth century was Germany's undisputed 'city of art'. Painters, writers, poets, musicians, actors, dancers, and scholars flocked from as far afield as America and Russia to take advantage of its vast cultural resources, and to savour its lively cosmopolitan atmosphere. Thus, when Wassily Kandinsky decided not to accept the offer of a lectureship in law at the University of Dorpat in Estonia, and left Moscow towards the end of 1896 to come to Munich and devote himself to the study of painting, he did so in the full knowledge of the Bavarian capital's reputation as a major European centre for the arts.

Accompanied by his wife Ania Chimiakin, whom he divorced in 1911, the thirty year old Kandinsky settled in Schwabing, Munich's bohemian quarter, where, as he recalled later: 'Everyone painted, wrote poetry, made music or danced. There were at least two studios in the attic of every house, where there was not so much painting done as there was a great amount of talking, arguing, philosophising and hearty drinking, all of it more dependent on the state of people's purses rather than their morale'. He described Schwabing as 'a spiritual island in the world at large, in Germany, and more often than not in Munich itself'. Kandinsky had been well educated in German culture, spoke the language fluently and soon felt quite at home.

As well as offering every kind of distraction, Schwabing also housed most of the city's leading progressive art schools and Kandinsky wasted no time in assuring himself a place at one of the most popular of these privately run establishments, which also happened to be one of the best. Anton Azbè (1859–1905), a Yugoslav painter, well-known for his liberal teaching policies, his flamboyance and his generosity towards impecunious students, attracted large attendances at his classes. Among the other Russians who attended Azbè's school whom Kandinsky met at this time were Alexei von Jawlensky and his friend Marianne von Werefkin, who had recently arrived from St. Petersburg together. A few years later, Kandinsky and Jawlensky's combined creative efforts were to have a decisive influence on the development of modern German art but, for the moment, both men were

tentatively feeling their way, and put all their energies into absorbing the lessons of their highly talented unorthodox master.

Like Jawlensky, who shared his natural gifts as a colourist, Kandinsky admired the primitive earthiness and expressive force of Russian folk art. In 1889 Kandinsky had taken part in an expedition to the Vologda region, sponsored by the Imperial Society of Natural Sciences, Anthropology and Ethnography, to study the province's peasant laws and customs. His discovery of the brightly painted and decorated peasant houses made a profound and lasting impression on his imagination. 'I still remember how, on entering the room for the first time I was stopped dead in my tracks on the threshold before the unexpected vision', he recalled. 'The table, the benches, the great oven . . . the wardrobes, every object was painted with bright-coloured, large-figured decorations. Folk paintings were on the walls: a hero in symbolic representation, a battle, a painted folk song'.

Such memories obsessed and stimulated him throughout his long years of voluntary exile. He worked hard under Azbè's instruction, eagerly learning about the advantages of pure colour over the dark palettes preferred by the academy schools. But he found himself increasingly at odds in the more conventionally run life-classes which were over-crowded, noisy and, what was much worse, demanded that he should produce a reasonably faithful representation of a naked human body. 'Students of both sexes swarmed around these smelly, off-handed, expressionless, and frequently characterless prodigies of nature', he wrote many years later, but with an intensity informed by his original repugnance, 'who were being paid between fifty and seventy pfennig an hour whilst the students tried to make an exact copy of someone who meant absolutely nothing to them'.

Failing in his initial attempt to submit himself to the discipline demanded by the life classes, Kandinsky gradually began to isolate himself from the other, more adaptable, students. He preferred to paint 'from memory, from study, or from my imagination, anything that did not have too much to do with the laws of nature . . . Dimly I felt that I could sense the secrets of a realm all its own, but I was unable to relate this realm to the world of art'.

Seeing the work that Kandinsky was producing outside the school, some of his fellow students labelled him a 'colourist', whilst others 'not without malice, called me the ''landscape painter''. Both hurt me, even though I could see the justice in these designations . . . Actually I sensed that I felt much more at home with colour than with drawing, and I had no idea how to help myself in the face of this threatening evil'.

After two years under Azbè's course of instruction, Kandinsky applied, unsuccessfully at first, for admission to the Academy painting class of Franz Stuck (1863–1928) who, although only three years older than Kandinsky, was already established as Munich's most celebrated academic painter. Stuck advised his would-be student to work in the Academy drawing class for a year to improve his technique, but again Kandinsky was turned down. Determined not to be beaten he worked diligently on his drawing, and on returning to Stuck for a second time in 1900 was rewarded by the offer of a place in his painting class. 'When I asked him about my drawing, I received the reply that it was expressive', Kandinsky wrote. Apart from the continuing problems with his drawing, Kandinsky was unable at this stage to complete any of the paintings he started, a difficulty Stuck quickly helped him to resolve.

'Even during my first pieces of work at the academy Stuck opposed my colour "extravagances" most vigorously', Kandinsky recollected, 'advising me to paint in black and white to begin with in order to study form alone. He talked about art with surprising affection, about the play of forms into one another, and gained my total sympathy . . . In the final analysis, I look back on the year I spent working with him gratefully, although there were times when I was made to feel bitterly angry. Stuck said very little, and when he did say something it wasn't always coherent. After his criticism I had occasion to ponder his comments for a long time, but afterwards I usually found them sound. A single remark of his corrected my unfortunate habit of not being able to finish a painting. He told me that I worked too nervously, that I gave out the most interesting things too quickly, and then ruined the effect by the indifference of what followed after. "I awaken with the idea: today, I am allowed to do so much". This "I am allowed" not only revealed Stuck's deep love and respect for art, but also the secret of serious work. And at home I finished my first painting'.

Stuck did not discourage Kandinsky from painting the imaginary, dream-like, fairy tale subjects that came to him more readily than the classical and genre repertory of the academy studios, but fully approved his individualistic approach. A contemporary fellow student of Kandinsky's at this time was Hans Purrmann, who later went on to work with Matisse. Purrmann also benefited from Stuck's liberal ideas on private experiment, but Paul Klee, who was also in the same class, found it virtually 'impossible to make any progress' under Stuck's idiosyncratic teaching methods.

Kandinsky left the Academy sometime during the early months of 1901. Throughout the four years that had passed since his arrival in Munich he had followed with interest the diverse and constantly changing exhibition programmes held at both the Glaspalast and in the Secession's gallery on the Königsplatz. Local regional groups such as *Die Scholle* were regular participants in the massive shows organized for the Glaspalast, whilst the more selective exhibitions arranged by the Secession were much more international in character. Between 1897 and 1900 Kandinsky could have seen paintings by, amongst others, Monet, Böcklin, Burne-Jones, Degas, Munch, Renoir, Hofmann, Evenepoel, Segantini, Hodler, van Rysselberghe, Liebermann and Slevogt. Thus it was possible for Kandinsky to familiarize himself with almost every recent tendency in modern painting since the advent of post-impressionism and, through these rich surveys of contemporary art, to measure his own attitude and aspirations against the questions posed by the new ideas—whether, for instance, art still had to depend on nature exclusively for its effects, or should begin to look elsewhere for a means of realizing the artist's private thoughts and feelings. Obviously there was no easy answer to these problems appertaining to the significant role art had to play in the twentieth century, but Kandinsky must have recognized at once that the painters whose work stimulated the most positive response in the spectator were those, like Monet, van Gogh, Cézanne, Seurat and Gauguin, who used colour either in a decoratively symbolic or a structural way, imposing their own creative individuality on to their subject matter.

Valuable as these visual experiences were to Kandinsky's understanding of the new age, he also needed to extend himself by a practical involvement with other young artists, of whom there were many like himself looking for an opportunity to exhibit their works but who were not well enough known to be accepted by the establishment. Thanks to the

65 Wassily KANDINSKY 1866–1944

Poster for the first 'Phalanx' exhibition MUNICH, Städtische Galerie. 1901. Colour woodcut
45 × 58 cm.

financial independence he enjoyed as a result of the allowance made to him by his father, a
wealthy tea-merchant, Kandinsky was able to set up his own artists' society 'whose set task
is to further common interests through close association. Primarily, it means to help young
artists overcome the difficulties which are frequently encountered when they wish to exhibit
their work'.

Kandinsky named this new group *Phalanx*, a symbolically appropriate title with its
militaristic associations, for this young, mutually dependent and forward-looking organiza-
tion dedicated to the propagation of the most advanced ideas. Among his fellow co-founders
were Rolf Niczky, the group's first president, Waldemar Hecker and Wilhelm Hüsgen,
two sculptors, the former acting as vice-president and the latter as secretary, and Gustav
Freytag who gave additional financial backing to the venture. The early exhibiting artists of
Phalanx included Alexander von Salzmann, a Russian painter who had met Kandinsky in
Stuck's class, Hermann Schlittgen, Edmund Blume, Richard Kellerhals and Eugen Meier.
From the very beginning, however, Kandinsky proved to be the most resourceful of all the
group's members and, after Niczky resigned as president in January 1902 leaving Kandinsky
in charge, he alone was responsible for the impressive succession of exhibitions covering a
broad spectrum of contemporary European art that the *Phalanx* staged until February 1904.

For the first *Phalanx* exhibition which opened at 2 Finkenstrasse on 15th August 1901,
Kandinsky designed a resplendent colour woodcut poster (Plate 65), one of the most

striking examples of his vitally important, early graphic style. It integrated free-form lettering and pictorial imagery in an essentially *Jugendstil* idiom, balancing dark and light shapes in a decorative, highly stylized manner and showing a refined sensibility in its use of the expressive, undulating line so characteristic of this international movement. As in many of his paintings Kandinsky's subject matter, showing two richly helmeted warriors advancing purposefully across a battle-field strewn with the fallen bodies of their opponents towards a crenellated medieval castle, utilised imaginary fairy-tale themes as a visual metaphor for the struggle between the forces of liberation represented by the *Phalanx* against the official bastions of repressive tradition.

By the time he came to design the *Phalanx* poster, Kandinsky had been immersed in the invigorating atmosphere of Munich's arts and crafts movement for a little over four years. Munich was the artistic centre of *Jugendstil*—the Style of Youth—which had taken its name from the *Jugend* review, founded in January 1896 by George Hirth, the Munich newspaper magnate. Magazines such as *Jugend* and its English equivalent *Studio* were widely circulated, disseminating the very latest ideas and information about current exhibitions and events appertaining to the new style quickly and efficiently. The modern decorative style irradiated with great speed across Europe from England where it had its origins in William Morris's revolutionary concept of total environmental reform. As a result of Morris's fight against the inferior standard of contemporary design, the minor arts and crafts enjoyed a major revival and all the most prestigious figures in this movement, such as the Belgian artist Henri van de Velde (1863–1957), were skilled designers of furniture, clothes, ceramics, jewellery, etc. in addition to their careers as painters. The general current of feeling that determined such all-embracing talents sprang from an urgent need to create a more harmoniously composed environment beginning in the home, so that life itself became more pleasantly agreeable and free from the humdrum standards of so much modern commercial design.

There was no uncontested leader of *Jugendstil* in Munich, which boasted a great many notable artist-craftsmen whose prolific creativity opened Kandinsky's eyes to the significance of expressive form and colour as the supreme artistic manifestation of energy and intellectual vitality in a world largely given over to the pursuit of materialism. Technical experiments were the order of the day, and one of the most crucial changes in direction was set by August Endell (1871–1925), designer of the excessively 'abstract' Elvira Studio on Munich's Von-der-Tann-Strasse in 1897 which caused a sensation when first seen in its entirety (the building no longer exists; on the orders of Hitler it was defaced as an example of 'degenerate art', and was subsequently destroyed by Allied Action in 1944). Contemporaneous with Endell's completion of the Elvira Studio came his now famous prediction of 'an altogether new art, with forms which mean nothing, depict nothing and remind us of nothing, yet will be capable of stimulating our souls as deeply and strongly as, until now, only music could do with tones'. Kandinsky's heart must have skipped a beat when he first read those prophetic words.

One of the most characteristic features of *Jugendstil* pictorial vocabulary was the curving 'whip-lash' line whose originator, Hermann Obrist (1862–1927), was not only a major exponent of embroidery designs utilizing a highly stylized, decorative treatment of natural forms as their subject matter (e.g. *Cyclamen* c.1895, Munich, Stadtmuseum), but also a

celebrated teacher. The experimental art school which Obrist ran in partnership with Wilhelm von Debschitz from 1901 was situated in Schwabing's Hohenzollernstrasse, just across the road from Kandinsky's *Phalanx* art school which opened later that same year. In fact, Kandinsky quickly came to know most of the leading members of Munich's *Jugendstil* circle and the influence of Obrist's concept of art as an intensified, symbolic form of the inner life had a crucial effect on his personal development towards abstraction.

Another friend who held a prominent position in Munich's vigorous arts and crafts movement was the architect and designer Peter Behrens (1868–1940) who, when Kandinsky met him, was a member of the Darmstadt Artists' Colony, first mooted in 1899 at the behest of Ernst Ludwig, Grand Duke of Hesse who wanted to prove the practicability of a cultural working community. When it opened in the spring of 1901 the Darmstadt Artists' Colony turned out to be one of the most successful attempts ever made to realize the currently fashionable dream of a total union between the individual arts—a utopian variation of the *Gesamtkunstwerk* ideal that Wagner had sought to bring to the live theatre in his epic music dramas, and upon which Kandinsky would later ring yet another change in 'Der gelbe Klange', an experimental stage 'play' with music. Behrens subsequently became one of the most important industrial designers of his generation. Between 1907 and 1911 in Berlin he had Mies van der Rohe, Le Corbusier and Walter Gropius all working for him

In 1903 Behrens offered Kandinsky a teaching post as head of the decorative painting class at Düsseldorf's Kunstgewerbeschule but he turned it down. Kandinsky's involvement in the current revival of interest in the applied arts was evident in the content of the second *Phalanx* exhibition, the first to be organized under his presidency, when it opened in January 1902. Not only did he have four of the leading members of the Darmstadt Artists' Colony represented, Behrens, Patriz Huber, Rudolf Bosselt and Hans Christiansen, but a whole contingent of German and Russian designers including Richard Riemerschmid, Bernhard Pankok and Paul Schultze-Naumburg from Munich's *Vereinigte Werkstätten*, and Natalia Davidov from Moscow. To represent the fine arts Kandinsky captured a fine prize by securing the participation of Ludwig von Hofmann, a leading *Jugendstil* painter then at the height of his fame.

Kandinsky included twelve of his own paintings, prints and drawings in the show. In a review of the *Phalanx* exhibition for *Die Kunst für Alle* Kandinsky was described as 'the unorthodox Russian colourist who paints purely and simply for the sake of colour, displaying all manner of chromatic fireworks, and using a wide variety of techniques: oil, tempera and lacquer. In the case of the latter he succeeds so well that the reflection ensures there is no longer a picture to be seen'.

Old City (Plate 66) was one of Kandinsky's painting in the second *Phalanx* exhibition. It represents a view of the medieval town of Rothenburg on the Tauber, but like so many of the Russian artist's landscapes it was painted from memory and not directly from the motif. On the day Kandinsky travelled north to Rothenburg it had rained continuously but, as he related in his reminiscences 'it was an unreal trip. I felt as if a magic power, against all the laws of nature had taken me back several centuries in time, deeper and deeper into the past . . . Only one painting remains from this trip . . . *Old City*, which I painted from memory after my return to Munich. It is filled with sunlight, and I painted the roof tops as red as I knew how'.

66 Wassily KANDINSKY
Old City—Rothenburg on the Tauber 1902. Oil 52 × 78.5 cm. Signed: *Kandinsky*.

Kandinsky felt no interest at all in dealing with the real world factually. Everything he experienced in terms of his art was coloured by a very romantic, lyrical enthusiasm—a poetic intuition by which he sought admission to a new level of meaning. Furthermore, he was obsessed by memories of his Slavic ancestry, and one such impression recorded in his reminiscences has a clear bearing upon his conscious decision to turn *Old City* into a symbolic representation of his inner joyousness and excitement rather than to show it as the grey, rainswept town it had been in reality. 'In this painting I was really chasing after a particular hour which was and always will be the best hour of the Moscow day', he wrote. 'The sun is already low, and has reached its greatest power, towards which it has been striving throughout the day. This image does not last for long, a few more minutes and the sunlight will become red from exertion, even redder than before, first cold, then warmer and warmer. The sun melts all Moscow into one spot which, like a wild tuba, sets all one's soul and senses vibrating . . . To be able to paint this hour seemed to me the most impossible and yet the greatest joy an artist could experience'.

Later that year, several prominent artists were presented at different *Phalanx* exhibitions, amongst them Lovis Corinth, a vigorously sensual exponent of a rather heavy Germanic form of impressionism and a major force in the Berlin Secession. Akseli Gallén-

67 Claude MONET 1840–1926
Two Haystacks EDINBURGH, National Gallery of Scotland. 1891. Oil on canvas 65 × 92 cm.
Signed and dated: *Claude Monet 91*.

Kallela, the Finnish *Jugendstil* artist and illustrator who later exhibited with the *Brücke*, enjoyed considerable success with his paintings of the old Nordic sagas.

Claude Monet was the special guest of the seventh *Phalanx* exhibition in May 1903. Kandinsky's personal admiration for the great Impressionist painter had first been awakened at an exhibition in Moscow shortly before he left Russia to come to Munich. Faced by one of Monet's paintings of haystacks (Plate 67), he was made aware for the first time of the emotional power of colour and, most disturbing of all, the shock of seeing what, at that particular moment, he could only take to be a non-objective painting. 'Suddenly, for the first time I saw a "picture"'. The catalogue informed me that it was a haystack. I could not recognize it. This lack of recognition was distressing to me. I felt that the artist had no right to paint so indistinctly. I had a vague feeling that the object was missing in this picture, and was so overwhelmed with astonishment and perplexity that it not only seized, but engraved itself indelibly on my memory, and without warning, repeatedly hovered before my eyes

68 Alfred KUBIN

Intruders MUNICH, Städtische Galerie. 1904. Pen and ink 19.7 × 28.4 cm. Not signed.

down to the smallest detail'. Whether or not it had been Monet's intention to 'discredit the object' in the way described by Kandinsky is open to doubt, but certainly by the time he came to paint this series of haystack compositions in 1891 Monet had grown to question 'easy things that come in a flash', and was trying to invest his work with 'more serious qualities' which Kandinsky, with his usual sensitivity to such things, had intuitively perceived.

In January 1904, Alfred Kubin, the Austrian draughtsman, writer and illustrator, was the featured artist with twenty-four drawings at the ninth *Phalanx* exhibition. After six years in Munich he was only now beginning to attract critical recognition within a small circle of enthusiasts for the grotesque style of which he was a master (Plate 68: *Intruders*). Paul Cassirer had been the first art dealer to take an interest in Kubin when he organized an exhibition of his work in Berlin in 1902. The following year Hans von Weber, a Munich publisher, had printed a portfolio containing fifteen reproductions of Kubin's work. Kubin's macabre, oneiric vision, made even more neurotically intense by his spidery drawing technique, explored a world of black fantasy in a style culled from Bosch and Breugel, the 'fantastic realism' of contemporary Austrian art, and the cursive *Jugendstil* line. Haunted by memories of an unhappy childhood—his mother and stepmother both died within two years of one another during his early adolescence—and an abortive attempt at suicide on his mother's grave when he was nineteen, Kubin's dark preoccupation with death and the mysterious workings of the subconscious mind made his art as far removed in feeling

69 Wassily KANDINSKY

The Blue Rider SWITZERLAND, Private Collection. 1903. Oil on canvas 52 × 54.5 cm.
Signed: *Kandinsky.*

The Blue Rider's mood of romantic chivalry and nostalgia for a fairy-tale world of innocence and idealism is typical of Kandinsky's early work of this period. At the same time the horse and rider galloping across the hilly landscape is one of the artist's earliest usages of this heroic and symbolic motif. The painting's first title was simply *The Rider*, and only assumed its present title when Kandinsky came to recatalogue his pictures after the naming of *Der Blaue Reiter* almanac in 1911.

as it possibly could have been from the courtly, romantic nostalgia of the fairy-tale dream world conjured up by Kandinsky in paintings such as *The Blue Rider* (Plate 69). But Kandinsky was fascinated by what one critic had recently described as Kubin's ability to transcend both time and place, and to create a totally authentic, credible art form out of his personal pain and suffering. Over the next few years the two men became close friends. In 1909 Kubin participated in the first exhibition of Kandinsky's latest venture, the *Neue Künstlervereinigung*, exhibiting seven 'microscope' pictures (Plate 70: *Thunderstorm*), com-

70 Alfred KUBIN
Thunderstorm MUNICH, Städtische Galerie. 1906. Gouache 32 × 35 cm. Signed. *Kubin*.

71 Alfred KUBIN
Monster Present whereabouts unknown. *c.*1911–12. Ink.

positions created after looking at the 'most delicate plant and animal substances' under a microscope, from 'fragments of crystal or parts of seashells, from layers of flesh and skin, from the pattern of leaves and a thousand other things'. Three years later Kubin took part in the second *Blaue Reiter* exhibition and was represented in the accompanying almanac by three drawings (Plate 71: *Monster*). On the back of one of these drawings Kandinsky scribbled a note to the book's publisher: '*Blaue Reiter* line technique! Handle with the greatest possible care!'

Kandinsky's greatest single achievement during the two and a half years he spent organizing the *Phalanx* society's exhibition programme was the group's tenth show devoted to paintings by French Post-Impressionists and Neo-Impressionists, and including pictures by Signac (Plate 4), Toulouse-Lautrec (Plate 5), Vallotton, van Rysselberghe, Flandrin, Guérin and Laprade. Almost overnight the exhibition confirmed Kandinsky's internationalism, and his indifference to local partisan feeling. Many of Munich's most influential critics denigrated the enterprise, but it was of enormous benefit to many younger artists seeking a new way out of hidebound studio convention, including Kirchner who still had it fresh in his mind's eye when he returned to Dresden after completing his current studies at the Obrist and Debschitz school.

During the winter months of 1901/1902 Kandinsky and his associates in the *Phalanx* society had decided to open their own art school. Situated at 6 Hohenzollernstrasse, in a large three storey building, and staffed by Kandinsky, Wilhelm Hüsgen, Waldemar Hecker

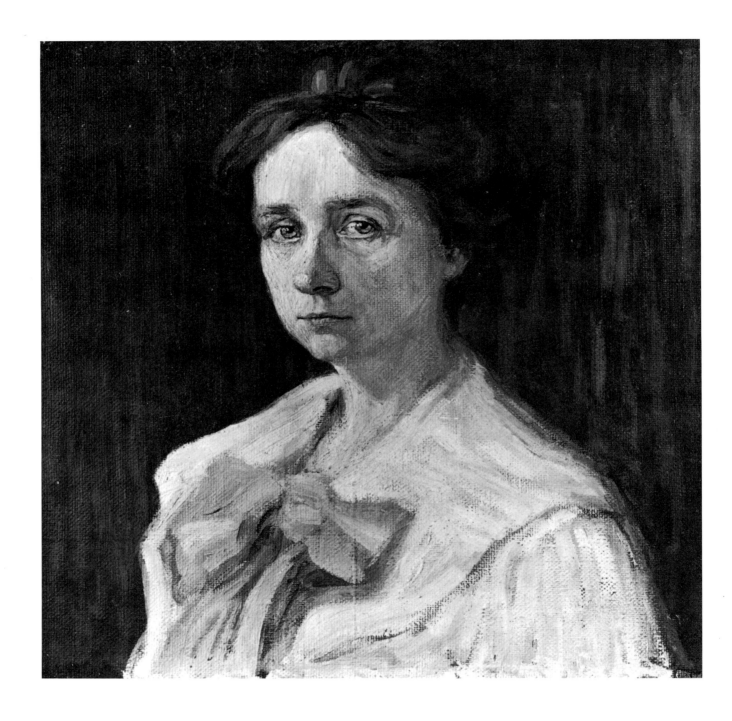

72 Wassily KANDINSKY
Portrait of Gabriele Münter MUNICH, Städtische Galerie. 1905. Oil on canvas 45 × 45 cm. Signed: *K-Y*.

and Gustav Freytag, the school soon attracted a substantial number of students.

One of the first to join, early in 1902, was Gabriele Münter (Plate 72), a former student of the Künstlerinnenverein (Society of Female Artists) in Munich—women still being excluded from the Academy schools at that time—who was eager to work with this energetic team of forward-looking artists. Initially Münter studied with the sculptor Hüsgen but soon afterwards she transferred to Kandinsky's painting class. His exceptional qualities as a teacher were already strongly developed and won many of his colleagues' students over to his classes. Paul Klee later described how Kandinsky's 'exceptionally handsome, open face inspired a certain deep confidence' in those around him, whilst Lyonel and Julia Feininger spoke of 'a warm glow that would shine in his eyes and illumine his entire face as soon as there was a contact established between himself and another person'.

Kandinsky did not adopt a pedantic attitude towards his students but encouraged them to think and observe deeply for themselves, and to resolve their work problems in relation to their own natural aptitude and ability. Gabriele Münter found his way of doing things 'quite a new experience for me, because unlike other teachers, Kandinsky explained all problems thoroughly and intensely, whilst accepting me as a human being with conscious aspirations, who was capable of setting herself tasks and aims'. A close personal relationship grew out of Kandinsky and Münter's early teacher/pupil association, which lasted until 1916 when he returned to Russia.

Much as she admired her new found mentor and friend, Münter—who was an extremely self-possessed and determined young woman—once felt compelled to question the reasoning behind Kandinsky's current preoccupation with the woodcut medium, which to her seemed a frivolous self-indulgence carried out at the expense of his oil painting. Kandinsky retorted vehemently in a letter dated 10 August 1904:

> You call it 'play'. You are absolutely right! Everything an artist does is play. He tortures himself to try and find an expression for his thoughts and feelings. He speaks through colour, form, drawing, sounds, words and so forth. And what for? That is a big question . . . Superficially just play. 'What for?' has very little meaning for an artist. The only question he understands is 'Why?'. That is how works of art are created, as well as things that are not yet works of art but only stages along the way towards them, things that are, even so, small glimmerings of light that sing out from the darkness . . . You saw the way I worked at Kallmünz [see Plate 73]. That's how I do everything that I need to do, it is there within me and must find a way of expressing itself . . . I don't give a damn whether it is difficult or easy, whether it comes quickly or takes a long time, nor whether it has any practical use or not. Now and again someone comes along who gets something out of my works, and is grateful to me for it. [Plate 74].

Kandinsky and Münter now began to travel regularly and for increasingly longer periods of time: Holland in the early summer months of 1904; two long winter sojourns, each of five months duration, the first in Tunis (December 1904–April 1905), the second at Rapallo in Italy (December 1905–April 1906). Kandinsky's work was now being exhibited regularly abroad too: most importantly perhaps between 1905–1908 at the *Salon d'Automne* in Paris, to which city he and Münter removed themselves for an entire year from the summer of 1906. During that winter Kandinsky sent examples of his graphic work to the second *Brücke*

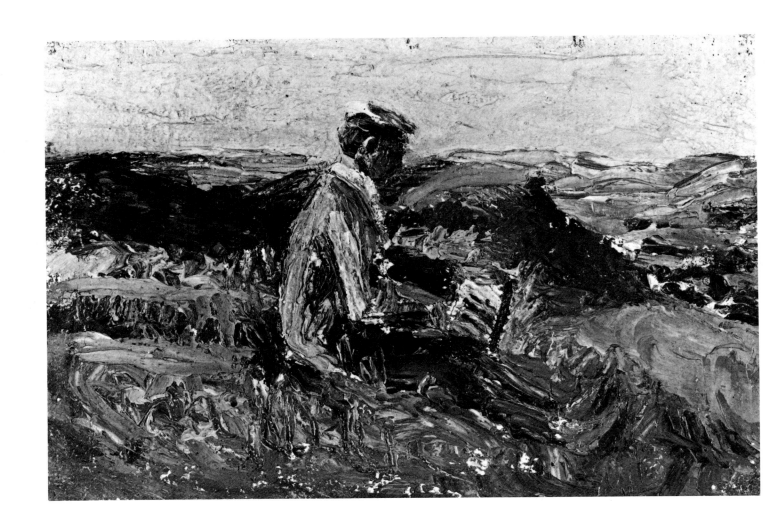

73 Gabriele MÜNTER 1877–1962

Kandinsky painting in a Landscape MUNICH, Städtische Galerie. 1903. Oil on canvas 16.9 × 25 cm. Signed and dated on reverse: *Gabriele Münter 1903*.

During the summer months Kandinsky and his students from the *Phalanx* art school cycled to Kallmünz near Regensburg where they painted in the open air. Kandinsky worked without an easel 'wandering about like a hunter with a paintbox', as he described himself.

74 Wassily KANDINSKY

Farewell

MUNICH, Städtische Galerie. 1903. Colour woodcut
31 × 31 cm.

Farewell was one of seven woodcuts exhibited at the eleventh
Phalanx exhibition in May 1904, which was devoted entirely
to the graphic arts. A smaller version of the same subject was
included in Kandinsky's *Poems without Words*, a hand-printed
portfolio of woodcuts published in Moscow by the
Stroganov press in 1904. The knight's 'classic' profile has
been likened to Stefan George (1868–1933), Germany's
leading Symbolist poet and a frequent visitor to the Munich
home of Karl Wolfskehl (1869–1948) who headed the city's
'cosmic circle' of intellectual aesthetes, and whom Kandinsky
met about this time.

exhibition in Dresden.

From May 1906 until June 1907 Kandinsky and Münter lived in Paris. Her winter
painting of the *View from a Window in Sèvres* (Plate 75), showing the outlook from their
temporary home in the rue des Binelles, transmits her visual experience directly and without
artifice in a basically impressionist style, bold in its use of brush and palette-knife and
brightly coloured, without the neatness of finish traditionally demanded from a painting. In
comparison to Münter's relaxed immediacy of approach, Kandinsky in a painting such as *In
the Park of Saint Cloud* (Plate 76) appears somewhat heavy-handed and uncertain, as if only
half-committed towards rendering a descriptive account of the landscape before him. He had
yet to learn how to make a landscape carry the weight of a 'spiritual' as well as a 'literary'
reference.

'I was once told about a very famous artist who was quoted as saying: ''In painting
take one look at your canvas, half-a-glance at your palette, and ten at the model''',
Kandinsky wrote in 1913. 'It sounded very good advice, but I soon discovered that where I
was concerned the exact opposite was true. I was looking ten times at the canvas, once at
the palette, and giving half-a-glance at nature. In this way I learned how to fight the canvas,
to recognise its capability of withstanding my desire'.

Kandinsky did not look back upon this visit, his third to Paris, with much affection.
Yet it contained many valuable and fertile experiences that in time gave fuller meaning to his
own art, notably the 'discovery' of Henri Rousseau's almost child-like paintings, the revela-
tion of Matisse's flat planes of luminous, anti-naturalistic colour, and the breathtaking
contents of the *Salon d'Automne* in 1906, where he was able to see a major Gauguin retro-

75 Gabriele MÜNTER
View from a Window in Sèvres MUNICH, Städtische Galerie. 1906. Oil on canvas 38 × 36 cm.
Signed: *Münter.*

76 Wassily KANDINSKY
In the Park of Saint Cloud MUNICH, Städtische Galerie. 1906. Oil on cardboard 23.6 × 37.7 cm. Signed by Münter (not by Kandinsky) on the reverse: *Kandinsky Park St. Cloud 1906.*

77 Paul GAUGUIN 1848–1903
Barbaric Tales ESSEN, Folkwang Museum. 1902. Oil on
canvas 131.5 × 90.5 cm. Signed and dated:
Paul Gauguin 1902 Marquises.

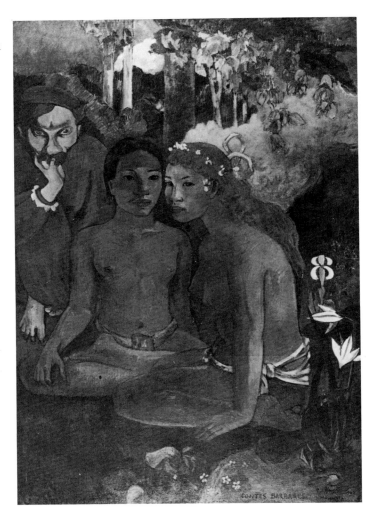

spective exhibition (Plate 77), as well as a large display of Russian art organized by
Diaghilev and including work by Benois, Bakst and other artists closely linked to the *Ballets
Russes* company, whose subjects reflected their interest in Russian folk-art motifs.
Kandinsky's *Couple on Horseback* (Plate XX) was probably painted in Paris the following
year. It is a fairy-tale fantasy filled with a distinctly Russian feeling of melancholy and using
only a few, but extremely vivid colours, some in large, sharply-defined strokes, others
applied as smaller flecks, the whole treatment harking back to the decorative *Jugendstil*
manner exemplified by the *Phalanx* poster in 1901.

III THE NEW ARTISTS' ASSOCIATION

In Munich the first and only serious representatives of the new ideas were two Russians who had been living there for many years working quietly away on their own until they were joined by a handful of Germans.

Franz Marc, *Der Blaue Reiter Almanac*, 1912

After leaving Azbè's school Jawlensky had returned to Paris. The second and most important of his visits to the French capital took place in 1905 and coincided with the emergence of the notorious *Fauve* painters at the *Salon d'Automne*, whose example eventually spurred him on to use colour with a greater sensual richness than before. Jawlensky shared Kandinsky's delight in the primitive, exuberant colours of Russian folk art, and the more passive treatment of form and line which distinguishes Jawlensky's later *fauve*-inspired paintings from the dynamic rhythms of Matisse probably had their origin in this particular source.

The two Russian artists were both represented at the *Salon d'Automne* of 1905. Kandinsky sent in six paintings, four graphics and two craft pieces, whilst Jawlensky exhibited ten recent paintings from his summer visit to Carantec in Brittany. *The Hunchback* (Plate 78) was painted in a harsh, vividly expressive post-impressionist technique. Jawlensky, using the kind of rhetorical phraseology to which he and Kandinsky were sometimes prone, later explained that he wanted to 'translate nature into colours appropriate to the passion of my soul'. The truth of the matter was that he had been deeply impressed by van Gogh whose influence affected not only Jawlensky's choice of subject matter during this period (see also Plate 79: *The Olive Grove*) but also his search for a greater compositional simplicity and a more vibrant use of colour. Kandinsky was not particularly impressed with the result, commenting disdainfully that 'anyone could pick up that style if they had a mind to'. The intense, vigorously alive landscape forms of *The Olive Grove* echoed van Gogh's surging and exalted treatment of a similar motif, but this was a short-lived tendency in Jawlensky's work, soon to be replaced by a more personal iconography on the desire to spiritualise painting.

In 1906 Jawlensky met Jan Verkade (1868–1946), a Dutch painter who during the last decade of the nineteenth century had worked with Gauguin's followers at Pont-Aven. Verkade was now a member of the Benedictine order at Beuron, a few miles south-west of Munich, and famous for its religious school of painting. Over the next few years Verkade communicated to Jawlensky the Symbolists' intellectual and poetic concept of painting as an outward expression of the artist's thoughts and feelings, the subject as such being of secondary importance to the creation of a specific mood or atmosphere. As a result of his discussions with Dom Verkade, Jawlensky adopted a cloisonnist system of thick, dark outlines, simplified forms and rich, warm colour harmonies redolent of the Pont-Aven group (Plate 80). Verkade also spoke about the group of artists known as the *Nabis*, of which he himself had become a member. This group of young French painters from the Académie Julian in Paris led by Bonnard, Vuillard, Denis and Ranson had been converted from their academic training in 1888 to the new aesthetic doctrine of Gauguin by Paul Sérusier's radically simplified little landscape painting *The Talisman* (Collection J. Fr.

78 Alexei von JAWLENSKY 1864–1941
The Hunchback MUNICH, Städtische Galerie. 1905. Oil on cardboard 52.5 × 49.5 cm. Signed:
A. Jawlensky.

79 Alexei von JAWLENSKY
The Olive Grove COLOGNE, Wallraf-Richartz-Museum. 1906. Oil on cardboard 52.5 × 75.5 cm. Signed:
A. Jawlensky.

80 Alexei von JAWLENSKY
Landscape near Murnau MUNICH, Städtische Galerie. 1909. Oil on cardboard 50.5 × 54.5 cm.
Signed and dated: *A. Jawlensky 09.*

Denis). The *Nabis'* theories on art were later summed up by Maurice Denis as a language of subjective and objective distortion which did away with the traditional aim of painting as an imitation of nature. 'Art is no longer just a visual sensation which we record, a mere photograph, however refined, of nature', Denis wrote in 1909.

> No, it is a creation of our spirit of which nature is only the occasion. Instead of 'working with the eye, we search in the mysterious centre of thought', as Gauguin said. Thus imagination again becomes, as Baudelaire wanted, the queen of the faculties. Thus we liberate our sensibility, and art, instead of being a *copy*, became the *subjective deformation* of nature. From the objective point of view, the decorative composition, aesthetic and rational, which was not conceived by the Impressionists because it was contrary to their task for improvisation, became the counterpart, the necessary corrective to the theory of equivalents . . . The *objective deformation* in turn obliged the artist to transpose everything into Beauty. To sum up, the expressive synthesis, the symbol of a feeling, must be an eloquent transcription of it, and at the same time be an object composed for the pleasure of the eyes.

In his autobiography Kubin remembered how Verkade 'this modern painter in priestly garb took a warm and kindly interest in my work, and for my edification sent me a box filled with studies by Denis, Bonnard, Sérusier, Filiger and the others'. In 1907 Paul Sérusier, nicknamed 'the *Nabi* with the glowing beard', visited Munich. Denis, Sérusier and Verkade shared an enthusiasm for abstract ideas which inevitably led them to paint subjects of considerable allegorical or symbolic complexity. Jawlensky, however, always took the most simple aspect of nature as the framework for his essentially romantic and lyrical images—a landscape, a face or a still life—being less concerned with the philosophical elements of Verkade's conversations than with that poetic harmony of colours by which a painter could turn his work into a vivid pictorial equivalent of a received sensation.

Returning once again to Paris in 1907, Jawlensky worked with Matisse (Plate 81), fortifying his recent experiments and research into Gauguin's ambivalent world of exotic mystery with the *Fauve* painter's less self-conscious, vigorous condensation of his sensations, whereby it became possible for him to concentrate the essence of his art into a few intensely coloured, concisely drawn and broadly simplified shapes. Jawlensky leavened the French artist's highly decorative and sensual style of painting with a more characteristically Slavonic tendency towards poetic melancholy and monumental passivity, but Matisse's influence can still be strongly felt in several of Jawlensky's later works, in their bold transcriptions of nature and increasingly radical interpretation of space. Colour, rhythm and a sinuous use of line were Jawlensky's primary resources during the period which now followed at Murnau. Kandinsky himself adopted many of the same expressive methods, heightening his colours, abandoning intermediary values, dealing with representational forms in a purely arbitrary way in an attempt to disclose more meaningful qualities, and constantly bringing into play those inner tensions that stimulated the need to transcend external reality.

A marked air of unreality distinguishes many of Jawlensky and Kandinsky's Murnau landscapes between 1908 and 1910, as if both painters were absolutely set on feeling their way towards the pictorial expression of things that remained unseen, 'things which exist without being'. For all its titular exactness, the subject matter of Kandinsky's *Church at*

81 Henri MATISSE
Joy of Life MERION, Pennsylvania, Barnes Foundation. 1905–6. Oil on canvas 174 × 238 cm.

Froschhausen (Plate 82) appears to be quite incidental to the emotionally expressive force generated by each brightly coloured, structural stroke of the brush. These unmodulated blues, pinks, greens and yellows were never intended to describe the Bavarian countryside nor the atmosphere that softens architectural forms, bathes landscape and veils natural colours. Kandinsky abandoned all the conventional picture-making techniques of *trompe-l'oeil*, resorting instead to a mosaic-like pattern of variously coloured strokes, some short, others long, some spread out in dense, broad areas, others separated and thinly applied. The painting has a slightly distorted look about it, the rhythms are spasmodic and elliptical, its overall effect not unlike that of some of the artist's earlier woodcuts but tinged now with a livelier surface animation reminiscent of the *Fauves*. It must have been such a painting as this which unexpectedly revealed to Kandinsky one day just how close he had come along the uncharted road towards abstraction without even realising it.

It was the hour of approaching dusk. I was coming home with my box of paints after sketching, still dreaming and caught up in my thoughts about the work I had done, when suddenly I found myself face to face with an indescribably beautiful picture

82 Wassily KANDINSKY
Church at Froschhausen LOS ANGELES, Dalzell Hatfield Gallery. 1908. Oil on canvas
45 × 33 cm. Not signed.

drenched with an inner glow. At first I hesitated, then I rushed towards this mysterious picture in which I could discern no visible subject, but which appeared to be completely made up of bright patches of colour. Only then did I discover the key to the puzzle. It was one of my own paintings, standing on its side against the wall. Next day I tried to capture the same effect by daylight, but I was only partially successful. Even when I set the painting on its side I could recognize the objects, and the fine finish supplied by the dusk had vanished. However, I knew for certain now that the depiction of objects in my paintings was not only unnecessary but indeed harmful.

Although Kandinsky effectively liberated colour from any localized description of the real world in paintings such as *Church at Froschhausen*, objects *did* persist for some time to come. Determined as he was to eliminate all reference to natural forms from his paintings, Kandinsky found it impossible to free either himself or his art from everyday memories and impressions. During the next four years, however, he deliberately set out to create wholly abstract forms, detached from all representation, painting pictures characterized by a chaotic, frequently violent, intermingling of form and colour in response to this inner need to express cosmic forces that transcended ordinary human experience. This conscious struggle to invent a pictorial language that had no artistic precedent had its origin in the painter's ambition to take art into a new, unknown world, one in which neither the painter nor the spectator had advantage over the other since both were moving forward slowly together, discovering meanings previously unsuspected. 'I felt more and more strongly that it is the inner desire, or content, of the subject which determines its form', he wrote. 'Thus the realm of art and the realm of nature drew farther and farther apart for me, until I could consider them as absolutely distinct from each other.' This separation between the real world and the world of art was not fully resolved 'in its full magnitude', however, until 1913.

Situated about forty miles south of Munich in the Alpine foothills of the Staffelsee, the village of Murnau was first discovered by Kandinsky and Münter in August 1908, just before they moved into their new apartment in Munich's Ainmillerstrasse. Captivated by its seclusion and unspoilt charm they decided to look for a summer residence there, and soon afterwards Münter bought a small, five-roomed house which served her and Kandinsky, Jawlensky and Werefkin as both home and studio during their visits.

Since their initial meeting in Ilya Repin's painting class at the Academy in St. Petersburg in 1891, Jawlensky and Werefkin had been constant companions. At that time he was still an officer in the Imperial Russian Guard, whilst Marianne, the independently-minded daughter of a high-ranking military commander, had already been studying art for several years, first of all in Lublin and then at the Moscow Art School with Prjanishnikov. After five more years at the Academy, Jawlensky—who in the meantime had become a captain—decided to leave both the army and Russia. In 1896 he moved to Munich, taking Werefkin with him.

After having temporarily given up her own work, Werefkin now returned to painting with gusto. 'I hurl all my feelings into the arena for the artistic triumph of life and activity', she asserted. 'Anyone who chooses to fight with me need fear only one enemy—banality.' There was little of the commonplace about the circle of painters, poets, writers, designers and musicians who congregated regularly in Werefkin's drawing room at the home she

83 Gabriele MÜNTER
Jawlensky and Werefkin MUNICH, Städtische Galerie. 1908–9. Oil on cardboard 32.7 × 44.5 cm.
Not signed.

shared with Jawlensky in the Giselastrasse. Here, the intellectual and cultural interests of the group were hammered out with enthusiasm, whilst Werefkin expertly attended to the comfort of her guests, assisted in her duties as hostess by the young Helene Nesnakomoff (Plate 104) whom she had brought with her from Russia. Brought up as one of the Werefkin family, Nesnakomoff subsequently married Jawlensky in 1922, and moved with him to Wiesbaden, leaving Marianne at Ascona where she remained until her death. (Plate XXI).

'It was a beautiful, interesting and happy time, with plenty of talk about art with the enthusiastic ''Giselisten''' (her pet name for Jawlensky and Werefkin), Münter wrote later in her diary. 'I particularly liked showing my work to Jawlensky. For one thing he was always ready to give generous praise, and for another he explained many things to me, giving me the benefit of his experience and achievement in his talks about synthesis. A nice colleague!' (Plate 83).

At Murnau they discovered a fresh source of inspiration in their search for synthesis and

84 Bavarian Glass Painting
Saint Martin and the Beggar
MUNICH, Städtische Galerie Stiftung Gabriele Münter und Johannes Eichner.

Formerly part of Kandinsky and Münter's large collection of Bavarian glass paintings, this devotional picture representing the saint as a Roman soldier cutting his cloak in two and giving half to a beggar was the original of the hand coloured drawing used as the frontispiece of *Der Blaue Reiter* almanac.

clarity of vision. The traditional, but little known Bavarian folk art of painting on glass was still practised at Murnau. Herr Krötz, a local brewer, owned a large private collection of these pictures which he was delighted to show to Kandinsky and the others. A few years later, when he was compiling material for *Der Blaue Reiter* almanac, Kandinsky asked Krötz for permission to reproduce several examples of his glass paintings in the book, a request which was readily granted. With their naively drawn images, emphatic outlines and bold colour separations, these unsophisticated little genre paintings made their point clearly and without artifice. After studying Herr Krötz's collection, as well as those they collected themselves (Plate 84), the Munich artists began to make their own experiments in glass painting, sometimes carrying the strong, simplified organization of the flat picture surface over into their oil paintings.

Since Kandinsky and Jawlensky had both broken an unwritten rule and exhibited on more than one occasion with the Berlin Secession, they found themselves black-listed by the Munich Secession, a fact which in itself did not particularly concern them since, as Wilhelm Worringer wrote at the time, the Secession had 'grown fat' and complacent, leaving itself wide open to attack from its more enterprising counterpart in the capital. One January afternoon in 1909, whilst the group of friends was taking tea in Werefkin's drawing room,

they decided to form their own independent artists' organization to be known as *Die Neue Künstlervereinigung München* (The New Artists' Association of Munich) or, for the sake of expediency, NKV.

After some hesitation as to who should be nominated president—first choice went to Hermann Schlittgen, a writer and illustrator for the Munich periodical *Fliegende Blätter*, and one of the participants in the seventh *Phalanx* exhibition—Kandinsky was eventually nominated, no doubt on account of his vast experience and proven ability as an organizer. The post of secretary went to Alexander Kanoldt (1881–1939) who had moved to Munich from Karlsruhe a year before, after studying at the local arts and crafts school and the Academy. The important role of chairman to the association's exhibition committee was given to Kanoldt's friend Adolf Erbslöh, a somewhat self-opinionated man and a solidly eclectic artist whose work, despite its professed internationalism—'van Gogh, Cézanne and Jawlensky showed the direction my work should follow', Erbslöh once announced—lacked any searching, or intensely personal, qualities of its own (Plate 85). Erbslöh's fixed ideas on the limits to which an artist might venture in his quest for self-expression soon ran counter to Kandinsky's completely open-minded belief in total freedom of stylistic expression. Münter, Werefkin and Kubin offered their allegiance to the new enterprise, and another dedicated supporter, although not a painter, was the Russian dancer Alexander Sacharov (Plate XXII).

Kandinsky drew up a public announcement, in which the NKV's aims were succinctly laid out:

> We take it that in addition to receiving ideas and impressions from the outside world, that is Nature, the artist is also continually accumulating the experiences of an inner world, and is searching for artistic forms that will express the relationship between each and every one of these experiences—forms which must be freed from all subsidiary roles so as to give vigorous expression to what is essential which is, briefly, the aspiration towards artistic synthesis: this to us seems to be a way of spiritually uniting more and more artists.

Almost a year went by before the public was given an opportunity to see how the NKV artists realized these claims. At first no-one in a position to offer them gallery space wanted to risk supporting a predominantly foreign group of artists, whose leader was well-known by now for his unorthodoxy. Finally, Kandinsky summoned up the courage to approach Hugo von Tschudi who, in 1909, had been appointed director of the Bavarian State Collections of Paintings after losing his directorship of the Nationalgalerie in Berlin for his policy of acquiring modern French art. After listening to Kandinsky put his case, Tschudi agreed to act on their behalf and, faithful to his word, persuaded Heinrich Thannhauser, whose privately owned gallery was generally acknowledged to be one of the best in Munich, to open his doors to Kandinsky and the NKV.

Thannhauser may well have wondered what he had let himself in for when the first NKV exhibition opened on 1st December 1909 to a barrage of public abuse and critical attack (Plate 86: Kandinsky, *Poster for the 1st NKV Exhibition*). Visitors to the gallery literally spat their disapproval at the more controversial canvases, leaving him the unpleasant task of cleaning up after them. The critics were no less violent in their hostility, sparing no

85 Adolf ERBSLÖH 1881–1947

Tennis Court IOWA, University of Iowa Museum of Art. 1910. Oil. Signed and dated: *A. Erbslöh 1910*.

86 Wassily KANDINSKY
**Poster for the first exhibition of
'Neue Künstlervereinigung München'**
MUNICH, Städtische Galerie. 1909. Colour woodcut
27 × 21.5 cm.

amount of venom in bringing Kandinsky and his associates to task for besmirching the fair name of Munich with their insulting foreign daubs.

Writing in the review *Cicerone*, Udhe-Bernays made little attempt at a serious critical appreciation of the paintings he had been paid to comment upon, dismissing the entire exhibition as 'a carnival leg-pull during advent'. But even that kind of derogatory thrust seemed mild in comparison to the broadside fired at them by Georg Jakob Wolf in *Die Kunst für Alle*, who accused the NKV artists of being utterly pretentious and advised his readers not to waste their time on the exhibition but to sample instead Thannhauser's alternative offerings, namely a display of animal pictures by Purtscher and another of Venetian scenes by Felber. 'We were amazed', Kandinsky remembered in later years, 'that in all of Munich, the "city of art", not a single person, with the exception of Tschudi, had a kind word to say

87 Marianne von WEREFKIN 1860–1938
Washerwomen MUNICH, Städtische Galerie. *c.*1908–9. Tempera on paper laid on cardboard
50.5 × 64 cm. Not signed.

about us'. (Plates 87 and 88).

One or two friends expressed their approval. 'Just look!' said one visitor to the
exhibition, possibly Obrist. 'So many outsiders have become residents—the entire face of
the city is changing, even though it is only happening slowly. Then one day, quite
suddenly, Munich will have awakened!' Such enthusiasm was largely confined to those
members of Kandinsky's intimate circle of friends who understood and shared his belief in
an art capable of transcending nationalistic as well as stylistic barriers but, in fact, it was the
large proportion of foreign artists in the NKV exhibition that most incensed the local
critics. Proof of this partisanship was openly forthcoming in Wolf's vitriolic attack on the
association's second show in September of the following year, whilst in January 1911
Erbslöh was forced to sue the highly respected Berlin dealer Paul Cassirer for breaking a
contractual agreement to show paintings by the NKV artists in his gallery because they were

88 Wassily KANDINSKY
The Blue Mountain NEW YORK, The Solomon R. Guggenheim Museum. 1908–9. Oil on canvas 106 × 96.6 cm. Signed and dated (possibly later): *Kandinsky 1908.*

89 Henri LE FAUCONNIER 1881–1945

L'Abondance THE HAGUE, Gemeentemuseum. 1910. Oil on canvas 75 × 49 cm. Signed: *Le Fauconnier*.
Le Fauconnier exhibited only once with the *Neue Künstlervereinigung* in 1910, and not at all with the *Blaue Reiter*, although he supported Kandinsky's break with the association, and was represented in the almanac by two illustrations, one of which was *L'Abondance*. Although his relationship to Kandinsky's Munich activities was peripheral, Le Fauconnier provided the Germany based artists with an early insight into the Cubists' methods of disposing of anything even vaguely illusionistic by extending the geometrical faceting of forms into the surrounding space so as to create a totally consistent structural picture surface. In *L'Abondance* the figures of mother and child sink into the surrounding landscape forms. Marc later adopted this new kind of integrated pictorial space from Delaunay and adapted it to suit his own personal thematic repertory.

not 'works by Munich artists'.

'The beautiful and culturally renowned name of Munich is being used as a roost for an artists' association of mixed Slavic and Latin elements', Wolf railed on seeing Kandinsky's unrepentant, indeed reinforced, line-up of foreign dissidents at the second NKV exhibition in 1910. 'Furthermore, they are hostile towards Munich's tradition in the arts . . . There is not one Munich painter amongst them. How then do they dare to describe themselves as a Munich group? They do not even work or feel like those who come from Munich'.

Much of the controversy this time was sparked off by Kandinsky's decision to invite a large contingent of young artists from Paris to take part: Georges Braque, André Derain, Kees van Dongen (Plate 31), Pablo Picasso, Georges Rouault, Maurice de Vlaminck and Henri Le Fauconnier (Plate 89) all submitted work. The most forceful impression was made by the Cubists who had pushed Cézanne's treatment of nature 'by the sphere, the cylinder and the cone' to a logical but infinitely more daring conclusion, fragmenting figures and objects as well as the surrounding space with a ruthless indifference to illusionistic convention. The more recent work of Derain and Vlaminck also manifested a new, disciplined approach to form in response to the highly influential Cézanne retrospective exhibition held at the *Salon d'Automne* in 1907. The two Russian brothers David and Wladimir Burljuk also exhibited pictures showing the impact of Cubism which quickly found converts amongst the Munich painters, although Franz Marc decried Erbslöh and Kanoldt's stiff and lifeless 'aping of fashionable Cubist ideas'. One aspect of analytical Cubism which found little favour with the German artists, however, was its use of drab, monochromatic colours. The vibrant, sensual palette of Matisse's *fauve* paintings appealed far more strongly to their emotional taste. To Kandinsky's great delight and surprise a voice was now raised in public defence of the NKV's epoch-making exhibition programme.

'One day Thannhauser showed us a letter from a Munich painter unknown to us, congratulating us on our exhibitions, and declaring his enthusiasm in the most vehement terms', Kandinsky recalled. 'This painter was Franz Marc, a "real Bavarian", who at that time was living in a farmhouse at Sindelsdorf'.

Infuriated by the insensitive and jingoistic press notices directed against Kandinsky's enterprise, Marc had felt compelled to take up the critical cudgels in defence of the NKV, drawing attention to its natural development of post-impressionist theories, and its importance as the only locally based artists' group to keep in step with current international

tendencies.

'This bold undertaking that ''spiritualises'' the subject matter of the Impressionists is a necessary reaction which first began with Gauguin at Pont-Aven, and has already produced countless experiments', Marc wrote in his pamphlet. 'The way in which this exhibition has been condemned by the Munich public is almost amusing. They behave as if the paintings were a few isolated abberations of sick minds when, in reality, they are sober, austere shoots in a soil that is being turned for the first time. Doesn't anyone realize that the same innovatory, creative spirit, at once restless and confident, is today at work throughout Europe?'

Kandinsky was so impressed by this unsolicited and eloquent defence of the NKV that he went out of his way to meet their unknown champion.

'Marc's appearance accorded perfectly with his inner nature', he wrote. 'A tall man with broad shoulders, a firm walk, and an expressive face with highly individual features, revealing a rare combination of strength, penetration and good temperament . . . One conversation was enough. We understood each other perfectly. In this unforgettable man I found a rare example—is it any more common today?—of an artist capable of seeing beyond the limits of mere unionism, a man inwardly, rather than outwardly, opposed to every kind of restrictive, suffocating tradition'.

Marc was accepted as a member of the NKV in January 1911 but, as events turned out, he did not take part in what was to be its third and final exhibition.

Prior to his decisive meeting with Kandinsky, Marc's career as a painter had followed an industrious but somewhat diffident course. Originally intending to become a priest, he had abandoned his theological studies in 1898 at the age of eighteen in order to study philosophy at the University of Munich. Two years later, he decided to become a painter like his father, entering the drawing and painting classes run respectively by Gabriel Hackl and Wilhelm von Diez at the Munich Academy, where he was taught in the traditional, studio-orientated naturalistic style favoured by his teachers. Marc emerged from this experience in 1902, a competent but uninspired painter of orthodox studio compositions whose subject matter, as well as the technical methods employed, tended to look backward towards the mid-nineteenth century realistic tradition, often tinged with a touch of the personal melancholy and aching romanticism that was to colour these early years of questioning self-doubt and indecision (Plate 90).

The by now compulsory pilgrimage to Paris took place for Marc in 1903. He also visited Brittany, and the impact of its magnificently brooding landscapes elicited a typically lyrical, rather breathless response from the impressionable young man. 'There a painter finds patterns he can look up to—atmosphere, light, and magnificent views such as I scarcely knew existed, compelling the eye to see, and constantly stimulating you to study and paint them', he wrote home. Maybe he had seen Charles Cottet's paintings of Breton scenes when they were exhibited at the Munich Secession in 1902, and remembered how the French artist had succeeded in realising an emotional unity between his rugged subject matter and his naturalistic style. At any rate Marc tried his hand at open-air painting, applying pigment in a slick but impersonal way, and reinforcing his rather dreary palette of greens, browns and greys with a more up-to-date brightness. Even so, the results as seen in paintings such as the *Self Portrait in a Breton costume* (Plate 91) are less than spellbinding, and

90 Franz MARC 1880–1916
Portrait of Sophie Maurice Marc, the Artist's Mother
MUNICH, Städtische Galerie. 1902. Oil on canvas
98.5 × 70 cm. Not signed. (Lankheit 2).

hardly seem sufficient to bear out Marc's claim, expressed at this time when he was beginning to take an interest in impressionism, that the Impressionists were 'the only salvation for us young artists'.

Most of the time his serious religious outlook on life made it difficult, if not completely impossible, for him to come to terms with the happy-go-lucky atmosphere that inevitably went hand-in-hand with the avant-garde art scene in both Paris and Munich. As if to escape from the necessity of having to commit himself one way or the other, Marc took summer refuge in the mountains where he painted a number of disheartened, rather nondescript landscapes and nature studies. If he was looking for a solution to his problems Marc certainly did not find it in an ill-advised and hasty marriage to the painter Marie Schnur, from whom he fled on their wedding night, not stopping until he reached Paris. This second 'visit' to the French capital took place over Easter in 1907.

Van Gogh 'is the most authentic, the greatest, the most poignant painter I know', Marc wrote from Paris at this time. 'To paint a bit of the most ordinary nature, putting all one's faith and longings into it—that is the supreme achievement.' Gauguin's paintings also

91 Franz MARC

Self Portrait in a Breton Costume DARMSTADT, Hessisches Landesmuseum. 1904–6.
Oil on canvas 99 × 60.5 cm. Signed: *F. Marc*. (Lankheit 21).

drew his warmest praise and now, for the first time, he began to express a desire to seek out the 'inner truth of things' in his own work. The possibility of creating a truly meaningful art form capable of replacing the social and cultural void left empty by the widespread loss of religious belief seemed infinitely desirable to Marc. Closely allied to this idealistic dream was the personal need for redemption and, if it was at all possible, fulfilment through painting. Yet still he hesitated, producing virtually no work at all during this second Paris sojourn apart from a few sketches, apparently unable to translate the lessons of his chosen models into a coherent, independent style.

Part of the problem was caused by Marc's growing awareness of a deep-rooted, psychological dislike of man. How could he use such an impure vehicle to carry the full weight of his message of hope without seriously compromising its value and significance? Thus, like Kandinsky at a crucial moment in his formative development, Marc, because he found man ugly and diminishing, was forced to look elsewhere for a visual metaphor compatible with the noble ideals he wished to embrace in his art. To begin with he painted 'the simplest things'—a wheatsheaf or a larch tree (Plate XXIII) because only in these natural forms, which clearly evoke van Gogh's influence, were 'the symbolism, the pathos and the mystery of nature to be found'. On occasions, it is true, the human figure is allowed to emerge clearly in Marc's work, but these instances are rare and in almost every instance the male or female body is presented in a state of naked, primal innocence as in *Red Woman* (Plate 92) where the imaginatively recreated, unspoilt paradisial mood is reminiscent of Gauguin's idealization of the European tainted Tahitian landscape in which he sought refuge from western decadence. More important still, in paintings such as *Nude Woman with a Cat*, 1910 (Munich, Städtische Galerie) and *Young Boy with a Lamb*, 1911 (New York, The Solomon R. Guggenheim Museum) Marc purified the human element by placing it firmly in that animal world which he gradually came to find 'more beautiful and clean' than any other.

On his return to Munich in 1907 Marc embarked on an intensive study of animal anatomy. The zoological gardens in Munich provided him with a rich source of living specimens which he drew with faithful, loving veracity (Plate 93: *Elephant*). He also spent a good deal of time working in the natural history museum where he was able to study in detail collections of animal bones. From this period of dedicated application Marc acquired that complete mastery of form which later enabled him to establish the sheer physical animality of his subjects even when he was beginning to adapt the expressive colour methods of the *Fauves*, Kandinsky and Delaunay to his own personal thematic subject matter. In the meantime, he put his recently acquired knowledge to good practical use over the next three years by giving lessons in anatomical drawing to other artists, his only source of regular financial income until the summer of 1910 when Bernhard Koehler, a wealthy Berlin manufacturer, provided him with a monthly allowance of 200 marks.

An important part was played in shaping and directing Marc's belief in the superiority of animal life by a young Swiss painter Jean Bloé Niestlé whom he had met in 1905, when Niestlé was still a student in Moritz Heymann's Munich studio. Niestlé was a gentle, highly perceptive animal painter, whose portrait Marc had sketched in charcoal a year after their meeting, showing him like a young, melancholic Saint Francis, contemplating a trustful flock of birds. Niestlé subsequently went to live with Marc at Sindelsdorf, feeding his mind

92 Franz MARC

Red Woman LEICESTER, Leicestershire Museum and Art Gallery. 1912. Oil on canvas 100.5 × 70 cm. Signed and dated on reverse: *Fz. Marc 12*. (Lankheit 174).

93 Franz MARC
Elephant
HAMBURG, Kunsthalle. 1907. Crayon 41.5 × 32.8 cm.
Not signed. (Lankheit 294).

with a romantic sympathy for animals as a more chaste form of life, but always basing this
yearning after a more perfect world on the most meticulously executed, naturalistic studies
of wild life (Plate 94). 'He is a very shy, very young artist', Marc wrote in October 1905,
'filled with such a deep melancholy that, when you see his drawings, makes you suffer with
him. Technically they remind me of the Japanese, except that Niestlé's feelings go deeper
and, what is even more astonishing, he is much more precise'.

Niestlé, however, did not seek to invest his animals with any spiritual attitude of mind
such as that expressed by Marc when he told Reinhard Piper, the Munich publishers, that
more than anything else he wanted to 'intensify my feeling for the organic rhythm of all
things, to achieve pantheistic empathy with the throbbing and flowing of nature's blood-
stream—in trees, in animals, in the air'. Marc's style had, in fact, already undergone a subtle
change from the exuberant but uncomplicated linear quality of an early animal study such as
Jumping Dog: 'Schlick' (Plate 95) to the altogether more mysterious and evocative *Deer in the
Reeds* (Plate 96), painted five years later. In that picture the two animals, beautifully drawn
and sensitively painted in a light, impressionistic impasto, are rhythmically arranged both in
the relationship to each other and to the swelling landscape forms of the grassy knoll on

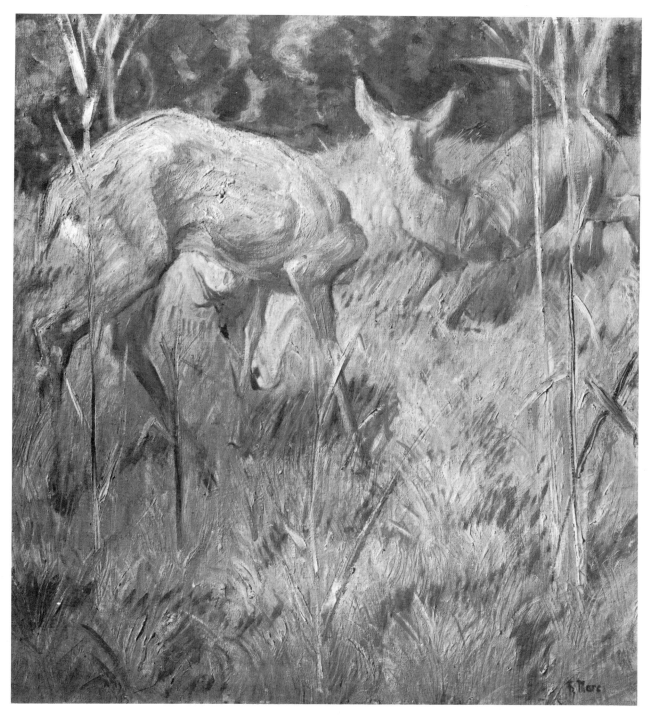

96 Franz MARC
Deer in the Reeds MUNICH, Bayerische Staatsgemäldesammlungen. 1909. Oil on canvas
88.5 × 78.5 cm. Signed: *Fz. Marc*. (Lankheit 94).

(Opposite Top)
94 Jean BLOÉ NIESTLÉ 1884–1942
Migrating Starlings MUNICH, Städtische Galerie. 1910. Oil on canvas 90 × 151 cm. Signed and dated:
J.B. Niestlé 10.
Originally owned by Bernhard Koehler, whose patronage extended to placing a house at Niestlé's disposal
when he left Sindelsdorf in 1914.

(Opposite Bottom)
95 Franz MARC
Jumping Dog—'Schlick' MUNICH, Städtische Galerie. 1904. Oil on cardboard 54.5 × 67.5 cm.
Not signed. (Lankheit 25).

which they stand. Each animal is clearly individualized. The foremost one with downturned head looks placidly to the ground in search of food, whilst its companion, its attention diverted by some disturbance outside the picture frame, twists its head violently back over its shoulder and pushes itself up into a half-standing, half-kneeling position as if in preparation for flight from some impending danger.

By January 1910 when Marc's first one-man exhibition opened at the Galerie Brakl in Munich's Goethestrasse he had come a long way towards realising that 'animalization of art' which a little over a year before he had declared to be his aim. Yet at the same time he felt something vital was still lacking, a fact indicated by the destruction of no less than ten large paintings between 1908 and 1910. A partial solution to Marc's recurring problem in making his animal forms sufficiently expressive of that other, non-human world which they inhabited, was provided by his meeting with the young August Macke. Macke introduced himself after seeing Marc's exhibition which had impressed him by its naturalness and quiet, contemplative attention to inner detail and mood, qualities which also informed Macke's own work as in the contemporary portrait of his young bride Elisabeth Gerhardt (Plate 97: *Girl with a Dish of Apples*), with whom he was then living at Tegernsee in Upper Bavaria.

Macke would have appreciated his new friend's use of parallelism in his animal pictures, the emphasis on rhythm and the carefully orchestrated attitudes, whose source can ultimately be traced back to Ferdinand Hodler, a highly influential Swiss painter, whose symbolic use of stylized gestures sought to express a universal quality that united all human beings. In *Fishermen on the Rhine*, painted in 1907 (Plate 98), Macke had based his compositional design on the simple kind of symmetrical arrangement preferred by Hodler. The rather cold, static quality of the landscape is broken firstly by the repeated curvilinear rhythms of the fishing rods, the diminishing line of isolated figures and the single dog, each one arranged like a musical notation along the river bank, and secondly by the underlying humanity which brings this strange little scene to recognizable life.

After completing a traditional course of training in Düsseldorf under the old academician Eduard von Gebhardt, a leading member of the local school of naturalistic religious painting, Macke made his first trip to Paris in 1907, a journey made possible with the financial help of Bernhard Koehler, the uncle of his future wife. Being in Paris 'means as much to me perhaps as two years' work', Macke wrote to his benefactor. 'I see everything quite differently, everything has a kind of elevation such as I have never experienced before . . . I want to be able to paint in such a way that my brush will dance across the canvas—no brown sauce painting for me'.

With remarkable facility and intelligence Macke took over the new colouristic pictorial language of the French Impressionists and their successors, consolidating his discoveries during the summer months of the following year when he returned to Paris. On this second visit he met Félix Fénéon, arch defender and advocate of neo-impressionism, at whose house he saw Seurat's *Sunday Afternoon on the Island of La Grande Jatte* 1884/86 (Chicago, The Art Institute of Chicago) and *Le Chahut*, 1890 (Otterlo, Kröller-Müller Museum). In a charming open-air painting of 1908 *Sunny Garden* (Plate 99) Macke wedded his fondness for Renoir's natural, unforced subject matter with Seurat's dazzling pointillist brush stroke. It is a young man's painting, full of light and warmth, and the excitement of new ideas enthusiastically seized upon and applied with unselfconscious assurance and gaiety.

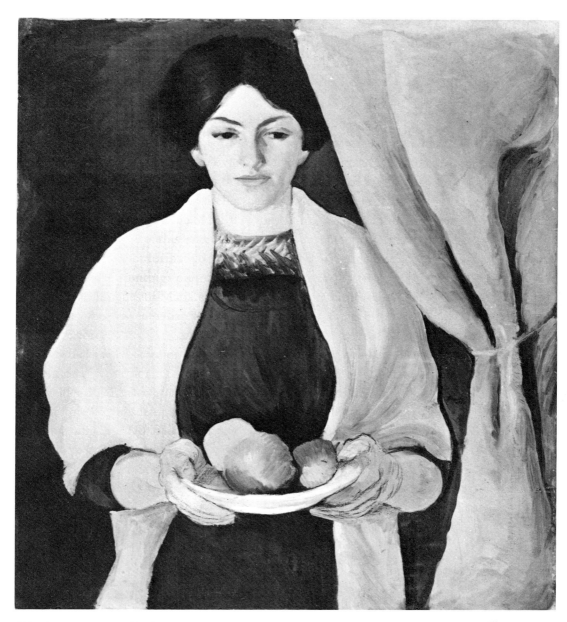

97 August MACKE 1887–1914
Girl with a Dish of Apples MUNICH, Städtische Galerie. 1909. Oil on canvas 66 × 59.5 cm.
Signed and dated: *A. Macke 1909*. (Vriesen 100).

For Macke his simultaneous acquisition of impressionist, neo-impressionist and *fauve*
tendencies was a means of re-ordering his own personal vision of the world about him into a
more fully expressive style. Like many of the young German artists of his generation,
including his close friends Marc and Klee, he had a life-long admiration for modern French
painting. Even when he was studying in Berlin under Lovis Corinth, a leading member of
the city's Impressionist circle, between 1907 and 1908, Macke preferred looking at the
contemporary French paintings purchased by Hugo von Tschudi for the Nationalgalerie
since his appointment as director in 1896. Between 1908 and 1910 the Berlin Secession

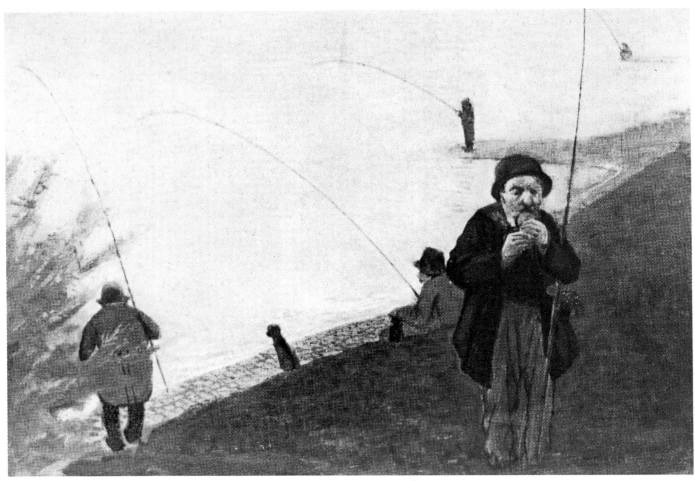

98 August MACKE
Fishermen on the Rhine MUNICH, Städtische Galerie. 1907. Oil on canvas 40 × 45 cm.
Signed and dated: *Aug. Macke 07*. (Vriesen 31).

staged exhibitions that must also have been of great interest to Macke, containing as they did works by most of the great late nineteenth and early twentieth century French innovators, including van Gogh, Manet, Monet, Renoir, Bonnard, Cézanne and Matisse. Macke's sensitivity to these influences enabled him to develop a broader, freer style, and by the time he met Marc in 1910 his painting was already confidently accomplished and assured in its graceful approach to the lessons of French painting.

Like all his chosen models Macke's work always took the external world of nature as its foundation. 'There is nothing of the transcendental in his nature, and all ideas of the beyond are foreign to him', his friend Lothar Erdmann wrote in 1908. 'He considers philosophising on metaphysical problems a waste of time . . . sees only the present, and takes life as it comes, rather than as it has become'. Macke's passionate concern for nature was a deeply-rooted part of his creative make-up as he expressed quite clearly in a letter written to Sofie

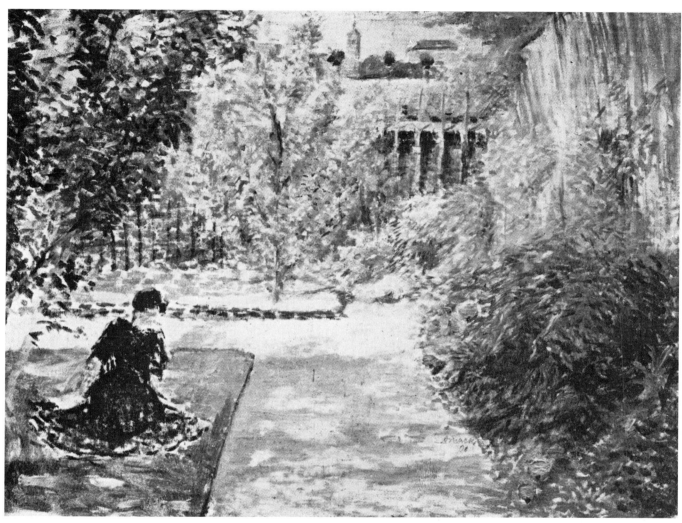

99 August MACKE

Sunny Garden PRIVATE COLLECTION. 1908. Oil on canvas 51 × 65 cm. Signed and dated:
A. Macke 08. (Vriesen 71).

Gerhardt in February 1910 from Tegernsee where he and Elisabeth were living:

> We can see the pine trees, tall and overgrown with lichen. The mountains, the lake and
> the buds beneath their burden of snow waiting for spring to come. And then there is the
> cat [see Plate 100: *Household Gods*, painted on 18 February 1910 at Tegernsee], and dogs
> and horses and people. This continuous intimacy gives one a tremendous feeling of
> admiration for nature, and everything in it, one feels a part of it, and not just a stranger
> who only knows about it from reading books. All those mountains, those sunbeams,
> and those animals flow through one's blood like an electric current. For me there is no
> greater happiness. The only irritating thing about all this is the artist's inability to paint
> it all. But there again, he only has to produce an image, a song about beauty.

Macke's work was a constant reaffirmation of his unaffected delight in this earthly paradise

100 August MACKE

Household Gods: Still life with Cat PRIVATE COLLECTION. 1910. Oil on canvas 69 × 74 cm.
Signed and dated: *18 Februar 1910 August*. (Vriesen 124).

of which he found himself to be a part, and in his paintings he recorded its small, apparently
insignificant, moments of pleasure with a penetrating and tender eye for the underlying
currents of feeling that made them memorable. People strolling by a lake or on a sunlit
terrace (Plate 122), children standing in rapt silence as they come face to face with the
animals at a zoo as in *Large Zoological Garden* (Plate 101), a portrait of his wife absorbed in
her book (Plate 102), these were the subjects Macke preferred. In them it is as if all worldly
cares have been temporarily laid aside, self-consciousness has been forgotten, and these men
and women once again experience something like their former state of lost innocence. Their
figures are static and calm in the midst of activity as they wait, quietly observing the ebb and

101 August MACKE
Large Zoological Garden DORTMUND, Museum am Ostwall (Gröppel Collection). 1912.
Oil on canvas. Triptych: Two side panels 129.5 × 65 cm. Centre panel 129.6 × 105 cm.
Signed and dated: *August Macke 1912*. (Vriesen 363).

flow of life around them—and it was no mere artistic affectation that made Macke show his characters either sunk deep in thought or in the act of silently watching. The passing moment becomes fixed in time—Macke later was helped in his desire to suggest a more complete representation of life by Delaunay's method of the use of light and colour in simultaneous contrast—with a painterly eloquence inspired by the artist's principal sources but ultimately translated into his own unique and instantly recognizable personal style.

Macke's later involvement with Marc and Kandinsky seemed, temporarily at least, to confuse his artistic development rather than to advance it (see below, Plate 112: *Storm*). Whereas Marc was ready to follow Kandinsky into an immaterial world of spiritual reality, Macke remained sceptical about so many high-minded aspirations. 'Kandinsky, Bechtejeff and Erbslöh all have enormous artistic sensitivity', he wrote to Marc in September 1910 after seeing the second NKV exhibition, 'but their methods of expression are too large for what they are trying to say . . . and as a result the human element is missing. I think they are concentrating too much on form'. Although Macke's viewpoint was essentially different from the others, in the early stages of their friendship he was enormously valuable to Marc, educating him to appreciate the full potentiality of colour as a releasing agent for the

102 August MACKE
Study of the Artist's Wife BERLIN, Nationalgalerie. 1912. Oil on card 105 × 81 cm. Not signed.
(Vriesen 306).

[DER BLAUE REITER]

emotions. 'I have made the following new discovery about painting', Macke wrote to his friend Hans Thuar in February 1914. 'There are some colour harmonies, let's say a particular red and green that begin to move and vibrate when you look at them. If you are looking at a tree in a landscape, you can either look at the tree or at the landscape, but not at both simultaneously because of the stereoscopic effect. When you are painting something that is three-dimensional, the vibrating colour harmony is the three dimensional effect of the colour, and when you paint a landscape, and the green foliage vibrates a little against the blue sky showing through, that happens because the green is on a different plane from the sky in nature too. To discover the space-creating energies of colour instead of being content with a dead chiaroscuro is the artist's finest task'. Written four years after his meeting with Marc and in the light of Delaunay's *Window* paintings (Plate 108) and the example set by the Italian Futurists, the foregoing illustration of Macke's gift for setting out his ideas clearly and persuasively provides a taste of the kind of exchange which Marc must have appreciated and turned to his advantage at the time of their meeting.

Marc was fully awakened to the expressive power of pure colour relationships when he came face to face with Kandinsky's 'vigorous, pure and fiery colours' at the NKV exhibition held in Munich between 1st–14th September 1910. 'It was as if, quite suddenly, through this eruption, powerful forces were released which had previously been held in check by his inhibitions', Maria Franck-Marc recounted later, remembering her husband's excited response to Kandinsky's paintings. 'Through the experience of Kandinsky's work, the scales were removed from his eyes and he realized almost at once why his own paintings did not have a unified effect. At that time he wrote: "Until now everything has been conceived organically except colour"'.

Kandinsky's most important painting in the second NKV exhibition was *Composition 2* (see Plate XXIV: *Study for Composition 2*), which demonstrated a major advance in the reduction and elimination of natural objects in his work in addition to its new found colouristic brilliance. Although many of the forms which appear in *Composition 2* can ultimately be traced back to the artist's formidable memory bank of ubiquitous fairy-tale horsemen, as well as including women and children and more generalised figures mysteriously grouped together, they have all been radically contracted down and compressed into an ambiguous, complex tangle of obscure formal relationships enclosed within an undefined space. A space full of strange, vigorous rhythms that seemingly have little to do with an overt transcription of nature. Confronted by this painting which challenged all his preconceived notions about a picture's traditional naturalistic function, Georg Jakob Wolf suggested that a more suitable title might have been 'Colour Sketch for a Modern Carpet'.

Before the end of the year Marc also came into his own as a colourist. The bold, expressive colours employed in *Horse in a Landscape* (Plate XXV) have no representational fidelity to nature, and the dynamic red of the animal's body gives it an enriched power and individuality far removed from the objective naturalism of his earlier work. Furthermore, by using a completely arbitrary range of colours throughout his composition, Marc was able to create a strong, suggestive relationship between the horse and the landscape. A vibrant rhythmic movement running through the hilly background finds its formal counterpart in the horse's swelling musculature and, although Marc has remained faithful to an anatomical

[151]

concept of form in his realisation of the animal's sleek elasticity, the form itself has been suitably simplified so as not to detract from the supremacy of the brilliant colour concords. 'Every colour must clearly state who and what it is', he wrote in January 1911, 'and must, above all else, be related to a clear form'. These words echoed Kandinsky's 'colour cannot stand alone, it cannot dispense with boundaries of some kind', in *Über das Geistige in der Kunst*, which, although not published until the end of that year, had been written for some time and was simply awaiting a publisher.

In keeping with Kandinsky's emotionally intense theories on colour symbolism as expressed in that essay, by early 1911 Marc had also developed his own ideas on the subject. Like Seurat and many other distinguished interpreters of the expressive language of painting, the most recent probably being the *Jugendstil* art critic Karl Scheffler who had explained his system in 'Notizen über Farbe' (Notes on Colour) published in 1901 in *Dekorative Kunst*, Kandinsky firmly believed that certain colours were capable of suggesting different kinds of mood and feeling. Thus, Kandinsky wrote in *Über das Geistige in der Kunst*:

> The power of profound meaning is found in blue . . . the deeper its tone, the more intense and characteristic the effect. We feel a call to the infinite, a desire for purity and transcendence. Blue is the typical heavenly colour . . . Green is the most restful colour, lacking any undertone of joy, grief or passion . . .

and

> Yellow is the typical earthly colour [and] has a disturbing influence; it has an insistent and aggressive character. The intensification of yellow increases the painful shrillness of its note, like that of a bugle.

Marc's account of his theory of colour symbolism was given in a letter to Macke written in December 1910:

> Blue is the *male* principle, severe and spiritual. Yellow is the *female* principle, gentle, happy and sensual. Red is *matter*, brutal and heavy, the colour that always has to be opposed and overcome by the other two. For instance, if you mix blue—serious and spiritual—with red, you intensify the blue to the point of unbearable sorrow, and yellow —conciliatory—the complementary colour to purple, becomes indispensable . . . If you mix red and yellow to make orange, you turn passive, feminine yellow into a Fury, with a sensual strength that again makes cool, spiritual blue indispensable, the male, and in fact blue always finds its way instinctively to the side of orange, the colours love one another. Blue and orange make a thoroughly festive sound. But then if you mix blue and yellow to produce green, you activate red, matter, the earth, but as a painter I always sense a difference here, because it is never really possible to subdue eternal, material, brutal red with green alone, as with the other colour notes . . . Green always needs the help of more blue (sky) and yellow (sun) in order to still matter.

Kandinsky's meeting with Marc was of the utmost importance in introducing him to someone capable of sharing his belief in the modern artist's role as a harbinger of cultural and social regeneration. Both men vehemently opposed the thesis of 'art for art's sake' and dedicated themselves to restoring the 'mutual relationship between art and society', which

had all but disappeared beneath the dead hand of European materialism. 'Painting is an art, and art is not vague production, transitory and isolated, but a power which must be directed towards the improvement and refinement of the soul', Kandinsky proclaimed in *Über das Geistige in der Kunst*. 'If art refrains from doing this work, a chasm remains unbridged, for no other power can take its place in this activity . . . The artist must have something to say, for mastery over form is not his goal, but rather the adaptation of form to inner meaning'. If a complete stripping away of the old accepted aesthetic values was necessary to achieve a new, dynamically positive and expressive art form that addressed itself directly, and without illusionistic contrivance, to the spectator's heart and mind, then Kandinsky and Marc were determined not to hesitate in purifying their work of all wordly associations. 'We no longer cling to the reproduction of nature', Marc wrote in 1912, 'but destroy it, so that the mighty laws which hold sway behind the beautiful exterior can be revealed'.

In Kandinsky's case this resolution to reveal in his own painting that 'reality which is visible behind things' had, by the summer months of 1911, carried him so far away from anything remotely resembling a naturalistic subject picture, that the more cautious members of the NKV, those in fact centred around Erbslöh and Kanoldt, began to stir restively. 'A painting is not only expression but also representation', declared Otto Fischer in an article published by the NKV in 1912 as a defence of the conservative element's stand against the radicals. 'It is not a direct expression of the soul, but of the soul in relation to the subject. A painting without a subject is meaningless. A picture that is half subject and half soul is sheer delusion. These are the false reasonings of mindless fanatics and imposters. These confused individuals may well talk about the spiritual, but the spirit clarifies, it does not confuse. A few colours and spots, a few lines and dots do not constitute art'.

Kandinsky did not waver in his chosen course of action, and Marc offered him enthusiastic and unfailing support in his stand against the NKV reactionaries who now began to close rank against their leader. 'Along with Kandinsky, I clearly foresee that when the next jury meets in late autumn a horrible argument will result', Marc wrote to Macke on 10 August 1911, 'and that either then or at the next available opportunity a split will occur, leading to the resignation of one or other of the parties. The question is, who will stay?'

Anticipating a final break, Kandinsky and Marc began to make preparations for their own independent exhibition, and asked Thannhauser to keep aside part of his gallery space for their use should the need arise. In the meantime, the autumn months were filled with the business of compiling articles, essays and illustrations for an ambitiously conceived book they were jointly editing, dedicated to exploring and elucidating the kinship between different art forms, with particular emphasis being placed on painting and music. The articles were to be 'written exclusively by . . . painters and musicians of the first rank', in an attempt to overcome 'the pernicious segregation of one art from another, of art from folk art or children's art, or from ethnography'. Writing to Marc in June 1911 Kandinsky had announced that for the illustrations 'we will place an Egyptian work beside a child's small drawing, a Chinese work beside a Rousseau, a folk print next to a Picasso, and so on!'

Painters, writers and musicians in France, Germany and Russia were approached for contributions, whether it be in the form of essays or photographs. Macke travelled from Bonn in October to join Marc at Sindelsdorf where he enthusiastically began to help him sort through the vast amount of ethnographical material which had already been received.

Determined to include nothing but the best, Kandinsky declared on 1 September in a letter to Marc that only 'Schönberg must write on German music' and he even threatened to cancel the whole undertaking rather than to publish without the controversial Viennese composer's promised article.

As time passed it became necessary to decide upon a title for the book, which Reinhard Piper had agreed to publish providing the two editor friends were willing to meet all the financial costs involved.

'We invented the name *Blaue Reiter* whilst sitting around a coffee table in the Marcs' garden at Sindelsdorf', Kandinsky wrote in recollection of the deceptively informal christening of their book during one of his frequent visits to the Marcs' farmhouse home at Sindelsdorf—this one occurring between 12–15 October 1911. 'We both loved blue, Marc liked horses, and I liked riders, so the name came of its own accord, and afterwards Frau Maria Marc's excellent coffee tasted even better'.

Kandinsky's disarming account of the inception of the name *Der Blaue Reiter* cannot hide the fact that there was obviously nothing at all fortuitous in the friends' choice of this particular title, by which their whole ideological programme of activities was to be identified for future generations. Both Marc and Kandinsky had clearly specified the symbolic significance which the colour blue represented to them in their separate colour theories. For Kandinsky it was the 'typical heavenly colour', for Marc it was 'severe and spiritual', therefore it was the most obviously relevant colour to symbolize the book's inner quest for harmony and the rebirth of ideas. Significantly, in his cover design for the almanac (Plate 103) Kandinsky used both blue and red. In *Über das Geistige in der Kunst* the reason for this apparent anomaly is made clear: 'this very placing together of red and blue was so beloved by the primitives of Germany and Italy that it has survived until today . . . One frequently comes across a red gown and a blue cloak in painted sculpture and popular paintings of the Virgin, as if the artists wanted to express heavenly grace in human terms, and humanity in terms of heaven'.

The horse motif was of primary importance in the work of both Kandinsky and Marc, and in European art generally the horse had always been traditionally associated with an instinctual, ecstatic life force, what D. H. Lawrence described in *Apocalypse* as the 'symbol of surging potency and power of movement, of action in man'. These are the very qualities engendered by the violent subject matter of fighting stallions in the woodcut by the sixteenth century German artist Hans Baldung Grien which Kandinsky and Marc selected to illustrate in the almanac. The horse was the major theme of Marc's work, evoking a world of lost innocence and naturalness which the artist now redefined, inviting the spectator to identify with the animal's pure state of being, its oneness with nature.

In both his paintings and his writings Kandinsky's image of the horse was invariably associated with the controlling, disciplinary figure of a rider. Beginning with his childhood passion for 'riding' on a hobby horse improvised out of the branch of a tree, and a little later in life with 'a piebald horse with a yellow ochre body and bright yellow mane' which figured in the game of jockeys which he played with his beloved aunt Elisabeth Tichejeff, Kandinsky's reminiscences of his youth and of his life during this Munich period are rich in references to this ubiquitous horseman. 'The horse bears the rider with strength and speed', he wrote, 'but the rider guides the horse. Talent carries the artist to great heights with

103 Wassily KANDINSKY
Cover of 'Der Blaue Reiter' Almanac MUNICH, Städtische Galerie. 1912. Colour woodcut
21.5 × 16 cm.

strength and speed, but the artist guides his talent. This is the "conscious" or, if you prefer, the calculating side to his work. The artist must know his talent thoroughly and, like an efficient businessman, leave not a bit of it unused or forgotten'. Kandinsky's later work of these Munich years is also rich in allusions to the knightly image of Saint George, slayer of dragons, and another symbol of the spirit's ascendency over rank corruption and materialism. The patron saint of England was a popular subject for representation in the colourful and unpretentious little Bavarian glass paintings that Kandinsky and the others collected. A painting of Saint George in action hung over the altar of the Ramsach church in Murnau. In 1911 Kandinsky made his own glass painting of the subject: *Saint George II* (Munich, Städtische Galerie), and it was this representation which he soon afterwards adapted into the motif which appeared as the woodcut cover design of *Der Blaue Reiter* almanac a year later (Plate 103).

The longing for spiritual and cultural rebirth symbolized by the image of the Blue Rider haunted Germany long after the original group had disbanded. Kandinsky and Marc's uncompromising idealism, based upon a vaguely argued but deeply-felt belief in the artist's ability to shape a new destiny for himself and for mankind out of those mysterious and elusive inner forces to which they found themselves instinctively drawn, found a new champion in Walter Gropius after the 1914–18 war when he established his own crusading, modernistic art teaching programme at the Bauhaus in Weimar. As Kandinsky had optimistically forecast in 1911 when he and Marc were about to embark on their new aesthetic enterprise to propagate a broader, less dogmatic concept of art via the *Blaue Reiter* book's didactic synthesis of all kinds of art forms, drawn from a wide variety of different societies and cultures, 'a real pulse' had been set in motion.

IV DER BLAUE REITER

We will have to give up nearly everything which, as good central Europeans, we hold precious and essential. Our ideas and our ideals will be dressed in hairshirts and fed on grasshoppers and wild honey, not history. We must do this in order to escape from our tired European lack of taste.

Franz Marc, *Letter to August Macke*, 14 January 1911

The American painter Albert Bloch has left an amusing, impartial account of the internal problems which beset the NKV during the months leading up to its third exhibition in the winter of 1911. Bloch had been working in Munich since 1909 when a friend advised him to show his paintings to Kandinsky with a view to joining the NKV. Bloch related:

> After some persuasion, I consented to see Kandinsky, and ask him round to my place if he would only come. As it turned out Kandinsky was glad to come, and when he did come—well, the upshot was, that I was invited to cast my lot with him and his friends. However, this was not the immediate result. The immediate result as I learned much later was that, quite innocently and unwittingly, I was directly responsible for the breaking up of the NKV. There had long been discussion among the members, who very soon after the formation of the society, divided sharply into two opposing factions, of compromisers, or as we would call them: pussyfooters—and inexorables, or as we would call them: radicals . . . Outwardly, when they came to my studio in a body, soon after Kandinsky's first visit, all was sweetness and light and harmony amongst them, and an outsider like myself could not suspect that there was anything else. The friction arose out of the fear and distrust felt by the compromisers, the backsliding respectables among the group, of the uncompromising independence and honesty shown by the radicals. The reactionaries feared that the radicals were going too far, and they had lost sympathy for their aims, while the other group was disgusted with the smugness and growing exclusiveness and snobbishness of the backsliders, and were by this time convinced that they were only a thinly disguised lot of not too capable academicians. And that was the situation when I came into the picture.
>
> It was simply the violent disagreement between the two factions concerning my worthiness to be admitted to membership that finally precipitated the already inevitable break . . . there the one faction was determined not to have me, while the other was quite as determined that I should be admitted—although I rather suspect that their determination was at least to some degree conditioned by the resistance of their opponents, and that I happened to be merely one of those convenient though funda-mentally unimportant bones of contention which are so often made the excuse for a decisive squabble and the ultimate showdown; although to be just, I believe that the separation took place under all the dignified aspects of a gentlemen's disagreement.

The final rupture occurred rather as Marc had anticipated in his letter to Macke. On 2 December 1911 when the NKV jury met to discuss the final arrangements for its next exhibition, due to open at Thannhauser's gallery on 18 December, a violent argument broke out over one of Kandinsky's large, eschatalogical paintings, *Composition 5* (Solothurn, Private Collection), which because of its size he was obliged to submit for approval. Erbslöh dismissed the picture, accusing Kandinsky of producing not a painting but a decorative art design. Supported by his followers, Erbslöh succeeded in getting the painting rejected from

the exhibition list, which drew a scathing criticism from Marianne von Werefkin who commented that they would 'all be wearing nightcaps before long!'

Kandinsky immediately tendered his resignation from the NKV and, accompanied by Marc and Münter, he withdrew. To his great surprise neither Jawlensky nor Werefkin chose to go with them, despite the fact that they respected Kandinsky's belief in the right of every artist to freedom of self-expression without restrictions being imposed by those who were either unwilling or unable to comprehend his motives. Kandinsky took his compatriots's decision to remain with the NKV very much to heart. Jawlensky and Werefkin had both been named in the provisional list of contributors to the *Blaue Reiter* almanac drawn up in September 1911 but, after this final confrontation with his opponents in the NKV, Kandinsky struck them off.

'The die is cast', Marc wrote to his brother Paul on 3 December 1911. 'Kandinsky and I have left the NKV, and from now on we must continue the fight alone. The editors of *Der Blaue Reiter* will start new exhibitions. I think this is excellent. We will try to become the focus of the modern movement, and the association can carry on from where *Die Scholle* left off'.

In a classic counter-offensive move Kandinsky and Marc put together their own independent exhibition in time for it to open on the same day as the NKV's third and, as it proved, final exhibition in rooms adjacent to it in Thannhauser's gallery. The *First Exhibition of the Editors of 'Der Blaue Reiter'*, although hurriedly arranged, utterly overwhelmed its rival's somewhat pedestrian offerings which, in contrast to Kandinsky and Marc's 'dictatorial' presentation of works by, amongst others, Delaunay, Macke, Schönberg, Bloch and Rousseau, had a distinct air of *déja vu*. Jawlensky alone continued to excite with a series of 'heads' and portraits (e.g. Plate 104: *Helene with Red Turban*) whose powerful vitality was concentrated into even simpler, more monumental forms and glowing colours than before.

'In our catalogue we made it quite clear that the exhibition was not intended to serve a definite programme, but was based more on the principle of a variety of artistic expressions', Kandinsky remarked later. 'The "progressive line" consisted of a "left" wing representing the newly created abstract side, and a "right" wing that was purely realistic. Such a combination was without precedent at the time, and has remained new ever since'.

At the head of Kandinsky's 'left' wing stood himself and the young French Cubist painter Robert Delaunay who sent four oil paintings and one drawing to the *Blaue Reiter* exhibition. Delaunay had first been brought to Kandinsky's attention by Elisabeth Epstein who had seen one of his three large non-illusionistic compositions of the Eiffel Tower (Plate 105) at the Paris *Salon des Indépendants* in April 1911. In these remarkable paintings Delaunay had audaciously set out to 'destroy' material reality by reorganizing space and volume into a harmonious, optically intense whole, superimposing divergent planes of colour and multiplying the perspectives so that the picture surface acquired a new density and uniformity. Delaunay included an Eiffel Tower picture in the Munich consignment and it was subsequently purchased from the exhibition by Bernhard Koehler for his private collection of modern art (the painting was later destroyed by Allied Action during the Second World War). Adolf Erbslöh acquired Delaunay's *Saint-Séverin No. 1* (Plate 106) one of an earlier series of seven pictures depicting the ambulatory of this fifteenth century Gothic church, in which light has been broken down into the bright colours of the spectrum, whilst the archi-

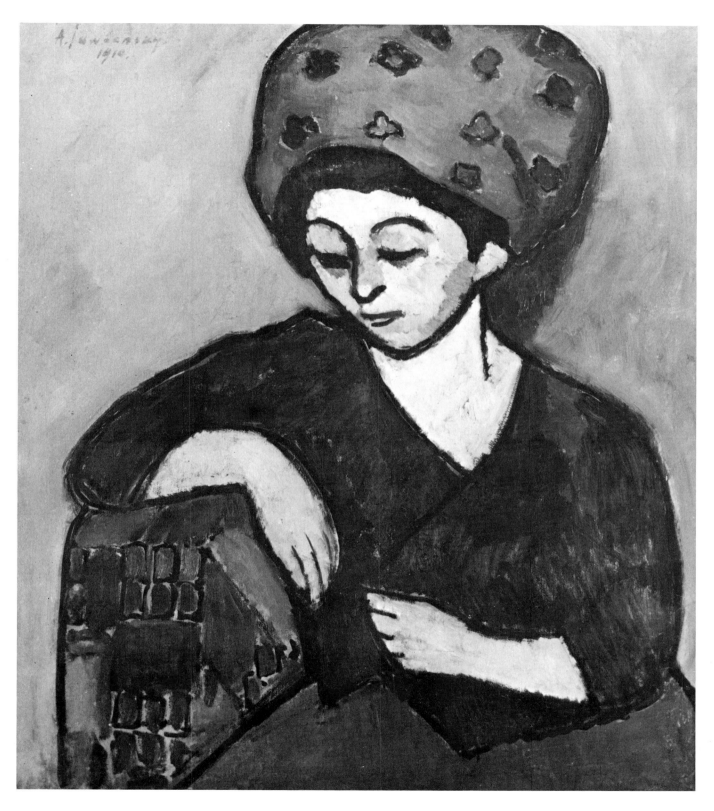

104 Alexei von JAWLENSKY
Helene with Red Turban NEW YORK, The Solomon R. Guggenheim Museum. 1910. Oil on board
94.2 × 81 cm. Signed and dated: *A. Jawlensky 1910.*

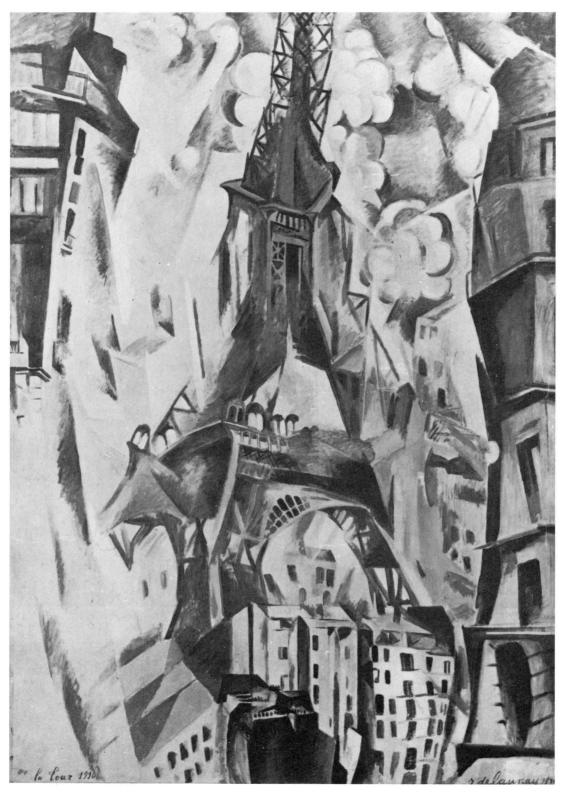

105 Robert DELAUNAY 1885–1941
The Eiffel Tower NEW YORK, The Solomon R. Guggenheim Museum. 1911. Oil on canvas
202 × 138.4 cm. Signed and dated: *r. delaunay 1910.*

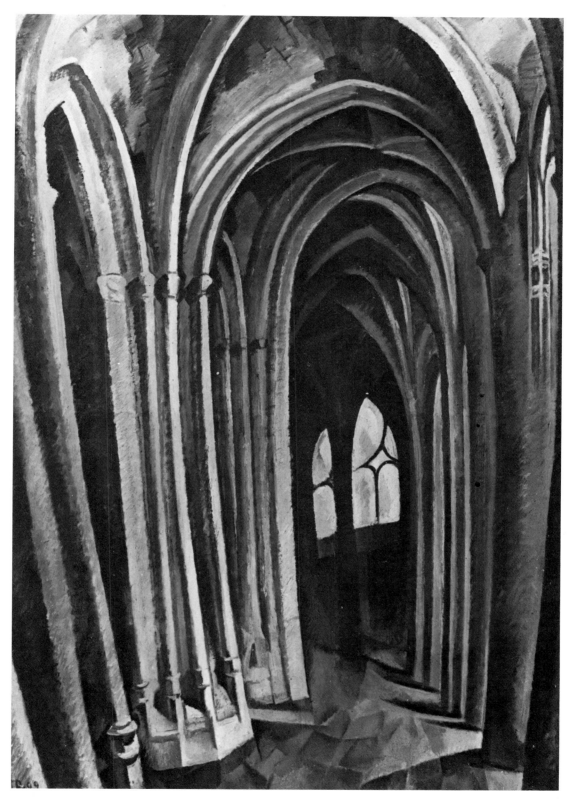

106 Robert DELAUNAY

Saint-Séverin No. 1 BASEL, F. Meyer Collection. 1909. Oil on canvas 115 × 79.3 cm. Signed and dated: *RD 09*.

tectural forms have been vertiginously distorted and simplified and seem to be turning in space.

In his *Blaue Reiter* almanac essay on Delaunay's methods of composition, Erwin Ritter von Busse, the German art historian, criticized the methods used in *Saint-Séverin* for emphasizing the subject matter at the expense of the 'idea'. 'To most spectators this painting will only look like a distorted reproduction of nature', Busse wrote, before going on to praise Delaunay's attempt to avoid the 'imitative reproduction of external appearances' in the Eiffel Tower picture where he 'shatters the optical image of nature and fragments it into small pieces'. Even so Busse felt that the French artist did not yet "dare to draw the final consequences" from his investigations into the rhythmical interplay of brilliantly coloured cubist forms. This problem was only resolved in the second of the two Paris views also included in the first *Blaue Reiter* exhibition, and subsequently bought by Jawlensky. 'Retaining the technical expedient of the cube, a further development is achieved through the balance of movement in all directions', Busse observed, 'downward and upward . . . a circling one . . . and, finally, a concentric movement that gives the painting the quality of a complete, self-contained whole . . . the treatment of colour supporting the spatial dynamics'.

Delaunay's formal and colourful representation of space and movement, for which his friend the poet Guillaume Apollinaire coined the word Orphism in 1912 to distinguish it from the more severe monochromatic Cubism of Braque and Picasso, had a powerful influence on Marc and Macke. Its impact can already be seen in the more transparent colours and the interlocking, crystalline forms of Marc's steely-eyed *Tiger* (Plate 107), which he had completed by the end of March 1912. In October 1912 Marc and Macke visited Delaunay in Paris and were wildly enthusiastic about his latest series of paintings, the *Simultaneous Prismatic Windows* (Plate 108) in which he sought to abolish objects 'that come to break and corrupt the coloured work'.

'He is feeling his way towards totally non-representational, constructive paintings, one might almost say purely musical fugues', Marc wrote to Kandinsky from Paris. On his return to Munich Marc brought with him Delaunay's essay 'On Light'—which he confessed to finding a good deal less lively and exciting than the paintings he had recently seen. The essay was freely translated into German by Paul Klee, who had been introduced into Kandinsky's inner-circle of friends by Louis Moilliet in the autumn of 1911. 'On Light' was eventually published by Herwarth Walden in *Der Sturm* in January 1913 at the time of Delaunay's Berlin exhibition. Macke's *Girl with a Fish-bowl* (Plate 109), with its simplified, semi-abstract treatment of the landscape forms and its 'simultaneous contrast' of luminous colour and light, follows the example set by Delaunay's *Window* compositions whilst preserving that poetic feeling for natural life so characteristic of Macke's own creative personality—a girl seated quietly beneath the trees, melting into a pure, hazy space.

Two tiny paintings by Henri 'Le Douanier' Rousseau led Kandinsky's 'right' wing at the first *Blaue Reiter* exhibition. In the almanac Kandinsky described Rousseau, who had died in 1910, as the 'father of the new total realism'. Delaunay had been a great friend of Rousseau—Delaunay's mother had commissioned *The Snake Charmer*, 1907 (Paris, Louvre) from Rousseau—and through Delaunay's influence Kandinsky was able to acquire *The Farmyard* (Plate 110), number one in the exhibition catalogue, from the artist's estate. 'In

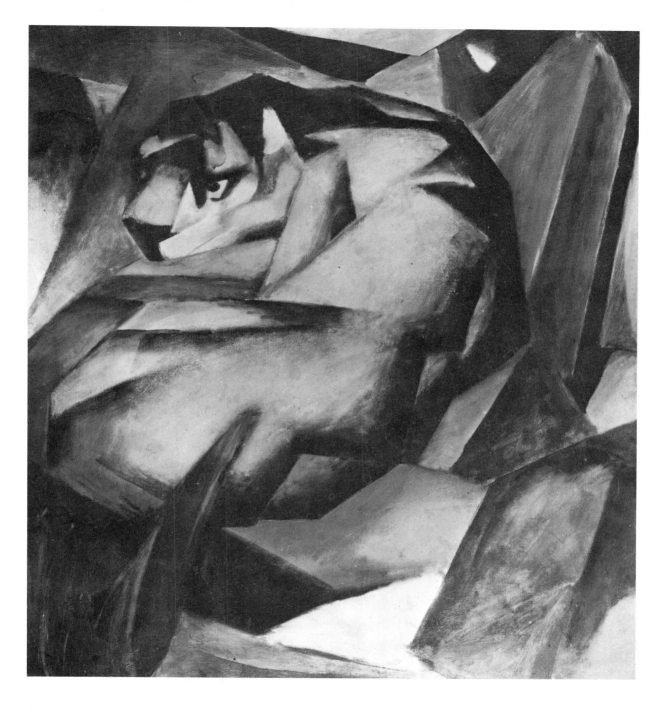

107 Franz MARC

Tiger MUNICH, Städtische Galerie. 1912. Oil on canvas 110 × 101.5 cm. Signed and dated on reverse: *Fz. Marc 12*. (Lankheit 164).

108 Robert DELAUNAY
Window PARIS, Musée National d'Art Moderne. 1912–13. Oil on canvas 110 × 90 cm.

109 August MACKE
Girl with a Fish-bowl WUPPERTAL, Von der-Heydt Museum. 1914. Oil on canvas 81 × 100.5 cm.
Signed and dated: *A.M. 1914.* (Vriesen 487).

rendering the shell of an object simply and completely', Kandinsky continued, 'Rousseau
has already separated the object from its practical meaning and released its inner sound . . .
pointing the way artlessly and convincingly, and revealing the new possibilities of
simplicity'.

Rousseau's ability to bathe the most ordinary, everyday incidents in magic gave to his
paintings of real life a freshness of vision that was always rich and alive. A childlike intuition
enabled him to arrange the picture surface in a totally unique way, giving equal emphasis
and definition to each form, subordinating the smallest fragment to the monumentality of
the whole, and creating a highly personal harmony of colours to describe them. Kandinsky
and Marc's enthusiasm for the 'angel' of the Plaisance quarter led them to reproduce seven
of his paintings in their book, including *The Farmyard* which was also used in the

110 Henri ROUSSEAU 1844–1910

The Farmyard: Landscape with White Chickens NEUILLY-SUR-SEINE, Estate of Mme. Nina
Kandinsky. *c.*1908. Oil on canvas 23 × 32 cm. Signed: *Henri Rousseau.*

preliminary advertising campaign. Most of the photographs of Rousseau's paintings were
provided by Wilhelm Uhde whom Rousseau had met in 1907. Uhde became one of
Rousseau's earliest patrons, as well as producing the first monograph to be written about
his work, published in Paris in 1911. The enchanted reality of Rousseau's paintings
continued to cast its spell over the imaginations of the Munich artists long after the
exhibition closed. Writing to Delaunay in 1913 Marc told him that 'Rousseau is the only
one whose work comes back to haunt me'.

Kandinsky and Marc's private search for the abstract principle in art strongly affected
the work of those younger, impressionable minds which were thrown into close contact
with them during this period of concentrated activity. This was certainly true of Macke and
Heinrich Campendonk, a young artist from Krefeld, both of whom were staying with Marc
at Sindelsdorf in the late autumn of 1911. Campendonk had trained at the Kunstgewerbe-
schule in Krefeld under the Dutch Symbolist painter and designer Johannes Thorn Prikker,
and was a good friend of Helmut Macke (1891–1936), August's cousin, with whom he
shared a studio after leaving art school. When Helmut went to work with Marc at
Sindelsdorf in 1910, Campendonk had carried on alone, developing a 'strong, independent
artistic temperament', to quote Alfred Flechtheim, the prominent Düsseldorf art dealer who
met him at this time.

Helmut Macke had moved to Berlin in the meantime, where he served as a useful go-

between in Marc's negotiations with Kirchner and the other *Brücke* artists during January 1912 when he was finalizing the arrangements for the second *Blaue Reiter* exhibition. Marc's hospitality extended itself to include Campendonk, who followed his friend's path to Sindelsdorf, arriving there at about the same time as August Macke in October 1911, when preparations for the almanac were at their height.

The charismatic aura generated by Kandinsky and Marc at this time of feverish excitement proved irresistible, and Macke and Campendonk seem to have succumbed to its influence without much resistance. Flechtheim wrote a strong letter of disapproval to Marc after seeing Campendonk's Sindelsdorf paintings, two of which—including *Jumping Horse* (Plate 111)—appeared in the first *Blaue Reiter* show. Criticizing these pictures for their lack of individuality, Flechtheim told Marc that he found them 'too heavily influenced by the inordinately powerful current emanating from you and Kandinsky, the result being that Campendonk has lost most of his originality. Wouldn't it be better if he worked by himself again?'

Macke also temporarily lost his sense of direction under the overwhelming impact of Kandinsky and Marc's desire to give direct expression to an objectified spiritual reality. *Storm* (Plate 112), like Campendonk's *Jumping Horse*, was painted during Macke's stay at Sindelsdorf, and was his major contribution to the opening *Blaue Reiter* exhibition, as well as being the only one of his paintings illustrated in the almanac. Like Marc's contemporaneous *Yellow Cow* (Plate 113), to which it bears a close stylistic resemblance in the convulsive, rhythmic flow of its hilly landscape forms raked by steeply angled tree trunks, *Storm* was intended to express cosmic significance through its vital, highly sensuous use of colour—it is, above all, this sublime use of colour that distinguishes the creative temperament of the *Blaue Reiter* artists—and symbolic form. The two pictures are essentially different in mood, however, Marc's rollicking, good-natured cow suggesting an ecstatic joyfulness far removed in feeling from Macke's uncharacteristically pessimistic vision of violent upheaval.

In terms of its mood Macke's *Storm* comes closer to some of Kandinsky's cataclysmic subjects, and even echoes the compositional lay-out of one such painting—*Composition 4* (Plate XXVI)—by removing the traditional horizon line, an innovation first effected by Kandinsky to create a new, constructed picture space in which each form could be clearly related to the surface of the canvas. All three paintings, however, incorporate the all-important triangular mountain shape which in Kandinsky's personal thematic repertory of images served a valuable spiritual function. In *Über das Geistige in der Kunst* he stressed the importance of the geometric triangle as a symbol of the life of the spirit, and throughout his Munich period Kandinsky experimented with the triangle—sometimes in the clearly representational form of a mountain as in *The Blue Mountain* (Plate 87), at others fining it down to a schematic, non-objective cone shape, as in his colour woodcut design for the first NKV exhibition (Plate 86). This same, basically cone-shaped form rises up in the middle of *Composition 4*, immediately behind the lance-bearing Russian warriors. Blue triangular mountains proliferate along the high horizon of the landscape in Marc's *Yellow Cow*, and Macke's storm tossed landscape has at its centre a gently sloping hill rising to a sharp peak. Small wonder then that this one painting by Macke was appreciated above all his others by the two *Blaue Reiter* editors, despite the fact that it was entirely devoid of his most individual lyric naturalism.

111 Heinrich CAMPENDONK 1889–1957
Jumping Horse SAARBRÜCKEN, Saarland-Museum. 1911. Oil on canvas 85 × 65 cm. Not signed.

112 August MACKE

Storm SAARBRÜCKEN, Saarland-Museum. 1911. Oil on canvas 85.1 × 113 cm. Signed and dated:
A. Macke 1911.

113 Franz MARC
Yellow Cow NEW YORK, The Solomon R. Guggenheim Museum. 1911. Oil on canvas
140.5 × 189.2 cm. Signed on reverse: *Marc*. (Lankheit 152).

The two Burljuk brothers, David (1882–1967) and Wladimir (1886–1917), who also
took part in the first *Blaue Reiter* show, had previously participated with Kandinsky in 1910
when they sent four paintings apiece to the second NKV exhibition, as well as contributing
one of the five introductory essays for the catalogue. After studying at Azbè's school, they
had moved on to Paris, and since returning to Odessa in 1907 were among the first Russian
painters to adopt Cubism. The Burljuks were each represented by two paintings in the *Blaue
Reiter* exhibition and David agreed to write an article about the state of contemporary
Russian painting for the almanac, which was translated into German by Kandinsky as 'Die
Wilden Russlands' (The Russian Savages).

A young, potentially interesting Czech artist Eugen Kahler (1882–1911), who had
known Kandinsky during their student days together in Stuck's academy class, had also

contributed to the second NKV exhibition, before being invited to show with the *Blaue Reiter*. Kahler was represented by two small mixed media paintings: *Garden of Love* (Munich, Städtische Galerie) and *Rider* (formerly owned by Franz and Maria Marc, but now lost), each one a delicate reminder of the artist's dream-like blend of fantasy and realism. Kahler died in Prague only five days before the *Blaue Reiter* exhibition opened. An obituary tribute to his short life was written by Kandinsky for inclusion in the almanac.

Ever since he had attended a public performance of Arnold Schönberg's atonal music with Marc early in 1911, Kandinsky had been forcibly impressed by the affinity between his own personal search for a completely new pictorial language that carried him further and further away from representational form and the Viennese composer's 'emancipation of the dissonance'. In a letter to Macke written on 14 January 1911, Marc also commented on the remarkable resemblance that both he and his wife noted between Kandinsky's paintings and Schönberg's music. 'Listening to that music [which included the Three Piano Pieces, opus 11] I found myself thinking of Kandinsky's large composition which doesn't have any tonality either', Marc wrote. 'In the music each tone stands by itself—like *white* canvas between *jumping spots* of colour!'

Kandinsky succeeded in persuading Schönberg to write an article for the almanac. 'Das Verhältnis zum Text' (The Relationship to the Text) was a brilliantly argued plea for music to be accepted and judged on its own purely abstract terms, and not according to an assumed dependency on a literary interpretation. The composer, who looked upon himself as equally a painter and a musician, was delighted to be invited to submit work to the *Blaue Reiter* exhibition. Writing about Schönberg's unsophisticated but expressive paintings in the almanac, Kandinsky likened his methods to the 'new total realism' headed by Rousseau. (Plate 114: *Red Eyes*).

Elisabeth Epstein was represented by two paintings in the *Blaue Reiter* show, possibly in return for bringing Delaunay to the editors' attention, since her work was, by any standards, fairly routine and untouched by any real mark of distinction.

Bernhard Koehler lent a sensitivity naturalistic painting of willow-warblers by Marc's friend Jean-Bloé Niestlé, who expressed a strong reluctance to take part in the *Blaue Reiter* exhibition when he saw its diverse stylistic content.

Alfred Bloch, the unwilling 'bone of contention' in Kandinsky's fight with Erbslöh's reactionary NKV faction, had six paintings in the breakaway group's first show, including *Harlequin with Three Pierrots* (Plate 115) which he described as striking 'a note of *pure fun*, of unbridled extravagance and folly . . . As with all my pictures, the clowns are an expression of mood'. As in the parallel cases of Macke and Campendonk, however, Bloch's work bears the clear imprint of Kandinsky's influence in the new way he has reduced the picture space to an all-over flat surface plane. The undulating lines and the rhythmic flow of overlapping non-material colours in Bloch's clown painting reflect Kandinsky's own contemporaneous attempts to dissolve representational forms beneath dynamic colour activities, whilst simultaneously trying to avoid the ever-present danger of meretricious decoration (Plate 116: Kandinsky, *Improvisation 26*).

Gabriele Münter was represented by four landscapes and two still-life subjects. One of the latter, *Still-Life with Saint George* (Plate 117), was also reproduced in the almanac where Kandinsky referred to it as a perfect example of the 'dissimilar and uneven transposition of

114 Arnold SCHÖNBERG 1874–1951
Red Eyes MUNICH, Städtische Galerie. On permanent loan from the Schönberg Estate. 1910.
Oil on cardboard 32.2 × 24.6 cm. Signed and dated: *Arnold Schönberg Mai 1910*.

115 Albert BLOCH 1882–1961
Harlequin with Three Pierrots CHICAGO, The Art Institute of Chicago. 1911. Oil.

objects creating a strong and complicated inner sound'. Spatial reality was once again reduced to an imaginary two-dimensional void which the artist then proceeded to illuminate by an informal arrangement of assorted Bavarian folk-art objects—a glass painting of Saint George slaying the dragon, a polychrome figurine of the Virgin and Child—that glow with a luminous brilliance out of the surrounding darkness.

Yellow Cow (Plate 113) was the most remarkable of Marc's four paintings in the show, its superb colour symbolism supporting the intense vitality of the animal's abandoned skittishness. The yellow cow stands at the centre of a universe peculiar to itself, and is firmly related to the surrounding landscape through the interaction of line, form and colour. For example, the two blue spots, one on the rump and one on the flanks, in the animal's bright yellow hide, echo the pure blue of the mountains immediately beyond. Marc had chosen his 'spiritualized' forms and colours with infinite care in his desire to express 'how nature is

116 Wassily KANDINSKY
Improvisation 26 (Oars). MUNICH, Städtische Galerie. 1912. Oil on canvas 97 × 108 cm.
Signed and dated: *Kandinsky 1912*.

117 Gabriele MÜNTER
Still Life with Saint George MUNICH, Städtische Galerie. 1911. Oil on cardboard 51.5 × 68 cm.
Signed: *Münter.*

reflected in the eyes of an animal'. But to those untutored in Marc's personal symbolism,
such paintings, with their beautifully realised sense of animality, seemed completely remote
from any metaphysical interpretation. Seeing *Yellow Cow* at an exhibition of Marc's work in
Frankfurt shortly before the outbreak of war, Edvard Munch, the Norwegian artist whose
expressive modern psychological paintings dealing with sex, death and depression had
caused a sensation at the turn of the century, was completely baffled. 'Most unusual, and
very nice to look at', he commented. 'Until recently when cows appeared in pictures they
were shown going quietly to church, but now they're dancing and jumping about all over
the place—which is really something new! The colours are amusing, but I have no idea
where it's all leading'.

Kandinsky showed three paintings including the controversial *Composition 5*, one of

those apocalyptic, visionary works which stand mid-way between the cataclysmic subject-matter familiar from his earlier treatment of last-judgment themes and the abstract pictorial language he evolved during the next three years. He had already started to give abstract titles to his paintings, however, and in the concluding chapter of *Über das Geistige in der Kunst*, Kandinsky defined the three categories into which the major works he produced between 1909–1914 were divided:

> 1. A direct impression of outward nature, expressed in purely artistic form. This I call an *Impression*.
> 2. A largely unconscious, spontaneous expression of inner character of a non-material nature. This I call an *Improvisation*.
> 3. An expression of a slowly formed inner feeling, which comes into being only after it has been worked over many times. This I call a *Composition*. In this category, reason, consciousness and purpose play an overwhelming part. But of the calculation nothing appears, only the feeling.

The *Improvisations* were started in 1909 and the *Compositions* a year later. Kandinsky regarded the seven *Compositions* painted between 1910 and 1914 as his most important pre-war pictures, and he considered them to be comparable in terms of their significance as pictorial works of art to the symphony in music. Invariably the paintings from each of these three divisions were further identified by a more specifically descriptive subtitle. Thus *Improvisation 26* is also known as 'Oars', and before it became *Composition 4* the painting which now bears that title was 'Battle'. Kandinsky constantly reiterated that a subtitle was provided only to activate the spectator's 'psychic chords' when looking at the painting and was never to be taken as a literal explanation of the picture's meaning.

The first *Blaue Reiter* exhibition created quite a stir, bewildering many with its rich variety of styles but, at the same time, sending out ripples that eventually led to the mammoth comprehensive survey of contemporary European art arranged in 1912 by the Cologne *Sonderbund*, and beyond that to the New York Armory exhibition of 1913. In his review of Kandinsky and Marc's 'dictatorial' selection of pictures for the first *Blaue Reiter* exhibition in the Swiss periodical *Die Alpen*, Paul Klee wrote:

> I would like to reassure people who found themselves unable to connect the offerings here with some favourite painting in the museum, even if it is an El Greco. For these are primitive beginnings in art, such as one finds in ethnographic collections, or at home in one's nursery. Do not laugh reader! Children also have artistic ability, and there is wisdom in their having it! The more helpless they are, the more instructive the examples with which they provide us, and they must be preserved free of corruption from an early age. Parallel phenomena are provided by the work of the mentally ill, and in this context neither childish behaviour nor madness are referred to disparagingly as they commonly are. All this is to be taken with the utmost seriousness, more seriously than all the public galleries when it comes to reforming today's art. If the currents of yesterday's tradition are really becoming lost in the sand, as I believe they are, and the so-called unflinching pioneers (liberal gentlemen) display faces that are apparently fresh and healthy but, in reality, in the light of history, are the very embodiment of exhaustion, then a great moment has arrived, and I salute those who are working towards the impending reformation. The boldest of them is Kandinsky who also tries to act by the word. [Plate

118 Gabriele MÜNTER
Paul Klee seated in an Armchair MUNICH, Bayerische Staatsgemäldesammlungen. 1913.
Oil on 95 × 125 cm.

In the spring of 1919 when Karl Nierendorf visited Klee in his Munich home, he found the unpretentious apartment in Schwabing's Ainmillerstrasse full of 'primitive Bavarian glass paintings, masks, collected nature objects, his own humorous figurines and constructions in wire . . . The dynamic spirit of the *Blaue Reiter* reached a crescendo of colour in paintings by Jawlensky, Kandinsky and other friends'.

118: Münter, *Paul Klee seated in an Armchair*].

After closing in Munich on New Year's Day 1912 the *Blaue Reiter* exhibition went on tour, travelling to Moscow where it formed part of the second *Bubonovgi Valet* (Jack of Diamonds) exhibition organized by Mikhail Larionov, Natalia Goncharova, Kasimir Malevich and the Burljuks. On its return to Germany the show was seen at Emmy Worringer's Gereon Club in Cologne before moving on to Berlin where in March 1912 Herwarth Walden incorporated it into the opening exhibition of *Der Sturm* gallery, along with paintings by Oskar Kokoschka, Edvard Munch, Ferdinand Hodler and selected French *Fauve* artists. Two years later, after making major changes in its content—Rousseau, Delaunay, Schönberg, Niestlé for example being dropped and replaced by Jawlensky and

Werefkin and, less understandably, by Kirchner, Heckel and Pechstein—Walden again revived the first *Blaue Reiter* exhibition and took it abroad.

Kandinsky had written *Über das Geistige in der Kunst* between 1908 and 1910 and now, thanks to Marc's pressing the matter with their friend Reinhard Piper, the Munich publisher who had already undertaken to print the almanac, Kandinsky's pioneering essay on the new movement to free painting from its naturalistic function was printed at the end of 1911, although post-dated in the original edition to 1912. Plans for a second *Blaue Reiter* exhibition devoted entirely to prints, drawings and watercolours were already underway by the New Year, and on 12 February 1912 this enormous—over three hundred exhibits—international survey of modern graphics opened at the Hans Goltz art shop in Munich's Briennerstrasse.

Kandinsky, Marc, Delaunay, Münter, Bloch and Macke all contributed to the new show, as did Kubin, Derain, Picasso, Braque and Vlaminck, all of whom had previously taken part in the second NKV exhibition. The remaining participants were showing under the *Blaue Reiter* banner for the first time.

The most significant newcomers to Kandinsky's rallying cry were the *Brücke* artists who, minus Karl Schmidt-Rottluff, contributed one third of the total number of works on display. Marc had argued eloquently and persuasively on behalf of Kirchner and his friends, in the face of strenuous opposition from Kandinsky who, at first, was unconvinced by their recent work which, since the group's removal to Berlin, had become more brutal and exaggerated in its attitude to life. So far as the almanac was concerned, however, Kandinsky's word was law and he made sure that all the illustrations of *Brücke* material were small, as a proper indication of what he considered to be its relatively minor significance.

Kandinsky dealt as ruthlessly with Paul Klee's *Stonecutter* (present whereabouts unknown), the only work to represent him in the almanac, because in Kandinsky's opinion Klee was still at the beginning of his development. Klee had seventeen drawings in the second *Blaue Reiter* exhibition and that, according to Kandinsky was the 'full extent of his participation'. But Klee was one of Marc's closest friends, sharing the same visual experiences, responding to many of the same interests, particularly to music, and generally involving himself in every aspect of art that was important to the *Blaue Reiter* circle. For example Klee was the first to visit Delaunay in Paris in April 1912, six months before Marc and Macke, and it was he who translated Delaunay's essay 'On Light' into German for *Der Sturm*. In April 1914 Klee accompanied Macke and Moilliet on the revelational trip to Tunisia, a decisive journey in his evolution as a colourist, colour now becoming an integral part in his organization of the picture surface where before he had been essentially a draughtsman (Plate 119: *Illustration to Voltaire's 'Candide'*). Klee took a deep, watchful interest in the later development of Marc's career, respected his friend's ideas even though they were completely incompatible with his own, and suggested that Marc's last masterpiece should be titled simply *The Fate of the Animals* (Plate XXX) and not the grandiloquent 'And All Being became Flaming Suffering' that had been Marc's own choice.

Klee's colleagues from the Swiss artists' group *Der Moderne Bund* were also invited to the second *Blaue Reiter* show, including Hans Arp, Wilhelm Gimmi, Walter Helbig and Oscar Lüthy.

From Moscow, Natalia Goncharova and Kasimir Malevich each sent drawings based on

119 Paul KLEE 1879–1940
Illustration to 'Candide' by Voltaire, Chapter 9 (*He ran him through and laid him beside the Israelite*).
BERN, Klee Foundation. 1911. Pen and ink 13 × 23 cm.

peasant themes, whilst Mikhail Larionov submitted a study of a soldier's head, all of them strongly worked in a 'crude' primitivist manner directly influenced by Russian folk art.

Kandinsky highlighted the underlying affinity between these modern and traditional 'primitive' art forms by including in the exhibition eight examples of nineteenth century Russian folk prints—or *lubki*—each woodcut freshly printed from the original blocks that Kandinsky owned. Seven of these prints were also reproduced in the almanac where Kandinsky had this to say about them: 'These prints were mostly produced in Moscow during the first half of the nineteenth century . . . They were sold in the most remote villages by travelling booksellers, and today one can still come across them in farmhouses, although they are now gradually being replaced by lithographs and oleographs'.

Maria Franck-Marc was represented by three works, including two pictures for children, one of which was a drawing of dancing sheep.

The exhibition was rounded off with work by three members of the New Secession in Berlin: Moriz Melzer, Georg Tappert, a former member of the Worpswede artists' colony, and his young pupil from that period Wilhelm Morgner. At twenty-one years of age, Morgner was not only the most gifted artist from this trio but the most receptive to Kandinsky's irresistible influence.

From working in a largely naturalistic vein inspired by van Gogh, Morgner's attention was now given over to ornamental, non-objective paintings based on a heavily stylized treatment of rhythmic lines and concentric circles. 'I want to communicate the living God in me directly through the expressive use of colour', he declared with passionate enthusiasm. Like Kandinsky, Morgner had inherited an impulse towards abstraction fostered by his formative

interest in the German arts and crafts movement. Many of his 'abstract' pictorial compositions were originally conceived as decorative designs for his sister to translate into embroideries. The war cut short Morgner's life before this early promise could be fully realized. He was killed in action on the western front in 1916.

After months of intensive preparation, complicated by the search for a financial backer who was eventually forthcoming in the familiar and reliable form of Bernhard Koehler who generously agreed to foot the bill, the *Blaue Reiter* almanac was published in May 1912. Dedicated to Hugo von Tschudi who had died during its production, the almanac opened with three essays written by Franz Marc. In the first of these essays, 'Geistige Güter' (Spiritual Treasures), Marc honoured Tschudi as an enlightened and committed champion of contemporary developments in modern painting, and also praised the influential writer and critic Julius Meier-Graefe for introducing the German public to artists such as Cézanne and El Greco, lamenting the fact that in doing so both men were attacked with 'undisguised hostility and indignation'. 'Die Wilden Deutschlands' (The German Savages), Marc's second essay, was devoted to the considerable achievements effected in the name of progress and radicalism in modern art by the artists of *Die Brücke*, the New Secession in Berlin, and the NKV in Munich. The essay ended with Marc extending the hand of friendship to those other, unknown German 'savages' struggling against officialdom and tradition with the 'same high, distant goals' as the *Blaue Reiter* whose artists are the 'heralds of the battle'.

Macke's single article was a typically poetic piece of writing on primitive art 'Die Masken' (Masks), in which he challenged European cultural orthodoxy and its indifference to non-western aesthetic traditions. 'Are not children who draw directly from the secret world of their own sensations more creative than the artist who imitates Greek form?' He asked. 'Are not the savage artists who have their own forms which are as strong as thunder? The paintings that we hang on the wall are basically the same as the carved and painted pillars in an African hut. The African considers his idol to be the comprehensible form for an incomprehensible idea, the personification of an abstract concept. For us the painting is the comprehensible form for the mysterious, incomprehensible conception of a sick person, an animal, a plant, of the whole magic of nature, of the rhythmical'.

Matisse had declined Kandinsky's invitation to write something for the book but gave permission for two of his paintings to be reproduced: *La Danse* and *La Musique* (both dated 1910, Moscow, Museum of Western Art). Roger Allard, an art critic and writer, provided the necessary article on contemporary French painting, translated as 'Die Kennzeichen der Erneuerung in der Malerei' (Signs of Renewal in Painting).

Far and away the most important theoretical essay on painting in the entire book was Kandinsky's 'Über die Formfrage' (On the Question of Form). Arguing that realism and abstraction in painting were not as necessarily opposed to one another as one might expect, Kandinsky drew parallels between his personal, seemingly complex experiments with non-representational forms and the deceptively child-like candour of Rousseau's private vision of reality. Kandinsky believed that both methods offered different approaches to the same universal truth, the artist affording insight of a reality far more profound than the commonplace material reality we know from the everyday world. As to whether or not the artist attempted to break away from representation 'the choice must be left to him, who best knows by which means he can most clearly give material expression to the content of his

painting'.

'Der gelbe Klang' (The Yellow Sound), Kandinsky's experimental stage drama, calling for the simultaneous use of an orchestra, a chorus, one tenor, actors, dancers, projected coloured lights and symbolic set designs, was originally published in the almanac. Plans to put on a performance at Georg Fuchs's avant-garde Munich Artists' Theatre never materialised. 'The Yellow Sound' demonstrated Kandinsky's highly personal, radical development of Wagner's idealistic concept of a perfectly synthesized, theatrical 'total art work'—the *Gesamtkunstwerk* dream beloved of writers, poets and musicians in the late nineteenth century and beyond. Kandinsky's interest in this whole area of creative thought was reflected in the inclusion elsewhere in the almanac of Leonid Sabaneiev's discussion of Scriabin's contemporary epic tone poem *Prometheus—The Poem of Fire* (1910), also post-Wagnerian in character, which was intended to be performed in conjunction with colours that flashed on to a screen in synchronization with the music. The ultimate fate of Kandinsky's 'Yellow Sound' was apparently decided by the Russian Revolution during the course of which all the original stage designs and Thomas von Hartmann's original music score were lost.

Music occupied a large part of the almanac. In addition to the articles by Schönberg and Sabaneiev already mentioned there were two others: Hartmann's 'Über die Anarchie in der Musik' (On Anarchy in Music) and Nikolai Kul'bin's 'Die freie Musik' (Free Music). Perhaps the most enterprising decision of all was the one to conclude the almanac with a musical supplement consisting of three *Lieder*: Schönberg's 'Herzgewächse' (The Fond Heart) to a poem by Maeterlink, Berg's 'Aus dem "Gluhenden"' (From the 'Ardent Lover'), poem by Alfred Mombert and Webern's 'Ihr tratet zu dem Herde' (You reached the Hearth), poem by Stefan George. Kandinsky borrowed the idea of this musical ending from a tradition well-established in Russian journals of the period. The ethnographic publications produced by the Imperial Academy of Sciences, which he had known since his student days, frequently carried an appendix of Russian folk songs. Furthermore, the almanac's liberal intermingling of articles on music, painting and poetry was akin to the miscellaneous art content of Benois and Diaghilev's lavish periodical *Mir Iskusstva* (World of Art), for which Kandinsky had written a review of the Munich art scene in 1902. Kandinsky's roots went deep and, even though he chose to live in voluntary exile, his Russian character imposed itself upon every aspect of his work.

Without doubt the most immediately striking feature of the *Blaue Reiter* almanac was the sheer wealth and variety of its illustrations which Kandinsky and Marc arranged without any regard for either cultural or historical associations but purely on the basis of a deep, underlying expressive relationship. In his essay 'Über die Formfrage' Kandinsky appealed to the reader to 'temporarily free himself from his own ideas and feelings', and to leaf through the book, 'turning from a votive picture to Delaunay, from Cézanne to a Russian folk print, from a mask to Picasso, from a Bavarian glass painting [Plate 84] to Kubin [Plate 71: *Monster*]'. Then, by the time the end of the book had been reached, Kandinsky believed that the reader will have experienced 'a number of deeply thrilling emotions', as a result of which he will enter the 'world of art . . . where he will undergo a positive spiritual charge'. The book's didactic purpose was exemplified many times over in its unorthodox juxtaposition of apparently unrelated paintings, such as the placing of El Greco's *Saint John*

120 EGYPTIAN
Shadow Play Figure
It was Marc's brother Paul who first brought the *Blaue Reiter* editors' attention to the figures from Egyptian shadow plays illustrated in two articles by Professor Paul Kahle that appeared in the magazine *Der Islam* in 1910 and 1911. This particular example, which belonged to Professor Kahle, occupied a full page in the *Blaue Reiter* book and was hand-coloured for the first edition. The magical qualities of the shadow-play theatre fascinated the *Blaue Reiter* artists.
One such theatre was founded in 1907 in the Ainmillerstrasse, where Kandinsky and Münter lived, by Alexander von Bernus, a friend of Kubin.

the Baptist (formerly Berlin, Bernard Koehler Collection, destroyed by Allied Action in the Second World War) face to face with Delaunay's *Eiffel Tower*. A more easily accessible cross reference was made between van Gogh's portrait of Dr. Gachet (Plate 13), wearing what the artist had described as the 'distressed expression typical of our times', and an early nineteenth century Japanese woodcut of the sort he was known to have been influenced by. 'Doesn't van Gogh's portrait of Dr. Gachet have its origin in a spiritual life akin to the amazed grimace of a Japanese juggler cut in wood?' Macke wrote in 'Die Masken'.

The editors studiously avoided all reference to the European 'classical' tradition in their choice of illustrations. Not even Rembrandt was admitted, whose *Return of the Prodigal Son* had filled Kandinsky with awe when he first saw it in the Hermitage before leaving Russia, reminding him of 'Wagner's trumpets' through its 'superhuman power of colour'. Instead pride of place went to the unknown artist-craftsmen of the so-called 'primitive' cultures. Sculpture from New Caledonia, Cameroon, the Eastern Islands and the Marquesas, Egyptian shadow play figures (Plate 120), Alaskan textiles and the despised folk art of Russia and Germany were all freely dispersed throughout the book next to the many examples of modern art by Gauguin, van Gogh, Cézanne, Matisse, Kokoschka, Picasso and, of course, the *Blaue Reiter* artists.

Although the almanac was generally well-received, going into a second edition two

121 Franz MARC

Creation II

BREMEN, Kunsthalle. 1914. Colour woodcut 23.7 × 20 cm. Signed: *M*. (Lankheit 843).

One of the proposed series of woodcut illustrations to the Bible which Kandinsky and Marc were arranging as the next *Blaue Reiter* project before their plans were disrupted by the outbreak of war. Stylistically the subject is related to such paintings as *Struggling Forms* (Munich, Staatsgalerie moderner Kunst) and *Abstract Forms II* (Münster Landes-museum), both painted in 1914. Marc considered them all to be abstract compositions although, as with the print shown here, they each contain clear references to natural forms.

years later, Kandinsky took the opportunity on that occasion to express his disappointment at the apparent failure of what he saw as the book's central message, namely to show 'that the question of form in art was secondary, and that the question of art is, before anything else, a matter of content'.

Plans to follow on with a second book devoted to establishing the 'common root of art and science' utilizing the expert assistance of, amongst others, Wilhelm Worringer the art historian and Paul Kahle, a noted Egyptologist, were disrupted by the war. Another *Blaue Reiter* project discussed at this time was a proposed modern edition of the Bible with illustrations by Kandinsky, Marc, Kubin, Heckel, Klee and Kokoschka. In the end, Kubin was the only artist to complete his part of the assignment—he had chosen to illustrate the Book of Daniel—Marc managing only to produce part of his undertaking (Plate 121).

Writing after the war, Kandinsky adopted a somewhat wry philosophical tone in his summing-up of the *Blaue Reiter* artists' impact on the world at large. 'At that time in particular, there were very few people with an awareness of the whole, and even less who experienced this total concept in the deepest fibre of their being, or were even qualified for such an experience', he commented. 'Their number is not all that much greater today. Because the world is too materialistic, that is to say the world inhabited by modern man, the world which, unfortunately for him, he has created for himself'.

V THE INVINCIBLE ENEMY

And the storm, breaking suddenly, destroyed many a delicate seed.

Franz Marc, *In War's Purifying Flame*, 1915

In the short time remaining to Kandinsky and his friends of the *Blaue Reiter* as Europe drifted towards war, an urgent need to pursue individual creative needs manifested itself in place of the demanding communal activities of the preceding months.

'I have a selfish wish to let my own ideas mature for a time, at least through the summer', Kandinsky told Marc in May 1912 in answer to a repeated plea about their plans for a second almanac. 'I'm feeling quite off course at the moment'.

There was no talk at all, however, of any further *Blaue Reiter* exhibitions. On 25 May the International Exhibition of the *Sonderbund* opened in Cologne, the first major attempt to present a comprehensive survey of the development of modern art since impressionism. Unlike the *Brücke* artists whose particular star shone brightly at the *Sonderbund*, Kandinsky and the other *Blaue Reiter* artists did not fare too well at the hands of the selection committee. Kandinsky had only two paintings in the exhibition, a rather disturbing reflection of the jury's preferential selection methods which managed to find room for a substantial retrospective of paintings by the much less important artist August Dresser, who also happened to be one of the only two painters on the panel.

Five out of the nine paintings Marc submitted were accepted, including *Tiger* (Plate 107), but at the last moment he withdrew from the exhibition in protest at the jurists' questionable system of judging the entries. Herwarth Walden seized the opportunity to take Marc's paintings, along with the rejected paintings of Kandinsky, Jawlensky, Münter, Werefkin and Bloch, and put them all together as the fourth exhibition of *Der Sturm* under the blanket title 'German Expressionists'. He also gave Marc space in the pages of *Der Sturm* periodical to give vent to his displeasure with the way most public exhibitions were organized.

Walden now took it upon himself to both promote and protect the work of the *Blaue Reiter* artists. Between the autumn months of 1912 and the spring of 1914 he arranged no fewer than nine exhibitions featuring their paintings, including a series of one-man shows devoted in turn to Kandinsky, Münter, Delaunay, Bloch, Marc and Macke (Plate 122). These artists, supplemented by Jawlensky, Werefkin, Kubin, Campendonk, Klee, the Burljuks and Bechtejeff, also figured strongly in Germany's first *Herbstsalon* (Autumn Salon) which Walden assembled with lightning speed in 1913. Valuable as his function was in fostering critical and public interest in their work, Walden frequently rode roughshod over some of the finer points of aesthetic difference that distinguished the more ambiguous paintings of Kandinsky's *Blaue Reiter* circle from the work of its more violently disposed contemporaries. 'It is in the interests of an accurate definition of artistic values and development to point out that all the artists who have any major significance for Expressionism are united in one place, and that place is *Der Sturm*!', Walden asserted dogmatically after the war. Klee for one was never in any real doubt as to where Walden's true priorities rested. 'He doesn't like paintings at all really', Klee noted in his

122 August MACKE

Promenade MUNICH, Städtische Galerie. 1913. Oil on cardboard 51 × 57 cm. Signed and dated:
August Macke 1913. (Vriesen 443).

Promenade was painted at Hilterfingen on the Thuner See in Switzerland during an eight month stay
beginning in the autumn of 1913. 'Everywhere we look forms speak out in an exalted language as if
scorning European aesthetics', Macke wrote in 'Die Masken'. 'In children's games, in a cocotte's hat,
in the pleasures of a sunny day, invisible ideas are quietly materializing'. To be sentient and watchful was
for Macke to experience a small daily miracle taking place in the earthly paradise he saw all around him.

diary after meeting Walden for the first time in 1912 on the occasion of the Munich opening of the *Sturm* sponsored Italian Futurist exhibition. 'He has a good nose for sniffing them out, that's all there is to it'.

One of the last projects on which Kandinsky and Marc were working together, before that fateful day on 28 June 1914 at Sarajevo when Gavrilo Princip fired the shot that changed the whole course of European history was a book called *Das neue Theater* (New Theatre) which was to be published in support of the waning fortunes of the Munich Artists' Theatre. Their collaborators included Hugo Ball and Erich Mendelsohn. Kandinsky's contribution was to have been on one of his favourite subjects, the perennial 'total work of art', whilst Marc had agreed to execute the stage designs for a production of Shakespeare's 'The Tempest' (*Der Sturm*). 'The consequences of all this squandering of energy are bound to be unfortunate for me', Kandinsky told Marc in March 1914, little knowing that within five months the problem would be wrested from his hands.

Macke was one of the first to enlist. He had not long returned from the brief but vitally important visit to Tunisia which he had made with Klee and Moilliet in April 1914, when colour communicated a new transparent radiance to his painting (Plate XXVIII: *Turkish Café*). Little of this new found intensity of vision informs *Farewell* (Plate XXIX), one of the last pictures on which Macke worked before he was mobilized and sent to the Front. The large, motionless figures of the women waiting with their children as the men enlist fill the crowded picture surface with a pensive fatalism that was undoubtedly an all too accurate reflection of the young artist's own sense of foreboding. Before leaving home Macke confided to his mother-in-law that he did not expect to return because his height would make him an ideal target for a sniper's bullet. On 26 September 1914 Macke was killed in action at Perthes in Champagne. He was twenty-seven years old.

'Everything he touched, everyone he knew came to life', Marc wrote, stunned by the sudden loss of his close friend. 'Every kind of material, and above all the people who were drawn into his spell as if by magic. How much we painters are indebted to him. The seed he scattered will always bear fruit, and we, his friends, will always make certain it does not remain hidden. But his work is wretchedly and irrevocably cut off'.

The dynamic spirit of the *Blaue Reiter* was extinguished. As an alien Kandinsky found it necessary to leave Germany. At first he lived at Goldach on Lake Constance, remaining there until November 1914 when he went back to Russia. He was reunited with Gabriele Münter during the winter months of 1915 and 1916 in Stockholm where he was living when the tragic news of Marc's death at Verdun on 4 March 1916 reached him.

Like many German intellectuals, Marc had believed in the war as a final and necessary cataclysmic purging agent, seeing it as 'the path to our goals . . . it will purify Europe'. The war came as the last possible chance for the kind of complete social, cultural and religious rebirth about which he and Kandinsky had dreamed for so long. 'For several years we have been saying that many things in art and life were rotten and done for, and we pointed to new and better possibilities', Marc wrote in 1915. 'No one wanted to know! What we couldn't know was that the great war would come with such terrible swiftness, pushing words aside, sweeping away death and decay to give us the future today'.

One of Marc's greatest pictures, *The Fate of the Animals* (Plate XXX), was painted 'as if in a trance' in 1913. It depicts the destruction of that natural world of animals which 'with

their virginal sense of life awakened all that was good in me'. Stylistically the painting is indebted to Delaunay in its prismatic method of composition, the splintered, crystalline forms overlapping and interpenetrating one another so that the animals—a blue deer, two green horses, two purple boars, a group of foxes—are drawn inexorably into the apocalyptic holocaust, their bodies distended into angular, semi-abstract shapes. The colour symbolism has become even more brilliantly intense, illuminating a world that is shortly to be extinguished. 'It is like a premonition of this war, at once horrible and stirring. I can hardly believe that I painted it!' Marc wrote from the Front in 1915 on receiving a postcard reproduction of the painting from Bernhard Koehler. 'Yet it is artistically rational to paint such a picture before the war, and not simply as a dumb memory after it is all over. That is the time to be painting formative pictures symbolic of the future'.

Tyrol (Plate 123) was also painted in 1913 but is a much less affecting vision of the impending cataclysm than *The Fate of the Animals*, since the tension has been expressed almost entirely by means of shattered, non-representational forms that overwhelm the few identifiable natural-motifs—an Alpine peak, a few trees, the sun—in a complex arrangement of transparent planes of colour. Shortly before he enlisted in August 1914 Marc returned to the painting and incorporated the heavily stylized, symbolic image of the Virgin and Child holding sway over the devastated landscape.

Klee had no success in his efforts to restrain Marc's increasing propensity to be abstruse and overly subjective in his later work. 'He should hate the war game more than he does or, better still, be totally indifferent to it', Klee wrote in his diary. Then, after he had received the news of Marc's death, Klee added 'I had been ready to look for causes with him, but not to indulge him in his search for hypothetical suppositions'. (Plate 124: Klee, *South Wind in Marc's Garden*).

The works Klee valued most from Marc's last days were the tiny, but passionately warm and gentle drawings from the sketchbook which Marc had constantly carried with him on the field of battle (Plate 125: *The Peaceful Horse*). 'The fellow should paint again, then his quiet smile, that is so much a part of him would appear, at once simple and simplifying', he wrote, but Marc was not destined to paint again.

'How much easier it is to paint nature than to resist her', Kandinsky had observed in 1912 as he struggled to suppress the involuntary recurrence of representational form in his work. By 1914 he felt able to say for the first time, and with total conviction, that it was possible to paint a totally abstract picture.

A conscious and deliberate broadening out in his handling of paint finally enabled him to sublimate the object beneath billowing clouds of fluid colour and flowing lines. In *Improvisation 30* (Plate 126), for example, the collapsing towers, symbol of the destruction of the prevailing material order, are still clearly discernible despite their schematic form. A year later, the same visual metaphor has been virtually submerged, if not quite totally obliterated, by the foaming upsurge of colours in 'thunderous collision' in *Fugue* (Plate XXI). Form and colour have become almost indivisible. The title reaffirmed Kandinsky's conscious effort throughout this Munich period to assimilate the abstract qualities of the pictorial structure to the musical score, to express 'the shock of contrasting colours, the sounding of one colour through another . . . all these open great vistas of purely pictorial possibility'.

In 1922, under the new 'impulse for reform' described by the Weimar Republic,

123 Franz MARC

Tyrol MUNICH, Bayerische Staatsgemäldesammlungen. 1913–14. Oil on canvas 135.7 × 144.5 cm.
Signed on reverse: *Fz. Marc*. (Lankheit 239).

(Opposite Bottom)

125 Franz MARC

The Peaceful Horse MUNICH, Staatliche Graphische Sammlung. 1915. Pencil 9.8 × 16 cm.
Not signed. Sheet 14 from the so-called 'Sketchbook from the Field'. (Lankheit 680).

4 Paul KLEE

uth Wind in Marc's Garden

NICH, Städtische Galerie. 1915. Watercolour 20 × 15 cm.
gned: *Klee*.

few months before the outbreak of war, Marc bought a
use at Ried, not far from the Benedictine monastery at
uron, where Klee often visited him when he was on leave.

126 Wassily KANDINSKY
Improvisation 30 (Cannon). CHICAGO, The Art Institute of Chicago (A. J. Eddy Memorial Collection).
1913. Oil on canvas 110 × 110 cm. Signed and dated: *Kandinsky 1913*.

Kandinsky accepted Walter Gropius's invitation to join the teaching staff of the Bauhaus school of design, craftsmanship and architecture. For a time, under the new, more rational and ordered tenor of the age, his paintings became geometric in form, without any of the characteristic turbulence and romanticism of his *Blaue Reiter* work. Several times during the next eleven years, before he was forced to leave Germany a second time with the rise to power of the National Socialists, Kandinsky repeatedly declined suggestions that he revive the *Blaue Reiter*. 'Franz Marc and I were the *Blaue Reiter*', he said. 'My friend is dead, and I have no desire to go on with it by myself'.

THE PHALANX, NEUE KÜNSTLERVEREINIGUNG MÜNCHEN AND DER BLAUE REITER EXHIBITIONS

THE PHALANX SOCIETY

First Exhibition. 2 Finkenstrasse, Munich. August 1901.

EXHIBITORS: Waldemar Hecker, Hans von Hayek, Franz Hoch, Wilhelm Hüsgen, Wassily Kandinsky, Leo Meeser, Carl Piepho, Alexander von Salzmann, Ernst Stern.

Second Exhibition. January 1902.

EXHIBITORS: Peter Behrens, Rudolf Bosselt, Hans Christiansen, Patriz Huber (Darmstadt Artists' Colony); Bernhard Pankok, Richard Riemerschmid, Paul Schultze-Naumburg (United Workshops of Munich); Moritz Baurnfeind, Natalia Davidov, Waldemar Hecker, Ludwig von Hofmann, Wilhelm Hüsgen, Wassily Kandinsky (including *Old City*, Plate 66) Erich Kleinhempel, Nikolai Kusnetsov, Alexander von Salzmann.

Third Exhibition. May 1902.

EXHIBITORS: Lovis Corinth, Wilhelm Trübner.

Fourth Exhibition. August 1902.

EXHIBITORS: Wilhelm Hüsgen, Akseli Gallén-Kallela, Ernst Geiger, Albert Weisgerber.

Fifth Exhibition. Winter 1903.

Sixth Exhibition. Spring 1903.

The contents of these two Phalanx exhibitions are not known but may have included paintings by Jan Toorop and Ignacio Zuloaga.

Seventh Exhibition. 15 Theatinerstrasse, Munich. May 1903.

EXHIBITORS: Waldemar Hecker, Wilhelm Hüsgen, Wassily Kandinsky, Philip Klein, Claude Monet, Herman Schlittgen, John Jack Vrieslander.

Eighth Exhibition. November/December 1903.

EXHIBITORS: Carl Strathmann, Max Arthur Stremel, Heinrich Wolff. (The exhibition also contained a portfolio of contemporary French and German prints entitled *Germinal*, published by Julius Meier-Graefe in Paris and including work by Bonnard, Brangwyn, Degas, Denis, Gauguin, van Gogh, Liebermann, Mueller, Renoir, Rodin, van Rysselberghe, Toorop, Toulouse-Lautrec, Vallotton and Vuillard.)

Ninth Exhibition. January/February 1904.

EXHIBITORS: Alfred Backmann, Alfred Kubin, Carl Palme, Hermann Pampel, Michael Linder, Eduard Muencke, Hans Schrader, H. J. Wagner.

Tenth Exhibition. 15 Theatinerstrasse, Munich. April 1904.

EXHIBITORS: Jules Flandrin, Charles Guerin, Pierre Laprade, Georges Lemmen, Jacqueline Marvel, Theo van Rysselberghe, Paul Signac, Louis Sue, Henri de Toulouse-Lautrec, Félix Vallotton.

Eleventh Exhibition. Kunstsalon Helbing, Wagmüllerstrasse, Munich. May 1904. Graphic art only.

EXHIBITORS INCLUDED: August Braun, Georg Braunmüller, J. Brockhoff, Mechtild Buschmann-Czapek, Franz Hoch, Wassily Kandinsky (including *Farewell* Plate 74), Paul Neuenborn, Ernst Neumann, Hans Neumann, Rudolph Schiestl, Rudolf Treumann, Martha Wenzel.

Twelfth Exhibition. Darmstadt. December 1904.

EXHIBITORS: Wassily Kandinsky, Karl Küstner, Heinrich Wolff.

NEUE KÜNSTLERVEREINIGUNG MÜNCHEN

First Exhibition. Moderne Galerie Thannhauser, 7 Theatinerstrasse, Munich. 1–15 December 1909.

EXHIBITORS: Paul Baum, Wladimir von Bechtejeff, Erma Bossi, Emmi Dresler, Robert Eckert, Adolf Erbslöh, Pierre Girieud, Karl Hofer, Alexei von Jawlensky, Wassily Kandinsky, Alexander Kanoldt, Moyssey Kogan, Alfred Kubin, Gabriele Münter, Carla Pohle, Marianne von Werefkin (including *Washerwomen*: Plate 87).

Second Exhibition. Moderne Galerie Thannhauser, Munich. 1–14 September 1910.

EXHIBITORS: Wladimir von Bechtejeff, Erma Bossi, Georges Braque, David Burljuk, Wladimir Burljuk, André Derain, Wassily Denissoff, Kees van Dongen, Francisco Durio, Adolf Erbslöh (including *Tennis Court*: Plate 85), Henri Le Fauconnier, Pierre Girieud, Hermann Haller, Bernhard Hoetger, Alexei von Jawlensky, Eugen Kahler, Wassily Kandinsky, Alexander Kanoldt, Moyssey Kogan, Alfred Kubin, Alexander Mogilewsky, Gabriele Münter, Adolf Nieder, Pablo Picasso, Georges Rouault, Edwin Scharff, Serephim Soudbinine, Maurice de Vlaminck, Marianne von Werefkin.

Third Exhibition. Moderne Galerie Thannhauser, Munich. 18 December 1911–January 1912.

EXHIBITORS: Erma Barrera-Bossi, Wladimir von Bechtejeff, Adolf Erbslöh, Pierre Girieud, Alexei von Jawlensky, Alexander Kanoldt, Moyssey Kogan, Marianne von Werefkin.

DER BLAUE REITER

First Exhibition. Moderne Galerie Thannhauser, Munich. 18 December 1911– 1 January 1912.

EXHIBITORS: Albert Bloch (including *Harlequin with Three Pierrots*: Plate 115), David Burljuk, Wladimir Burljuk, Heinrich Campendonk (including *Jumping Horse*: Plate 111), Robert Delaunay (including *Saint Séverin*: Plate 106), Elisabeth Epstein, Eugen Kahler, Wassily Kandinsky, August Macke (including *Storm*: Plate 112), Franz Marc (including *Yellow Cow*: Plate 113), Gabriele Münter, Jean Bloé Niestlé, Henri Rousseau (including *The Farmyard*: Plate 110), Arnold Schönberg.

Second Exhibition. Kunstsalon Hans Goltz, 8 Briennerstrasse, Munich. 12 February/ April 1912.
Prints, drawings and watercolours only.

EXHIBITORS: Hans Arp, Albert Bloch, Georges Braque, Robert Delaunay, André Derain, Maria Franck-Marc, Roger de La Fresnaye, Wilhelm Gimmi, Natalia Goncharova, Erich Heckel, Walter Helbig, Wassily Kandinsky, Ernst Ludwig Kirchner, Paul Klee, Alfred Kubin, Mikhail Larionov, Robert Lotiron, Oscar Lüthy, August Macke, Franz Marc, Moriz Melzer, Wilhelm Morgner, Otto Mueller, Gabriele Münter, Emil Nolde, Max Pechstein, Pablo Picasso, Georg Tappert, Paul Vera, Maurice de Vlaminck and eight nineteenth century Russian folk prints.

DER BLAUE REITER BIBLIOGRAPHY

Barr, Alfred H., Jr., *Matisse. His Art and His Public.* New York, 1951, London, 1975.

Barr, Alfred H., Jr., *Picasso. Fifty Years of His Art.* New York, 1946, London, 1975.

Bilder Enstehen, Kunsthalle, Bremen. Exhibition Catalogue, 1975.

Bloch, Albert, 'Kandinsky, Marc, Klee: Criticism and Reminiscence'. A lecture given in 1934 at the Denver Art Museum. A copy of the original text is in the Städtische Galerie, Munich.

Der Blaue Reiter Almanac. Edited by Wassily Kandinsky and Franz Marc. Documentary edition by Klaus Lankheit, Munich 1965. English translation, London, 1974.

The Blue Rider Group. An exhibition organized with the Edinburgh Festival Society by the Arts Council of Great Britain, London, 1960.

Bowness, Alan, *Modern European Art.* London, 1972.

Buckle, Richard, *Nijinsky.* London, 1971.

Cézanne. Letters. Edited by John Rewald. Translated from the French by Marguerite Kay. Oxford, 1976.

Chipp, Herschel B., *Theories of Modern Art.* Berkeley, Los Angeles, London, 1968.

Cogniat, Raymond, *Paul Gauguin. A Sketchbook.* 3 Vols. Foreword by John Rewald. New York, 1962.

Dube, Wolf-Dieter, *The Expressionists.* London, 1972.

Eddy, Arthur James, *Cubists and Post-Impressionists.* Chicago, 1914.

Fischer, Otto, *Das Neue Bild.* Munich, 1912.

French Symbolist Painters. An Arts Council of Great Britain exhibition catalogue. London, 1972.

Gage, John, 'An Instinct for the Abstract'. *Times Literary Supplement.* 18 March 1977.

Lettres de Gauguin à sa femme et à ses amis. Edited by Maurice Malingue. Paris, 1949.

Paul Gauguin. Letters to Ambroise Vollard and André Fontainas. Edited by John Rewald. San Francisco, 1943.

Gauguin and the Pont Aven Group. An Arts Council of Great Britain exhibition catalogue. London, 1966.

Gay, Peter, *Weimar Culture.* London, 1969.

Gogh, Vincent van, *The Complete Letters.* 3 Vols. New York, 1958.

Gollek, Rosel, *Der Blaue Reiter im Lenbachhaus München.* Catalogue of the Collections in the Städtische Galerie, Munich. Munich, 1974.

Grohmann, Will, *Wassily Kandinsky.* Cologne/London, 1959.

Grohmann, Will, *Paul Klee.* Stuttgart/London, 1954.

Ferdinand Hodler. Vienna Secession exhibition catalogue. Vienna, 1962.

Jullian, Philippe, *The Symbolists.* Oxford, 1973.

Kandinsky, Wassily, 'Der Blaue Reiter, Rückblick', *Das Kunstblatt XIV,* 1930.

Kandinsky, Wassily, *Rückbliche.* Berlin, 1913. English translation in *Modern Artists on Art.* Edited by Robert L. Herbert. New Jersey, 1964.

Kandinsky, Wassily, *Über das Geistige in der Kunst.* Munich, 1911. English translations:
 1. *The Art of Spiritual Harmony.* M. T. H. Sadler, London 1914. Republished as *Concerning the Spiritual in Art.* New York, 1977.

2. *Concerning the Spiritual in Art.* Francis Golffing, Michael Harrison and Ferdinand Ostertag. 'The Documents of Modern Art' Vol. 5. New York, 1947.

Wassily Kandinsky. Edinburgh International Festival exhibition catalogue. Edinburgh, 1975.

Paul Klee. Paintings, Watercolours 1913–1939. Edited by Karl Nierendorf. New York, 1941.

Klee, Paul, *Tagebücher von Paul Klee 1898–1918.* Cologne, 1957. English translation, *The Diaries of Paul Klee 1898–1918.* Berkeley, Los Angeles, London, 1964.

Kubin, Alfred, *Aus meinem Leben.* Edited by Ulrich Riemerschmidt. Munich, 1977.

Kubin, Alfred, *Die andere Seite.* Munich, 1909; 1977. English translation, *The Other Side.* Penguin Books Ltd., 1973. Including 'Alfred Kubin's Autobiography'.

Lankheit, Klaus, *Franz Marc.* Berlin, 1950.

Lankheit, Klaus, *Franz Marc.* Katalog der Werke. Cologne, 1970. The complete catalogue raisonné.

Lankheit, Klaus, *Franz Marc. Sein Leben und seine Kunst.* Cologne, 1977.

Lindsay, Kenneth, 'The Genesis and Meaning of the Cover Design for the first Blaue Reiter Exhibition Catalogue'. *The Art Bulletin XXXV*, 1953.

August Macke. Gemälde, Aquarelle, Zeichnungen. Frankfurt, Kunstverein exhibition catalogue, 1969.

Marc, Franz, *'Briefe'. Aufzeichnungen und Aphorismen.* 2 Vols. Berlin, 1920.

Marc, Franz, *Briefe aus dem Felde.* Berlin, 1959.

Marc, Franz, 'Im Fegefeuer des Krieges'. *Kunstgewerbeblatt. XXVI.* Leipzig, 1915. English translation ''In War's Purifying Fire''. *Voices of German Expressionism*, 1970.

Franz Marc, exhibition catalogue. Munich, 1963.

Marks, Alfred, *Der Illustrator Alfred Kubin.* Munich, 1977.

Miesel, Victor H. (Editor), *Voices of German Expressionism.* New Jersey, 1970.

Overy, Paul, *Kandinsky. The Language of the Eye.* London, 1969.

Phaidon Dictionary of Twentieth-Century Art. London, 1973.

Phaidon Encyclopedia of Expressionism. New York, 1978.

Prawer, S. S., 'The horror and the idyll'. *Times Literary Supplement*, 12 August 1977.

Read, Herbert, *The Philosophy of Modern Art.* London, 1964.

Rewald, John, *The History of Impressionism.* New York, 1946; London, 1973.

Roethel, Hans Konrad, *Modern German Painting.* London, 1958.

Roethel, Hans Konrad, *Der Blaue Reiter.* Munich, 1970. English translation, *The Blue Rider.* New York, 1971.

Roethel, Hans Konrad, in collaboration with **Benjamin,** Jean K., *Kandinsky.* London, 1980.

Rosen, Charles, *Schoenberg.* Glasgow, 1976.

Rosenthal, Mark, *Franz Marc.* Berkeley. University Art Museum Exhibition Catalogue, 1979.

Roskill, Mark, *Van Gogh, Gauguin and the Impressionist Circle.* London, 1970.

Rudenstine, Angelica Zander, *The Guggenheim Museum Collection. Paintings 1880–1945.* 2 Vols. New York, 1976.

Schardt, Alois, *Franz Marc.* Berlin, 1936.

Schopenhauer, Arthur, *Die Welt als Wille und Vorstellung 1819.* English translation, *The World as Will and*

Idea. 1883. Translated by R. B. Haldane and J. Kemp.

Schopenhauer, Arthur, *Essays and Aphorisms*. Translated by R. J. Hollingdale. Penguin Books Ltd., 1970.

Selz, Peter, *German Expressionist Painting*. Berkeley, Los Angeles and London, 1957.

Signac. Exhibition Catalogue. The Louvre. Paris, 1963.

Der Sturm: Herwarth Walden und die europäische Avantgarde, Berlin 1912–1932. Exhibition catalogue. Nationalgalerie, Berlin, 1961.

Tietze, Hans, 'Der Blaue Reiter'. *Die Kunst für Alle XXVII*, 1911–1912.

Tisdall, Caroline and **Bozzolla,** Angelo, *Futurism*. London, 1977.

Vergo, Peter, *The Blue Rider*. New York, 1977.

Vriesen, Gustav, *August Macke*. Stuttgart, 1953.

Weiler, Clemens, *Alexej Jawlensky*. Cologne, 1959.

Weiss, Peg, 'Kandinsky and the Jugendstil Arts and Crafts Movement'. *The Burlington Magazine*. May 1975.

Weiss, Peg, *Kandinsky in Munich*. The Formative Jugendstil years. Princeton, 1979.

INDEX

Figures in italics refer to caption numbers and those in bold type refer to plate numbers

JAN 25 1990	DATE DUE		